THE KIRLIAN AURA

THE KIRLIAN AURA

Photographing the Galaxies of Life

edited by

Stanley Krippner and Daniel Rubin

———————

1974

ANCHOR BOOKS

ANCHOR PRESS/DOUBLEDAY

GARDEN CITY, NEW YORK

THE KIRLIAN AURA was originally published as GALAXIES OF LIFE: The Human Aura in Acupuncture and Kirlian Photography by Gordon & Breach, Science Publishers, Inc., in 1973. The Anchor Books edition is published by arrangement with Gordon & Breach, Science Publishers, Inc.

Anchor Books edition: 1974

ISBN: 0-385-06574-4
Library of Congress Catalog Card Number 73–10733
Copyright © 1974 by Doubleday & Company, Inc.
Copyright © 1973 by Gordon & Breach, Science Publishers, Inc.
Printed in the United States of America
First Edition

Man is an endangered species.

We think the separation of fact from value is the principal illusion responsible for the nearly terminal condition of species man on planet Earth. This series is an attempt to share the facts and values of intelligent people who know valuable things that might help us find, live, and experience in ways that are species-enhancing, not species-destructive.

We think sharing information of this kind is as vital to humans as water is to fish.

We think we can depollute our information environment by introducing life-enhancing values into the changing currents of our lives.

We think the series should serve as a critical information resource for people who are seriously trying to enhance the life of species man.

We will publish hard science only when we think it will help us do that. We will publish opinion, analysis, exhortation, review, speculation, experiment, criticism, poetry, and/or denunciations if we think it is of critical human benefit.

We are not naïve. We don't think publishing a few truths will set us free. We are not optimists. We don't think the chances for human survival are very good. We are not elitists. We don't think that showers of wisdom from Olympus will illumine the simple man's darkened awareness.

We believe that human consciousness both guides and responds to human interaction, and that most contemporary interaction proceeds from and perpetuates assumptions about human life that are no longer valid. We believe that these assumptions *can* be changed if/when we want to.

Some of our fondest assumptions have already been unmasked by changes, unleashed by blind commitments to short-run values. The most glaring example: we once believed technology made interaction "easier." Now we know that when our technologies violate ecological laws, we murder each other.

Some new forms of interaction—and some old ones—are currently being touted as *the* way. We don't think there is, or can be, any *one* way. How to sort out the promising ones from the blind alleys constitutes our principal aim.

We therefore deliberately adopt a postdisciplinary stance, believing that no one view, be it philosophical, scientific, aesthetic, political, clinical, what have you, has *the* answer.

We intend to be a sort of whole earth idea catalogue for people who think that thinking about the human predicament *might* help us to live as one self-aware species, deliberately guiding its own evolution for the first time.

As editors, we will select and publish things *we* value as attempts to foster that kind of voluntary humanity.

Therefore, we invite anyone, whether clinical, social, behavioral scientist (or fan), student, faculty (or interested person), young or old (or in the middle) to join us in the attempt to make a joyful human future not only possible but likely.

So—if you think "science" is *the* way, we're not for you, and you probably won't like us. If you think radicals are mad (née crazy, disturbed, insane, deviant, misguided, etc.) we're not for you, and you'll probably loathe us. If you think the world will not be safe until sociologists are kings, we think *you're* mad. Ditto for politicians.

Every day, changes race into our world like mad floodwaters, undermining all we hold sacred and sure.

Change is called for.

Yet, change is crisis.

What to do in such times. How to live. Feel. Know. Experience.

That's what this series is about.

VICTOR GIOSCIA
Editor, *Social Change Series*

Dedicated to the memory of Valentina Khrisanova Kirlian,
who devoted her life to the search for the new
and the cultivation of the hidden

Contents

AUTHOR REFERENCES 11

PREFACE Letter from *Semyon Davidovich Kirlian* 13

INTRODUCTION The Cosmic Flow 17
 Daniel Rubin and Stanley Krippner

Historical Notes Relating to Kirlian Photography 25
 Max Toth

Photography by Means of High-frequency Currents 35
 Semyon D. Kirlian and Valentina Kh. Kirlian

Bioplasma or Corona Discharge? 51
 Thelma Moss and Kendall L. Johnson

A Portable Kirlian Device 73
 Robert Martin

Cold Electron Emission Patterns Due to Biological
 Fields 75
 Rodney Ross

High-voltage Radiation Photography of a Healer's
 Finger 80
 E. Douglas Dean

Field Theory and Kirlian Photography: An Old Map
 for a New Territory 85
 Stanley Krippner and Sally Ann Drucker

Some Energy Field Observations of Man and Nature 92
 William A. Tiller

Acupuncture and the Human Galaxy 137
 Corinne Calvet

Chinese Acupuncture and Kirlian Photography 141
 Jack R. Worsley

Phenomena of Skin Electricity 145
 Viktor G. Adamenko

Detection of Acupuncture Points by the Biometer 149
 *Viktor G. Adamenko, Valentina Kh. Kirlian and
 Semyon D. Kirlian*

Massage in Oriental Medicine: Its Development
 and Relationship to "Ki," or Vital Energy 151
 Robert Feldman and Shizuko Yamamoto

Questions from the Audience 160

The Art of the Aura 170
 Ingo Swann

Bioplasma and Kirlian Photography 178
 Zdeněk Rejdák

Kirlian Photography, Acupuncture, and the Human
 Aura: Summary Remarks 181
 Brendan O'Regan

Epilogue to the Second Edition 188
 Stanley Krippner and Daniel Rubin

REFERENCES 200

INDEX 205

Author References

Viktor G. Adamenko, Ph.D., The Radio-Physics Institute, Do Vostrebovaniya, Moscow K-9, U.S.S.R.

Corinne Calvet, 257 Central Park West, New York, New York 10023, U.S.A.

E. Douglas Dean, M.S., Newark College of Engineering, 323 High Street, Newark, New Jersey 07102, U.S.A.

Sally Ann Drucker, M.A., Dream Laboratory, Maimonides Medical Center, 4802 Tenth Avenue, Brooklyn, New York 11219, U.S.A.

Robert Feldman, M.A., 82-56 212th Street, Hollis Hills, New York 11427, U.S.A.

Kendall L. Johnson, A.B., J.D., Paraphysics, Inc., 16636 Calneva Drive, Encino, California 91316, U.S.A.

Semyon Davidovich Kirlian, Ph.D., Kazakh State University, Alma-Ata, Kazakh, U.S.S.R. (Deceased)

Valentina Khrisanova Kirlian, Ph.D., Kazakh State University, Alma-Ata, Kazakh, U.S.S.R. (Deceased)

Stanley Krippner, Ph.D., Maimonides Dream Laboratory, Maimonides Medical Center, 4802 Tenth Avenue, Brooklyn, New York 11219, U.S.A.

Robert Martin, B.S., 156 Fourth Street, Troy, New York 12180, U.S.A.

Thelma Moss, Ph.D., Center for the Health Sciences, University of California, Los Angeles, California 90024, U.S.A.

Brendan O'Regan, M.S., Stanford Research Institute, Menlo Park, California, U.S.A.

Zdeněk Rejdák, Ph.D., Czechoslovak Coordination Committee for Research in Psychotronics, V. Chaloupkoch 59, Prague 9, Hloubetin, Czechoslovakia.

Rodney Ross, Foundation for Gifted and Creative Children, 385 Diamond Hill Road, Warwick, Rhode Island 02886, U.S.A.

Daniel Rubin, B.S., Dream Laboratory, Maimonides Medical Center, 4802 Tenth Avenue, Brooklyn, New York 11219, U.S.A.

Ingo Swann, 357 Bowery, New York, New York 10003, U.S.A.

William A. Tiller, Ph.D., Department of Materials Science, Stanford University, Stanford, California 94305, U.S.A.

Max Toth, M.A., 8160 248th St., Queens, New York 11426, U.S.A.

Jack R. Worsley, Doctor of Acupuncture, The College of Chinese Acupuncture, 6 Glebe Crescent, Kenilworth, Warwickshire, England, U.K.

Shizuko Yamamoto, 23 West 73rd Street, New York, New York 10023, U.S.A.

Preface

May 15, 1972

Stanley Krippner, Ph.D.
Director, Dream Laboratory
Maimonides Medical Center
4802 Tenth Avenue
Brooklyn, N.Y. 11219

Deeply esteemed Dr. Stanley Krippner:

On the opening of the first conference on the Kirlian effect, I personally greet you, all the conferees, and everyone in attendance.

Research with varied types of objects by means of studies of their "electrical conditions"—called by the Soviet scientists "the Kirlian effect"—apparently will have such enormous significance that an impartial assessment of the methods will be carried out only by minds in succeeding generations. The possibilities are immense; indeed, they are practically inexhaustible.

I wish the conference success. From the conference, I hope there will develop significant creative solutions for the blessing of mankind and the affairs of the world.

In conclusion, I ask you to please keep in mind the contributions of Valentina Khrisanova Kirlian who devoted all of her conscious life to the search for the new and the cultivation of the hidden.

With sincerest respect,
SEMYON DAVIDOVICH KIRLIAN

Kazakh State University
Alma-Ata, Kazakh, U.S.S.R.

THE KIRLIAN AURA

Introduction

The Cosmic Flow

The importance of contemporary Soviet psychology has been acknowledged by many authorities (e.g., Brozek, 1970; Cole and Maltzman, 1969; Razran, 1971). Gardner Murphy and J. K. Kovach (1972:377) have written of "the magnitude of its existing and potential impact on the entire body of modern psychology . . . ," stressing (1972:396) that "Soviet psychology is not a closed system . . ."

The pioneering work of I. P. Pavlov (1928) has been as great an influence on psychology in the United States as it has been in the Soviet Union (Murphy and Kovach, 1972:378). Among other advances, it stimulated experimentation in the area of neuropsychological mechanisms of the brain. Among these experiments have been some notable research studies in the field of parapsychology (e.g., Vasiliev, 1965).

Firsthand reports of the Soviet work in parapsychology have been given by many American investigators (e.g., Moss, 1971; Pratt, 1968; Tiller, 1972; Ullman, 1971). Stanley Krippner and Richard Davidson (1972), the first scientists to give an invited lecture on parapsychology at the Institute of Psychology in the Soviet Academy of Pedagogical Sciences, wrote:

> The most striking discovery we made during our stay in the Soviet Union was the difference between American and Russian approaches to parapsychology. In America the thrust of research is simply on proving the existence of ESP (extrasensory perception) and PK (psychokinesis) . . . Russian parapsychologists seem to harbor no doubts about the existence of parapsychological phenomena. Instead, they are seeking practical applications and an understanding of how these phenomena operate.

Krippner and Davidson (1972) cited acupuncture as one of the possible "practical applications" of Soviet parapsychology. They mentioned Kirlian photography as one of the tools utilized in attempting to understand ESP (referred to as "biological information" in the U.S.S.R.) and PK (referred to by the Soviets as "biological energy"). Krippner and Davidson (1972) wrote:

Almost everyone we met in Russia mentioned acupuncture, although it is not as widely practiced there as in China. There are, in fact, important differences between the two techniques. Instead of using needles, as the Chinese do, Soviet physicians usually stimulate the appropriate area with massage, ointments, lotions, weak pulses of electricity, injected chemicals, and even, in the case of epileptic seizures, laser beams. Although most parapsychologists in the U.S.S.R. believe in the efficacy of acupuncture, it should be noted that not all physicians who use acupuncture are interested in parapsychology. Many use acupuncture simply because it seems to work.

Krippner and Davidson heard how acupuncture was used to treat various medical problems from impotence to bedwetting. Viktor Adamenko, a Soviet physicist, demonstrated the tobiscope, a device used to detect the body's acupuncture points. Adamenko also told them about a device invented by Semyon and Valentina Kirlian to photograph objects by means of high-voltage spark discharges. The Kirlians (1958) describe their photography as a method for the conversion of nonelectrical properties of an object into electrical properties which are then captured on film.

Russian interest in electrophotography has a long history, dating back to 1898 when an engineer, Yakov Narkevich-Todko, displayed photographs taken with the assistance of electrical discharges. V. I. Mikhalevskii and G. S. Frantov (1966) have applied Kirlian photography to locating and recovering mineral ores ranging from high-conducting sulfide minerals to low-conducting silicates. The principle underlying the ore recovery process is evolved from the diversity of electrical conductivities encountered in minerals. Mikhalevskii and Frantov stated that "the method of Semyon and Valentina Kirlian can be used to investigate inanimate objects electrophotographically which constitute a new field of application for this method."

GENERAL SYSTEMS THEORY

Both acupuncture and Kirlian photography may eventually take their place among recent scientific developments which are subsumed by the general title of "systems research" (Laszlo, 1972a). According to Ludwig von Bertalanffy (1966), the emergence of a "systems science" was an outgrowth of the simultaneous rise of the biological, behavioral, and social sciences. A need existed for theoretical constructs similar to those used in physics. However, a simple application of physics did not suffice for this purpose; instead, a series of generalizations of scientific concepts became necessary (Laszlo, 1972b). These generalizations demonstrated what highly complicated sets of activities, each subject to the basic laws of physics, do when they interact.

A "system" is defined by von Bertalanffy (1966) as a complex of components in mutual interaction. R. Buckminster Fuller (1972) utilizes the term "synergy" to describe the behavior of systems as being unpredictable by the separate behaviors of any of the parts. Just as our knowledge of chemical compounds does not permit us to predict the level of organic associability of molecules as biological cells, our knowledge of biological cells does not enable us to predict their association as biological tissue. In turn, data about tissue do not help us to foresee the behavior patterns of biological species.

Kirlian photographs of various forms of life demonstrate that different species have their own flare patterns (Krippner and Davidson, 1972). However, the flare patterns of any one organism cannot be explained solely on the basis of the behaviors of either the separate parts of a system or of the species as a whole.

Furthermore, the "phantom leaf" or "lost leaf" effect (in which the flare pattern of a cut-off portion of a leaf purportedly could still be seen in subsequent pictures; could provide, if verified, visual proof of Fuller's concept of "synergy." Another example of both "synergy" and "systems" would be acupuncture—with its suggestion of complex bodily interactions.

In "General Systems Theory" (von Bertalanffy, 1966) living organisms fall into the specific category referred to as "open

systems." Systems which are "open" maintain an exchange of matter with their environment through import and export as well as through the building up and breaking down of components. Open systems as compared to the closed systems of traditional physics show singular characteristics. An open system may attain a steady state in which it remains constant but, in contrast to conventional equilibria, this constancy is one of continuous exchange and flow of component material. Von Bertalanffy (1966) notes, "Even without external stimuli, the organism is not a passive but an intrinsically active system . . . The stimulus (a change in external conditions) does not cause a process in an otherwise inert system; it only modifies processes in an autonomously active system."

Kirlian photographs of a healthy, calm, and even-tempered man's fingertips are reported to differ from those of an anxious, tense individual (Ostrander and Schroeder, 1971). Thus, it seems that the general state of the system as well as its response to external stimuli can be monitored using Kirlian photography. Conceptualizing the living organism as an "open system" may prove to be useful in interpreting the information that the Kirlian method provides.

Because the Kirlian process responds to changes in the state of the system, it may prove to be a useful diagnostic device in medicine. It may become a useful tool in extending the brain's receiving capabilities and providing a means to more accurately monitor the energy complexes of the universe. At the same time, acupuncture presents the healing professions with a holistic approach very much in tune with the synergetic, systems-oriented image of the world which appears to be emerging from interdisciplinary scientific research.

THE HUMAN GYROSCOPE

Kirlian photography and acupuncture represent a double paradox: their utility and their method of operation. It has yet to be determined, by orthodox Western scientists, if the approaches represent anything of value. Acupuncture may produce a few positive results as suggestible patients suffering from psychosomatic

illness get well because they would respond to any novel treatment technique. Kirlian photographs may represent artifacts due to the electric charges that are a part of the process. On the other hand, acupuncture and Kirlian photography might prove to be valuable adjuncts in medicine and other fields. If so, the second question remains, "Are they parapsychological in nature?"

Some writers doubt that either acupuncture or Kirlian photography will help to explain ESP or PK. They admit the validity of these approaches but feel they can be explained within the structure of traditional biology, neurology, and physics. Others insist that new energies, new systems, and new concepts must be posited to understand these phenomena.

In any event, there are other recent findings which appear to be related to acupuncture and Kirlian photography, findings which also demand attention from Western scientists. L. J. Ravitz (1970) has reported that hypnosis produces field shifts that can be recorded electrometrically—just as hypnosis has been found to alter the fields recorded by Kirlian photography (Moss, 1971).

J. H. Seipel and R. D. Morrow (1960) have reported the existence of electrostatic and electromagnetic fields arising from neuron impulses. These fields are reported to be of sufficient strength to be readily detectable through air at an appreciable distance from the stimulated preparation. Seipel (1971) has suggested that these fields may represent "methods of direct information transfer or signaling which avoid the usual sensory channels . . ." Roger Eckert (1972), in his studies of ciliary activity, also produced data suggesting an informational aspect of these fields, finding that

> . . . the direction and frequency of beating cilia is regulated by the intracellular concentration of free calcium ions in the vicinity of the ciliary apparatus, and that the intracellular accumulation of Ca^2+ is regulated by the local and distributed electrical responses of the cell membrane to environmental stimuli . . . The bioelectric organization of the ciliate is based entirely on analog-to-analog transforms.

An adolescent boy's congenitally defective tibia was stimulated to heal by direct electric current; newly formed bone in the

defective region was produced within two months of electrical treatment (Lavine, et al., 1972). This electric enhancement of bone healing resembles certain types of acupuncture treatment and may provide clues as to the mechanism involved.

There is considerable evidence that both natural and artificial magnetic fields can exert important effects on living organisms. In their review of the literature, Frank Russo and W. E. Caldwell (1971) concluded:

1. Magnetic fields affect biological organisms through the physiological processes of the organisms.
2. The effect is quite general since it affects the total rather than specific parts of the organism.
3. The effect is most probably due to physiological control of inhibitory processes that are of an electrical nature (e.g., neurophysiological and humoral ionic processes).
4. The "compass" behavior exhibited by some animals may in essence be an attempt toward reducing the disorganizing effects of the magnetic fields.

J. B. Beal (1972) sees the human being as "an intangible synergistic higher order of mental and psychic patterns . . ." while O. L. Reiser (1972) stresses the importance of attuning the "music of human consciousness" to "the galactic wave field . . ." In other words, the evidence mounts that the well-functioning, fully developed person is a human gyroscope who maintains both an internal and external balance with a series of forces and energies.

The papers in this volume raise many questions and answer few in regard to the cosmic flow. The papers resulted from a conference held to exchange knowledge among scientists who are investigating the information made available by Kirlian photography techniques and its possible application to acupuncture—as well as an even more ineffable topic, the "human aura." The Kirlian devices were built as the direct result of the visits to the U.S.S.R. by Moss (1971), Krippner and Davidson (1972), and others who brought back plans and blueprints generously provided by their Soviet hosts in the spirit of international cooperation.

The First Western Hemisphere Conference on Kirlian Photog-

raphy, Acupuncture, and the Human Aura, held at the United Engineering Center in New York City on May 25, 1972, also demonstrated international cooperation. Of the papers selected for this book, several are from the Soviet Union (those by S. D. Kirlian, V. Kh. Kirlian, and V. G. Adamenko); one is by a Canadian (William A. Tiller). Others represent France (Corinne Calvet), Japan (Shizuko Yamamoto), the United Kingdom (J. R. Worsley), Eire (Brendan O'Regan), and the United States. Of the latter, some are students (Rodney Ross, Sally Ann Drucker, Robert Feldman, Daniel Rubin) and some are professors or professional researchers (E. Douglas Dean, Kendall Johnson, Thelma Moss, Max Toth, and Stanley Krippner). Letters received after the conference included three which were important enough for inclusion in the book (Robert Martin, Ingo Swann, and Zdeněk Rejdák).

Indeed, the bulk of the American work in Kirlian photography is now being undertaken by students at various colleges and universities (e.g., the photographs by James Hickman, Larry Amos, Kerry Krumsiek, and Ronny Mastrion). Also included in the volume are informal remarks by the speakers and discussants—among them another American (John W. C. Fox).

Credit must be given to the co-sponsors of the conference: The Center for the Study of Social Change (315 West 57th Street, New York, N.Y. 10019) and the Foundation for ParaSensory Investigation (1 West 81st Street, New York, N.Y. 10024). Both organizations were aware of the speculative nature of much of this information but felt that it should be presented and shared. The Russian-to-English translations at the conference and in this volume were capably handled by Robert D. Nelson, and manuscript typing was under the direction of Hadley Smith.

DANIEL RUBIN and STANLEY KRIPPNER

July 15, 1972

Historical Notes Relating to
Kirlian Photography

Max Toth

The nonconventional photographic process currently referred to as Kirlian photography has, in actuality, been in existence since the late 1890s. According to Viktor Adamenko (1970), at the fifth photographic exhibition given by the Russian Technical Society in 1898, the Russian engineer and electrical researcher Yakov Narkevich-Todko demonstrated "electrographic photos obtained with the help of quiet electrical discharges."

These discharges, which appear in the form of a bluish flame, were apparently first noted in biblical times. The many instances in both the Old and New Testaments of miraculous fires, such as the burning bush which Moses saw on Mt. Sinai (Exodus 3:2), and the flames which allegedly appeared upon the twelve apostles, on the day of Pentecost, (Acts 2:3), could, in reality, have been occurrences of this phenomenon. It is, very possibly, this mysterious fire which Renaissance artists attempted to depict when they painted nimbi or aureolae encircling the heads of divine religious figures.

This general phenomenon, then, has been recorded by historians since the dawn of recorded time. It has usually appeared hovering above sharp or pointed structures such as ships' masts, church spires, airplane wing tips, or treetops. Probably because this bluish flame most often appeared around the masthead, yardarm, rigging, etc., of wooden ships, it became associated with St. Elmo, the martyred Italian bishop who was the patron saint of sailors. Although most commonly known as St. Elmo's fire, this phenomenon is also known by a profusion of other names, among which are Castor and Pollux, the Dioscuri, corposant, and Fermie's fire (Gaidoz and Rolland, 1884–1885).

According to Carey (1963), it was not until the middle of the

nineteenth century that scientists "proved that the hobgoblin of the mariner's existence was no more than an overabundance of electricity in the atmosphere. Once ignited by the chafing of the rigging, the flames would naturally adhere to anything metallic, thus the iron of the spars and yardarms became likely targets for the fitful fires. If touched, the greatest harm the fiery tongues can deliver is to give the meddler an unpleasant shock."

So much a part of maritime history was St. Elmo's fire that Shakespeare, when writing *The Tempest,* introduced the phenomenon in the form of Ariel, "an airy spirit," who proclaims (in Act I, Scene II):

> I boarded the king's ship; now on the beak,
> Now in the waist, the deck, in every cabin,
> I flamed amazement: sometime I'ld divide,
> And burn in many places; on the topmast,
> The yards and bowsprit, would I flame distinctly,
> Then meet and join. Jove's lightnings, the precursors
> O' the dreadful thunder-claps, more momentary
> And sight out-running were not: the fire and cracks
> Of sulphurous roaring the most mighty Neptune
> Seem to besiege, and make his bold waves tremble,
> Yea, his dread trident shake.

This poetic description is remarkably like John J. O'Neill's account (1971:185) of Nikola Tesla's experiment to duplicate lightning. In this experiment Tesla, the man responsible for the development of alternating current, used giant coils with banks of condensers and other apparatuses. As the coils began to build up the necessary voltage, they developed a blue glow around them. O'Neill (1971:185) states that there was

> a strange ghostly blue light in the great barnlike structure. The coils were flaming with masses of fiery hair. Everything in the building was sprouting needles of flame, and the place filled with the sulphurous odor of ozone, fumes of the sparks, which was all that was needed to complete the conviction that hell was breaking loose and belching into the building.

Not only did Tesla unknowingly create St. Elmo's fire during the experiments in which he produced the first bolts of man-made

lightning ever created, he also apparently produced St. Elmo's fire in a glass tube. O'Neill (1971:139–140) writes:

> Walking to the middle of the room, Tesla gave orders to turn out all lights. The laboratory was in pitch darkness. A workman stood with his hand on the switch of the oscillator.
>
> "Now!" shouted Tesla.
>
> Instantly the great room was flooded with brilliant but weird blue-white light and the workmen beheld the tall, slim figure of Tesla in the middle of the room waving vigorously what looked like two flaming swords. The two glass tubes glowed with an unearthly radiance, and he would parry and thrust with them as if he were in a double fencing match.

The St. Elmo's fire effect attests to the ability of high voltage to ionize the gases in the surrounding air. In America since the time of the settlement of the West, many plainswomen have reported opening their cast-iron stoves and seeing a big bluish ball of flame come tumbling out. These instances probably occurred because the stove chimney, which was metal, attracted static electricity, freely available whenever electrical storms were in the neighborhood. This electricity accumulated in the oven cavity, creating a spherical blue version of St. Elmo's fire (Tesla, 1956).

The science editor for the Scripps-Howard newspaper chain, David Dietz, described some cases of "ball lightning" or "fireballs" which occurred in early 1962 (Edwards, 1969:169). One of them took place in a grade school during a severe thunderstorm. Dietz reported that a brilliantly glowing ball about a foot in diameter came through an open window behind the platform on which the teacher was standing. It floated slowly upward to a point just above the horrified lady's head, hung there for a few seconds and faded away. Edwards (1969:169) describes another incident:

> On Long Island, a fireball about the size of a basketball came through an open window, rolled slowly across the floor between a husband and wife who were watching television, and then the fireball swept into the hall through an open door and vanished without a sound.

Even today in the American Midwest, drivers traveling at dusk

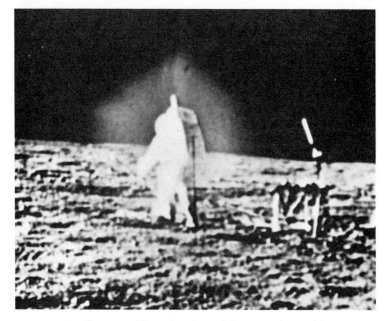

Figure 1. Apollo 12; wide-angle view of lunar surface with astronaut (courtesy, NASA)

down straight stretches of road paralleled by high-voltage transmission lines often see a transparent blue glow enveloping the power lines.

Interestingly, St. Elmo's fire seems not to be restricted to the planet Earth, but may also be present on the moon. The picture on the cover of a 1970 *Life* magazine issue devoted to the Apollo 12 moon landing shows astronaut Pete Conrad on the moon, with a bluish glow around him. This NASA picture of a blue halo encircling Conrad appeared in the May 1970 issue of *Saga* magazine and many other publications (*Figure 1*). Apparently this glow is generated by the various items of voltage-producing equipment contained in his backpack.

According to J. B. Beal (1971), a NASA employee, space officials have stated that the glow around the astronaut's helmet is nothing more than moon dust kicked up by the astronaut as he

moved about. However, the characteristics of this glow are so similar to St. Elmo's fire that we should not discount the possibility that there is some relation between the two phenomena.

If the electrical energy charging an object is prevented from discharging in a quiet form, or if the electrical energy charge is too rapid in buildup, a strong, loud discharge will take place. This discharge could be in the form of a small spark accompanied by the familiar crackling sound one experiences when touching a metal plate on a cold day after having walked across a rug, or it could be in the form of a spectacular and dangerous lightning bolt occurring during an electrical storm.

Curiously, nature seems to have used these strong discharges, in their milder form, to imbue several persons in different parts of North America with the properties of human storage batteries; anyone who touched these people would receive a painful shock (Edwards, 1959, Chapter 42).

The first recorded case dates back to 1879. A nineteen-year-old girl, living in Ontario, Canada, after recovering from an unknown illness symptomized by convulsions, not only discharged electricity but also appeared to have electromagnetic properties. Any metal objects which she picked up would adhere to her open hand and would have to be forcibly pried away from her by another individual.

Nine years later, in Maryland, a sixteen-year-old boy with similar electromagnetic properties came to the attention of scientists at the Maryland College of Pharmacy because of his ability to suspend iron and steel rods, half an inch in diameter and twelve inches in length, from his fingertips. The boy could also lift a beaker of water filled with iron fillings merely by pressing three fingers against the side of the container. An audible clicking would occur when he pulled one of his fingers away.

Perhaps the most impressive of these cases was that of a fourteen-year-old girl in Missouri who, in 1895, suddenly seemed to turn into an electrical dynamo. When reaching for metal objects such as a pump handle her fingertips gave off sparks of such high voltage that she actually experienced pain. So strong was the electricity coursing through her body that a doctor who attempted to examine her was actually knocked onto his back, where he remained unconscious for several seconds. To the young lady's

relief, her ability to shock eventually began to diminish and had vanished completely by the time she was twenty.

In all of the above-mentioned cases, this strange electrical phenomenon was at its peak in the early part of the day, diminishing in power as the day waned. It was also, in all of the cases, entirely uncontrollable and involuntary.

Oddly enough, at the same time that nature was using strong electrical discharges to turn people into human storage batteries, it was also using these same discharges, in their more spectacular form, to etch pictures into glass (Edwards, 1959, Chapter 62).

One morning in 1865 a Kentucky farmer and his wife stepped outside their house after a particularly heavy rainstorm and were astounded to see a full-color picture of a rainbow, six inches wide, arching across the lower three panes of their front window. Although the rainbow could not be viewed from inside the house, the couple proved that the brilliant multihued picture was actually embedded in the windowpanes, since, when they raised the window, the rainbow rose correspondingly.

Another violent thunderstorm, this one in a Tennessee valley in 1887, etched a photographic likeness of an aged widow into a windowpane of her home. This picture, which was described as comparable in detail to any conventional photograph, was reportedly an amazingly accurate portrait of the old woman, complete with lacy bedcap and jagged smile. The image remained for many years before it disappeared.

A similar incident occurred in Washington, D.C., when the images of a man in his sixties and his aged mother were etched into the large plate-glass window through which, it was known, they often enjoyed watching electrical storms. The window was subsequently paneled over and the true-to-life portrait was not discovered until 1903, many years after their deaths. The windowpane was turned over to scientists at the Smithsonian Institution who admitted that lightning had etched the picture into the window, but were at a loss to explain how it had been done. The glass is believed still to be in the Smithsonian's collection.

One of the strangest of these cases of lightning photography occurred in Indiana in December 1891, when a picture of a woman who had died four days earlier was found apparently etched into the glass of the front window of her house. The

picture was, everyone who saw it agreed, an excellent likeness of the dead woman; it remained for approximately seven days, then disappeared. It reappeared within the month, at first vaguely, then more distinctly. Although several persons tried to scrub the picture away, it remained until a son of the deceased, who had been in California at the time of her death, erased the likeness forever simply by rubbing it lightly with his handkerchief.

It is debatable whether this case was an instance of lightning photography, or a manifestation of a different phenomenon known as psychic photography. Certainly it bears some similarity to cases described by Harriet Boswell (1969) as "delayed photo impression phenomena." In speaking of conventional photographs, Boswell (1969:214) writes that "frequently 'extras' appear on pictures which showed no such presences at the time the pictures were printed. They appear many weeks or months *after* the picture has been processed . . . Sometimes psychic images appear long after the photographic developing and printing process has been completed."

Some psychic photographs are pictures of persons no longer alive. Some of these photographs are taken with conventional camera equipment; others, called skotographs, are obtained through nonphotographic methods.

The first psychic photographs were taken in 1862 by William Mumler, a Boston engraver and amateur photographer. At the time, photography was a mere twenty-three years old, and the pictures Mumler took of his relatives and friends were largely experimental in nature. One day, when developing a batch of negatives, Mumler found that, in addition to the faces of those people he had knowingly photographed, there were images of relatives who were no longer alive. Mumler, who had never believed in spirits, nor displayed any interest in psychic research, had become the father of spirit photography.

Mumler's record as the first spirit photographer is upheld by U. S. Court of Appeals Judge John Edmond, who investigated Mumler personally and obtained photographs under test conditions of people known only to him who were dead. Originally Judge Edmond had gone into the investigation thinking it was all a deception. In a letter published by the New York *Herald* on August 6, 1853, however, the judge spoke not only of

Mumler's experiments, but also of his subsequent sittings with well-known mediums of his day (Holzer, 1969:3–4).

Despite this public testimonial by such an august personage as a judge of the U. S. Court of Appeals, psychic photography has not, 120 years later, attained respectability. This is due in part to the disorganized state of research in the field, and in part to the fact that such photographs can so very easily be falsified.

John Nebel (1970:103), a radio interviewer, relates, "I've been told about a number of spirit pictures taken by well-known photographers that have not been publicized because of fears of ridicule or accusations of fakery."

One branch of psychic photography which is receiving less cavalier treatment is "thoughtography." This photographic technique entails the transfer of mental images or thoughts onto film, either in or out of a camera. Its recent rise in respectability is directly attributable to Jule Eisenbud (1967), who had performed a number of scientifically controlled experiments with world-famous thoughtographer Ted Serios.

No scientific explanation of thoughtography conforming to the current universal laws has yet been offered. However, this author believes that the motivating force of this process is biological energy or bioenergy, as defined by the Czechoslovakian parapsychologists. Bioenergy is apparently a kind of force much more subtle than electromagnetic waves and is always associated with psychic impulses and psychic components of a living organism. Some reports from Eastern Europe suggest that this bioenergy is actually being photographed by the Kirlian process.

The Kirlian process employs a high-voltage alternating current energy field between two condenser-like plates. Interestingly, the same techniques had been employed by previous researchers since the early 1900s. These early researchers successfully duplicated the corona-like effects equivalent to, but much more dramatic than, St. Elmo's fire.

Several physicists claim that the images recorded by the Kirlian process are merely impressions of displacement currents affecting the photographic emulsion. The Czechoslovakian researcher, Josef Zahradnicek (1948), proved that the flow of a high-energy field (Maxwell's currents) in a condenser is not constant. He demonstrated this by placing photographic plates inside a specially con-

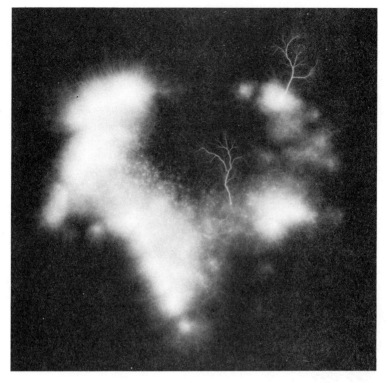

Figure 2. Electrophotograph, ivy leaf (courtesy, M. Toth)

structed high-voltage condenser for anywhere from one to ten seconds.

According to some physicists, the spots and filaments of light seen in this process and in the Kirlian photographs (e.g., *Figure 2*) might indicate that the high-voltage currents have chosen imperfections in the emulsion surface as paths of least electrical resistance. The spots could be defined as Maxwell's currents (Maxwell, 1881), and the filaments of light may in reality be Lichtenberg figures (Zelany, 1945).

It is the feeling of this author that the claims of these physicists are valid. However, the modulating effects of the object being photographed does affect the resultant picture. Kirlian photographs of a "human fingertip . . . of a healthy man, calm and even-

tempered . . ." and of "the finger of an overtired, emotionally tense individual" not only are reported to show the differences between the two physiological states, but reportedly show the same differences every time (Ostrander and Schroeder, 1970:446).

First the Russians, then the Czechoslovakians, and finally the Americans came to the realization that the electrodynamics of living systems are vitally important, and that some means of detecting or recording the biodynamic relationships within a living organism have to be developed. The method of contact photography using high-frequency current may be the means of recording the bioenergetic phenomenon of living organisms.

Photography by Means of High-frequency Currents

Semyon D. Kirlian and Valentina Kh. Kirlian

This essay concerns a method of producing photographs from the action of high-frequency currents. The principle is based on the transformation of nonelectrical properties of the photographed subject into electrical ones, via motion of a field involving the controlled transfer of a charge from an object to a photographic film or screen.

If the capacitor plates of the high-frequency generator's oscillator circuit are pulled apart a small distance, and if the oscillator circuit is closed, then a high-frequency field forms between the plates. When the plates are drawn together, a high-frequency spark discharge appears. Such a discharge depends on outside factors (e.g., ions and free electrons), hence the channels along which the discharge occurs are not always repeatable. However, in an electrical field, under appropriate conditions, stable discharges may also flow. These channels are repeatable because the discharges are stable and the conditions are controlled.

If the oscillator plates are covered by a dielectric (e.g., by celluloid), this dielectric will become polarized in the electrical field and will take on the role of the plates. On the surface of the dielectric, which is somewhat larger than the area of the plates, charges (i.e., displacement currents) are evenly distributed.

With the reduction of air gaps (or the increase of voltage in the oscillator circuit) between plates, which are covered by the dielectric, a discharge forms with different characteristics than that of the high-frequency spark. It will appear not on any one point on the plate but will generate from the entire polarized surface of the dielectric and will include a multitude of discharge channels. If we place some object between the plates and move them so that an appropriate air gap forms between the surface of

the object and the plate, then, when a voltage is applied, an electrical discharge corresponding to the object's topographical configuration and its dielectrical structure will form on the surface of the object. If photographic film is substituted for or placed upon the dielectric on a plate, then the role of the plate is transferred to the film; it becomes polarized and with a given applied voltage, charges will be emitted through the air gap along the electrical field which has been distorted by the object, producing slow, stable discharges. The high-frequency discharges flow in both directions between the symmetrical plates. Electrons and ions of the discharge flux affect the photographic emulsion in a manner analogous to electromagnetic radiation. After the film has been developed, the image of the electrostatic structure of the objects appears on it.

In this system we used high-potential gradients and adjusted the discharge gap to a critical distance, thereby creating conditions under which the field strength, regardless of external causes, is able to generate emission from an object. In this way we obtained a stable discharge in auto-electron form at atmospheric pressure. Whenever this discharge was repeated it emanated from the previous points having the same characteristics. This distribution of charges, with the subsequent scattering of them on photographic film, is actually photography by means of high-frequency currents.

Figure 3 shows schematically the position of the object in the oscillator circuit of a high-frequency generator in which there is: (1) a single electrode with a film dielectric connected to the generator and the object connected to ground; (2) dual electrode production of the image of the object from two sides; and (3) production of ten pictures from five objects by the action of a high-frequency pulse, simultaneously passing through all of the objects.

Images emitted under these conditions in a high-frequency field are received from objects having quite different properties (conductors, dielectrics, semiconductors) at a wide interval of pressures.

Our work showed that in a high-frequency field, auto-electron and auto-ion emission is characteristic of all bodies of nature including living organisms.

The form of images in a high-frequency field is dependent upon

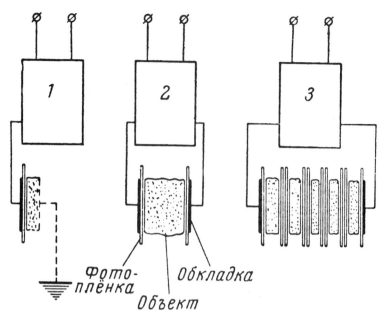

Figure 3. Position of object in Kirlian photography device (courtesy, S. D. Kirlian)

the object. If the object has uniform structure and properties of conductance (i.e., electric conductors), then only an image of topographical configuration appears on the film.

If an inanimate object has impurities of different ohmic, capacitive, and inductive magnitudes, then the density and distribution of discharge channels during the formation of the image is also determined by dielectric parameters of these impurities. The image received reflects, in addition to the topographical configuration, the electric (or dielectric) structure of the complex of selective capacitances and conductances, which is always constant. The image is accurately reproduced in repeated pictures.

The electrical structure of a living organism is not constant, because it depends on its condition at any given moment. All changes in the course of its life processes are accompanied by changes in its dielectric structure.

In this system, every discharge channel contains a potential

configuration of the corresponding part of the field, formed by some point of the object and its characteristics. In this way, a discharge in the aggregate is a group of channels of various densities. These channels carry the physical, chemical, and dynamic characteristics of the object, transformed into electrical characteristics which are represented on film or on a screen as geometric, dynamic, colored figures. Since a biological object emitting discharges is a complex electrode, then evidently each discharge channel carries a spectrum of its bioelectrode and its components.

By studying the geometric figures, their spectrum and dynamics of development, it will be possible to judge the biological state of an organism and its organs including disease and pathology.

A living organism (e.g., the leaf of a plant) which has been placed in the electrical field of an oscillator distorts the field according to its dielectric structure. No matter how many species of plant are photographed under the same conditions, each species will give an image of special character. For example, *Figure 4* is a violet, *Figure 5* is maize, *Figure 6* is a geranium, and *Figure 7* is a verbena.

During pathological changes (e.g., disease, dehydration, aging) a leaf gives a distinctive image, characteristic of the biological condition. *Figure 8* shows a healthy ageratum leaf, while, in *Figure 9,* the leaf is withered. The forming of an auto-emissive image, as practice has demonstrated, does not disrupt the life processes of a biological object.

We may conclude that the biological condition of living objects, when being photographed by high-frequency current, is represented in electrical magnitudes, and that this electron-optical system is able to record their topography.

By ascertaining the connection between the change of the electrical state and the anatomy and physiology of a living object, the method of high-frequency photography may have varied scientific applications. For instance, in agriculture, it may determine the ripeness of a plant, the crop's capacity, various pathological processes, etc.

To obtain an emission image of an object, we must use contact photography by means of oscillator plates varying in structure in accordance with specifications of the object. The magnitude

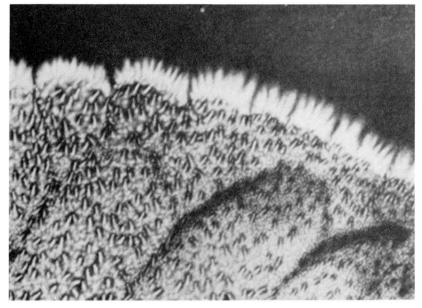

Figure 4. Electrophotograph, violet (courtesy, S. D. Kirlian)

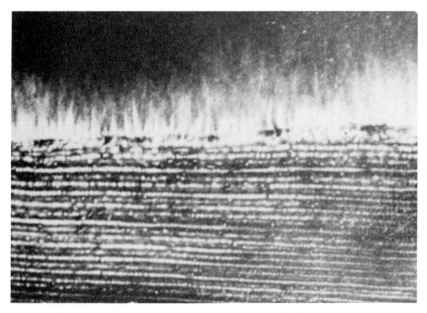

Figure 5. Electrophotograph, maize (courtesy, S. D. Kirlian)

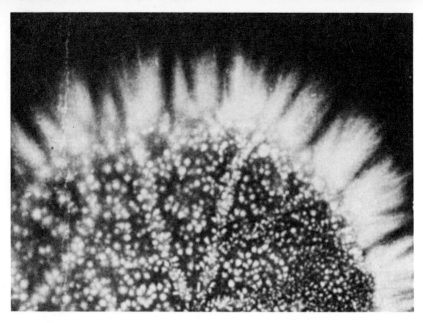

Figure 6. Electrophotograph, geranium (courtesy, S. D. Kirlian)

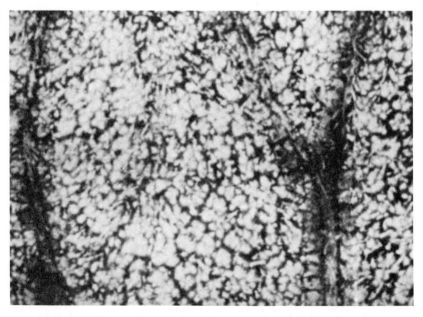

Figure 7. Electrophotograph, verbena (courtesy, S. D. Kirlian)

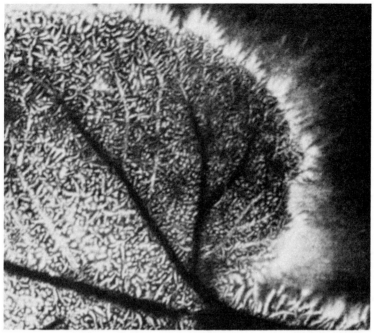

Figure 8. Electrophotograph, healthy ageratum leaf (courtesy, S. D. Kirlian)

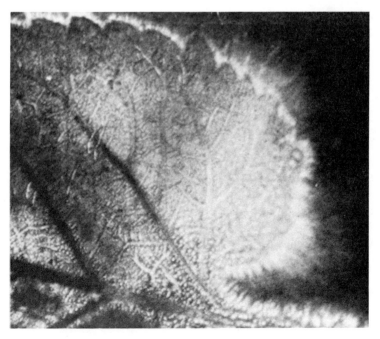

Figure 9. Electrophotograph, withered ageratum leaf (courtesy, S. D. Kirlian)

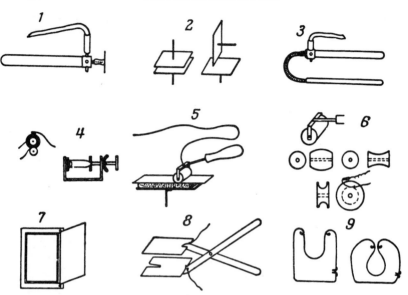

Figure 10. Plate for various Kirlian photography devices (courtesy, S. D. Kirlian)

of the examined portion of the plant depends on the dimensions of the oscillator plate and its principle of action.

In *Figure 10* a number of different plates are shown: (1) A disc plate on an insulated handle. This plate, which has been aligned by a micrometer screw, makes it possible to isolate various biological details from the same part of an object, such as skin integument. (2) Flat, square plates. (3) Flexible, close-fitting plates for obtaining an image from a rounded object (e.g., hands and legs). (4) A system of capacitors; the object itself serves as the centrifugal plate and the photo is made with a plate. (5) A roller plate for obtaining prints by rolling an object of unlimited length. The rollers can be interchangeable; their width determines the dimensions of the photo. (6) The assembly of these roller plates is in accordance with the configuration of objects. (7) A plate in the shape of a frame. Pictures are obtained from several flat objects simultaneously from both sides by one pulse. (8) Capacitors which have been assembled in the shape of tongs to photograph leaves on the plant. The relative position of the plates

and the object is regulated by compressing the tongs. With these phototongs, other flat objects may be photographed. (9) A soft, flexible plate for photographing the entire surface of objects of diverse shapes.

When photographing certain objects we use only one capacitor plate of the high-frequency generator's oscillator circuit. The other plate is the object itself. For example, a man being photographed is connected to ground and acts as a plate would in the oscillating circuit.

It should be noted that when photographing on multilayer color film with disc plates, different parts of a living man's skin are transposed into different colors. For example, the heart region is intensive blue, the forearm is greenish blue, and the thigh is olive. When photographing under similar conditions, the inherent color in each section is repeated. There is reason to assume that during unexpected emotional experiences (e.g., fear and illness) the inherent color in a section changes. It seems to us that these characteristic appearances merit serious study for diagnostic value in medicine for early detection of a disease.

For a deeper examination of the electrical phenomena and processes revealed by photographing the surface of a living organism, the dynamic character of these processes and their connection with the biological state of the organism are a source of interest. In order to observe visually and to record the dynamic development of these processes, we designed an optical discharge capacitor plate. With the help of this device, observations may proceed without disruption of the life activities of an object.

This capacitor plate, functioning in the high-frequency generator's oscillator circuit, may be used as an adapter for a conventional optical device. The optical discharge plate's principle of operation does not differ from those already described. It has mobile tuner components and a pneumatic device for stable attachment of the plate to the object and for the preparation of the surface of the object for visual observation.

In *Figure 11,* a schematic of the optical discharge plate is shown: (1) transparent plate; (2) traction screw; (3) stopper ring; (4) mobile crossarm; (5) recess; (6) sleeve for evacuation; (7) tube of the light detector; (8) adjustment screw for sharp tuning of the image.

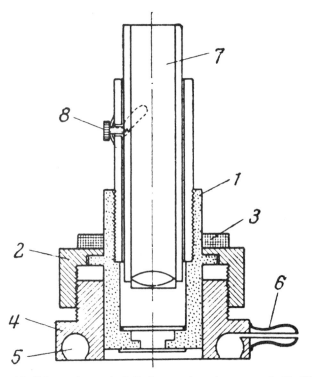

Figure 11. Schematic, optical discharge plate (courtesy, S. D. Kirlian)

On the surface of a man's skin and on other objects of a living and nonliving nature in an electrical field (e.g., the ground and atmosphere), electrical charges are distributed. The topographical distribution and electrical character of these charges are determined by the configuration and dielectric structure of the object.

With the help of the optical discharge device at the appropriate high-frequency field strength, electrical charges on the polarized surface (e.g., a man's skin) are made visible in the form of discharge channels cut perpendicularly by the lines of the electrical force field, with a magnification (i.e., $800\times$) of the image. The device for visual observation is unipolar and is supplied with a high-frequency current. The discharge channels on the surface of the skin are connected to the ground and the generator. The

above-mentioned discharges evidently have a nature close to that of flare discharges.

Let us stop to consider several electrical occurrences observed on the skin of a living man. In the visual field, on a background of the configuration of the skin, discharge channels with varying characteristics are visible: point, corona, and flares in the form of luminescent clusters. These are of different colors: blue, lavender, and yellow. They may be bright or faded, constant or of varying intensity, periodically flaring up or constantly flaring, motionless or moving. All of these qualitative properties of discharge channels depend on the type and activity of the mechanisms contained in the skin.

The distribution of discharge channels is not uniform all over. For example, on the skin of the pads of the fingers, the channels are in flare form arranged only on the lines of the fingerprints (*Figures 12* and *13*). On the forearm, the distribution of flares is irregularly shaped, apparently grouped as dictated by the structure of the skin. If the fingerprints are obliterated, they may be reconstructed according to the distribution of flares, seen through observation and photography.

On some sections of skin, points of blue and gold abruptly flare up. Their characteristic feature is a rhythm of flashes and immobility. Some clusters constantly splash out from one point of the skin to another where they are absorbed. It must be noted that until one cluster is absorbed, the next will not splash out. In some instances, luminous clusters are not oriented in their motion. They move slowly between flares and are finally extinguished with a flash or they dissolve in space. The color of the clusters may be milky blue, pale lilac, gray, or orange. These faded clusters, possibly caused by some matter of undetermined origin, change from time to time to take on a spherical shape.

In our opinion the different colors of adjacent parts of the discharge current indicate that each system of biomechanisms of the skin has its own characteristic color.

Other characteristic phenomena are easily observed in the field of vision. For example, high field intensity and visual observation for five to ten minutes of one part of the skin will strongly modify or eliminate the electrical phenomena. After a three- to five-minute

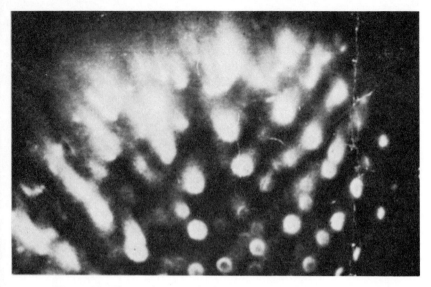

Figure 12. Electrophotograph, finger pad (courtesy, S. D. Kirlian)

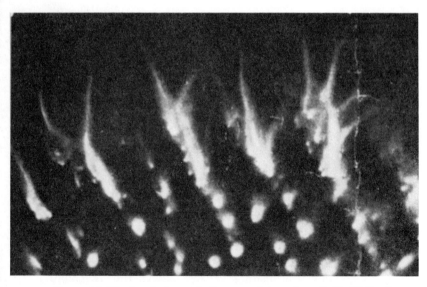

Figure 13. Electrophotograph, finger pad (courtesy, S. D. Kirlian)

rest or a light refreshment (e.g., splashing water on the face), the picture restores itself.

It seems to us that the method of photographing characteristics of the activity of biological mechanisms embodied in the skin opens new possibilities of investigation and documentary recording in the fields of biology, botany, and medicine.

We shall dwell finally on a description of the capacitor plates of an electron-optical system.

If objects with different electrical characteristics (e.g., porcelain, metal, rubber, wood, plastic) are drenched with a dielectric such as paraffin, then when photographed by means of a high-frequency current, configurations of these objects will be recorded on the print in varying densities corresponding to the dielectric parameters of each object and its spatial position with respect to the surface of the unit.

The luminescence of a paraffin unit in a high-frequency field is distinctive. It differs from shadow X-raying and does not have pronounced elements of fluorescence. This luminescence is obviously determined by the capacitive and ohmic conductivity under the conditions of photographing with a high-frequency current. In visual observation the luminescence on the surface of the unit creates an impression of transparency.

Experimental work in this direction indicates that a polarized dielectric in a high-frequency field may serve as an agent which transmits electrical charges from one side of its surface to the other. Photos taken by means of high-frequency current directly from the object and through a dielectric barrier do not differ significantly.

We have come to the conclusion that this property of a dielectric may be used to transmit the electrical characteristic of an object through a dielectric barrier from one medium to another. This possibility reveals the enticing prospect of drawing upon electron optics to obtain a magnified image of the "electrical state" of an object without placing it in a vacuum.

Work on the transmission of the electrical characteristic of an object from one medium to another, through a dielectric barrier with subsequent magnification of the image, led us to the discovery of the following effect: If one of the capacitor plates of the oscillator circuit of a high-frequency generator is replaced by the

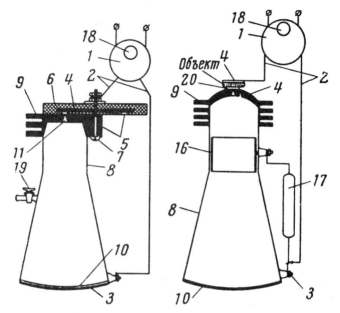

Figure 14. Schematics, optical systems (courtesy, S. D. Kirlian)

fluorescent screen of an evacuated tube envelope on a current-carrying transparent base, while the other plate is replaced by an object which is placed against an opening coated with a thin dielectric located in the envelope opposite the screen, then we obtain the capacitor plate system: plate-dielectric-plate (or object-dielectric-screen).

Figure 14 shows schematics of high-frequency capacitor electron-proton optical systems: (1) high-frequency generator; (2) transmission lines; (3) transparent current-conducting plate; (4) metallic plate; (5) beam with depressions for micro-objects; (6) dielectric; (7) axle of the beam; (8) tube envelope; (9) high-frequency surface-discharge protective fins; (10) fluorescent screen; (11) opening in envelope fin which determines the size of the active portion of the plate; (16) supplementary adjustable scanning plate; (17) high-frequency choke which supplies the auxiliary plate; (18) generator tuning control; (19) stopcock; (20) dielectric which transmits the electrical characteristic of an object from a medium at atmospheric pressure in a vacuum.

When the pressure within the envelope is not greater than 3 times 10^{-3} nor less than 8 times 10^{-5} mm Hg, and the generator is operating at a fixed frequency, then an image of the polarized object appears on the fluorescent screen. If the diameter of the screen is 240 mm and the opening in the envelope is 1 mm (as in *Figure 14*), then the active portions of the plates will have the dimensions of 1×240 with a minimum image magnification of 240 times.

The degree of magnification of the image on the screen may be increased within wide limits by the auxiliary plate and may be regulated by its displacement along the axis of the device and also by variation of the voltage on the auxiliary plate.

Thus by means of high-frequency current the transmission of an image to a fluorescent screen in a low-pressure gas is formed not in the discharge gap between the object and the dielectric by a stable discharge in an auto-electron form, but by a selective capacitive conductance, and is transmitted from a medium at atmospheric pressure into a vacuum envelope with close superposition of the object on the dielectric of the envelope.

Under these conditions the picture of the "electrical state" of the object is represented not in the form of electrical channels, but in the form of geometrical figures of various densities and dynamics. The obtaining of a magnified image on the fluorescent screen is accomplished by using various sizes of the acting portions of the capacitor plates, greater in a low-pressure gas (i.e., screen), smaller at an atmospheric pressure (i.e., object), which assures, by virtue of the inhomogeneity of the field, a continuous directed motion (from the smaller plate to the larger) of the charged particles which form the image.

In a low-pressure gas with different electrode areas, the directed motion of the charged particles is considered as a rectifying action. With respect to this question, we have our own point of view. The different geometry of the electrodes in a low-frequency gas acts, as it were, like a pump which transfers charges from the smaller electrode to the larger one, regardless of their sign (i.e., polarity). Therefore, the continuously moving charges which form the image on the screen alternate in sign with the speed of the frequency of the oscillating circuit. This gives us reason to assume

that the electron-optical devices proposed by us are actually electron-proton optical devices.

An electron-proton optical system is able to transmit to a fluorescent screen an enlarged image of the "electrical state" of a living object without physically disturbing it (i.e., without removing the portion being observed from the whole).

Thus, photographing by means of high-frequency current (consisting of contact photography) and the use of high-frequency capacitor electron-proton-optics are methods of converting nonelectrical phenomena of living and nonliving objects into electrical ones. This method puts at the disposal of science and technology a new means of laboratory investigations which reveal enticing prospects in the study of nature through the effect of the "electrical state" of an object.

Bioplasma or Corona Discharge?

Thelma Moss and Kendall L. Johnson

In examining the Soviet literature concerning Kirlian photography it becomes quickly clear that the basic question, still unanswered, is: what phenomenon is revealed by this radiation field photography? The four principal investigators of this topic in the Soviet Union appear to be the inventors of the device, Semyon and Valentina Kirlian, the Kazakh biologist V. M. Inyushin, and the Moscow biophysicist Viktor Adamenko. In their two basic articles (Kirlian and Kirlian, 1958, 1961) the Kirlians carefully describe their photography as a method for "the conversion of nonelectrical properties of the object being photographed into electrical ones . . . with a direct transfer of charges from the object to the photographic plate."

V. M. Inyushin (1968), in a long theoretical paper, has opted for the term "bioplasma body" as descriptive of the emanations and internal structure of the objects photographed, quoting from such authorities on bioenergetics and bioelectronics as Szent-Györgi and Presman. In conversation with Inyushin, Moss learned that he conceives of the "bioplasma body" as similar, if not identical, to the "aura" or "astral body" as defined in Yogic literature.

Adamenko (1970)—who as a boy lived next door to the Kirlians, and spent many years in intimate collaboration with them—sees the photographs as demonstrating the "cold emission of electrons" which can furnish pertinent and as yet unknown information about the nature of organic and inorganic materials, in particular, the nature of living organisms.

Many American scientists have translated the phrase "cold emission of electrons" into the more familiar "corona discharge," and, as such, believe this photography reveals nothing but a commonplace electrical phenomenon. A few critics have taken the trouble to go to libraries in order to find earlier investigators of

this radiation field photography. They claim that certain Germans, Czechoslovakians, or Americans were predecessors in the discovery of "electrography," pointing out that these investigators apparently thought so little of the discovery that the work was not pursued. In the face of such criticism, it is pertinent to report that Adamenko, while doing his thesis in this area, found in a Moscow library an article by the Czechoslovakians Prat and Schlemmer (1939), published in English in the *Journal of Biological Photography,* which not only describes a similar method of photography, but also includes several photographs that look remarkably similar to the ones produced by the Kirlians. Prat and Schlemmer wrote:

> There can be no doubt about the complex nature of the radiation pictured on the photographic material. The visible and ultraviolet rays are present . . . (and) xylonite, an English fabric, which is impermeable to infrared, visible, and ultraviolet radiation, did not hinder reproduction of the corona.

Surely an unknown radiation produced by this photography is worthy of study.

The question remains unanswered: what does this photography reveal—bioplasma or corona discharge? Clearly no scientist should be willing to take sides in such a controversy without serious study of the issues involved, preferably with extensive research of his own. In order to carry out such research, our laboratory was fortunate in obtaining an apparatus invented by Johnson, based on the principles described by the Kirlians, but using a different schematic diagram and a different power source. Therefore, this paper does not address itself primarily to Kirlian photography, which we believe to be only one among several empirically tested techniques of obtaining radiation field photography.

METHOD

Apparatus
Before arriving at the standard technique which was used for taking the photographs illustrated in the text, a wide variety of

power sources and experimental ranges of voltage, frequency, pulse, and wave form were designed and experimented upon by Johnson. Power sources included the Tesla coil (utilizing on some occasions a spark gap, and on other occasions a vacuum tube), piezocrystals, induction coils of low frequency coupled to a capacitor discharge system, Van de Graaf generators, and charged capacitors. Photographs were obtained with each method. The frequencies employed ranged from very low (as little as 1 cycle per second), up into the megacycles, sine waves and square waves were explored (which were both pulsed and unpulsed), and voltages ranged from about 1,500 to 80,000. The primary concern in all exploration of voltage and frequency was to keep amperage at a minimal value.

The dangers attributed to the use of this type of photography seem to be based primarily on the fact that even low amperage can, under certain conditions, be hazardous. As early as 1893, in a lecture to the Franklin Institute in Philadelphia, Tesla (1956) gave a lecture-demonstration in which he is quoted as showing that

> . . . the streams of light . . . issuing from my hand are due to a potential of about 200,000 volts, alternating in rather irregular intervals, something like a million times a second. A vibration of the same amplitude, but four times as fast, to maintain which over three million volts would be required, would be more than sufficient to envelop my body in a complete sheet of flame. But this flame would not burn me up; quite contrarily, the probability is that I would not be injured in the least. Yet a hundredth part of that energy, otherwise directed, would be amply sufficient to kill a person.

Heeding this warning, no matter how high the voltage and frequency, amperage in our laboratory never exceeded $\frac{1}{10}$ of one microampere. And even this value, if misused, could be lethal.

It should be emphasized that the manipulation of these electrical parameters considerably changes the type of pictures. On many occasions, we have made photographs that seem similar to those published in Soviet and Czechoslovakian literature; however, on other occasions photographs were produced which are extravagantly different in many details. It should be constantly remem-

bered, then, that in the work to be discussed the results were obtained from only one type of apparatus, standardized for voltage, frequency, pulse, wave form, and exposure time.

This standardized apparatus uses a 12-volt battery as its power source, with an undamped harmonic frequency of approximately 1,500 and 3,000 hertz, pulsed at 160 hertz. Almost every kind of film produces satisfactory pictures, but in this research for black-and-white photography, Kodak (Orthochromatic 4154 Thick) 4-inch by 5-inch sheet film was used; either Kodak Ektacolor (S6101) or Kodak Ektachrome (6115) was utilized for color photography.

Procedure

All photography was done in a darkroom (used on other occasions as an isolation booth for sensory deprivation and telepathy studies), where temperature and humidity remained constant. For black-and-white pictures, a red darkroom light permitted visibility without exposing the Orthochromatic film. For color photography, all operations had to be performed in total darkness, which naturally caused technical problems, some of which have still to be overcome. (For example, no work has as yet been done at our laboratory in color, with leaves still attached to the living plant.)

The power source is kept outside the booth, but is connected by cables to the film holder, into which the 4-inch by 5-inch sheet of film is inserted. A timing device is utilized, so that by pressing a switch, exactly one second of electrical current passes from the electrode into the object and onto the film. This procedure contrasts with the Kirlian technique, in which the film is between the plate and the object being photographed. The Soviet investigators send the current up through the plate and into the person while we send the current through the person and down into the plate.

The object to be photographed—whether animal, vegetable, or mineral—is placed in direct contact with the emulsion of the film. Then the electrical charge is sent through an electrode covered with a dielectric into the object being photographed. In working with a human subject (S), his body serves as the electrode; S simply holds in one hand the dielectrically covered electrode.

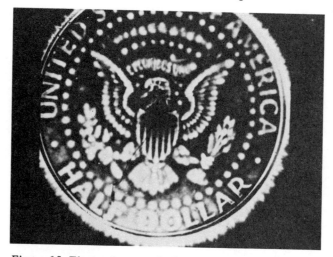

Figure 15. Electrophotograph, fifty-cent coin (courtesy, T. Moss and K. Johnson)

Using this basic technique, over the past ten months our laboratory has produced more than ten thousand photographs, chiefly of the human finger pad, leaves, and metal objects. It is estimated that more than five hundred persons and more than a thousand leaves have been photographed. Results of any one parameter—for example, the finger pad—have given such different results from person to person (or in the same person under different conditions), that a variety of controlled studies were devised to learn what was actually being revealed in the pictures.

RESULTS

Figure 15 is a photograph of a U.S. fifty-cent coin, showing the surface details of the metal with great clarity, and, beyond the rim of the coin, an emanation which has been described variously as "corona discharge," "bioplasma body," or "aura." (These three terms will be used interchangeably in the text as descriptive of the phenomenon, whatever it may prove to be.)

Figure 16 is a picture of a leaf, again revealing the aura beyond its borders. But instead of seeing the surface of the leaf as it appears to the eye (as with the coin), we find an internal structuring

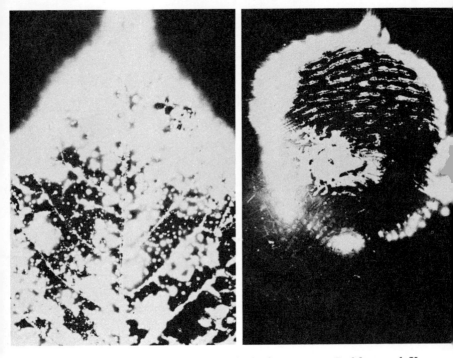

Figure 16. Left: Electrophotograph, leaf (courtesy, T. Moss and K. Johnson)

Figure 17. Right: Electrophotograph, right index finger pad (courtesy, T. Moss and K. Johnson)

of "bubbles" which cannot be seen visually. We believe these bubbles to be what the Kirlians have described as "the conversion of nonelectrical properties of the object . . . into electrical ones."

Figure 17 is a photograph of the right index finger pad belong-ing· to a human *S*. Again, the corona extends beyond the rim of the finger. Here the internal structure of this finger pad is revealed with much clarity, showing both the fingerprints and some scar tissue. In fact, if one studies the corona, it is possible to observe, in faint gray and black lines, an extension of the whorls of the fingerprints. Soviet investigators (Kirlian and Kirlian, 1961)

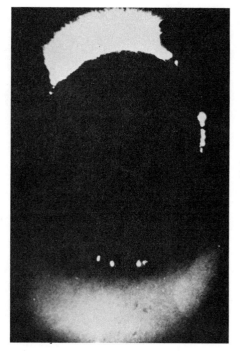

Figure 18. Electrophotograph, right index finger pad (courtesy, T. Moss and K. Johnson)

prints could be accurately reconstructed from those indentations appearing in the aura.

Figure 18 is a photograph taken of the same *S*'s fingertip, using the same photographic technique—but on a different day. We see a totally different picture. Now there is no corona, nor are the fingerprints or scar tissue visible. Instead, we see a diffuse cloud-like manifestation extending far beyond what we have learned to expect of the aura. (In color, this cloud-like "blotch" characteristically photographs in vivid red, while the corona photographs in bright blue-white.)

Very early in the work, then, it became clear that the emanations from human *S*'s change dramatically, and that these changes could perhaps be linked to physiological, psychological, or psychical conditions. The question arose: would we find similar changes in the aura around metals and leaves, were we to change the physiological conditions under which the pictures were taken? To

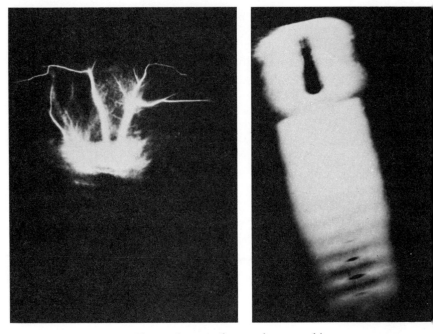

Figure 19. Left: Electrophotograph, metal screw, $\frac{1}{50}$ sec. exposure (courtesy, T. Moss and K. Johnson)

Figure 20. Right: Electrophotograph, metal screw, 1 sec. exposure (courtesy, T. Moss and K. Johnson)

answer this question in regard to metals, we boiled a dime in water for five minutes, then immediately dried and photographed it; its corona remained the same as in its unheated state. Next we took the same coin and stored it in a freezer for five minutes, after which we immediately dried and photographed it again; its aura remained the same as in its normal temperature.

The corona around coins and metals, then, seems to remain constant—*but only when all the parameters of photography are held constant.* If, for example, the coin is photographed at a different frequency, or voltage, or pulse duration, or exposure time, we observe remarkable changes in the photographed coin. *Figure 19,* for example, shows the photograph of a small metal screw taken at $\frac{1}{50}$ second exposure. The edges of the screw can

be seen, slightly highlighted, while extending above the screw are long lightning-like emanations. That same screw was photographed next at one second exposure (as all other parameters held constant), and the picture shown here as *Figure 20* was obtained —which, superficially, would appear to be an entirely different object than that of *Figure 19*. The only change was an increase of exposure time.

Similar dramatic changes have been observed with coins, minerals, leaves, and finger pads by varying the electrical parameters of the photograph. But these complexities, while fascinating, are as yet not understood and perhaps do not relate to the central question: what is being photographed? It is only relevant to point out these differences in order to make clear that what our research reveals does not negate in any way what the Russian research has claimed, because the Russians are using an apparatus whose electrical parameters are far different from ours. Also, this research does not negate the claims of those American investigators who have reported that no photographs can be taken with the Kirlian technique. In varying the frequency with which we have taken pictures, we have seen an object (such as a leaf or finger pad) appear with brilliant detail at one frequency, change its shape at a higher frequency, disappear entirely at a higher frequency, only to reappear again with brilliant detail at still a higher frequency. It is our belief that some law of harmonics—as yet unknown to us—is responsible for this capricious appearance and disappearance of the object being photographed.

Our attention was next directed to the vegetable world. Would the aura around a leaf change, if physiological parameters were to be manipulated? To answer, a leaf was plucked from a plant and photographed over a period of several days. Both its corona and internal geometry altered extensively, until finally no picture at all was obtained. The leaf had "died." Thus, it became clear that the properties of *organic* materials change, whereas inorganic materials do not, when photographed by this technique. Further, we learned that plants respond dramatically to heat, cold, and mutilation. *Figure 21,* for example, shows in color a leaf freshly plucked from a plant, whereas *Figure 22* shows the same leaf after it had been gashed with a needle. (See back cover of this book for color reproductions of these photographs.) The appear-

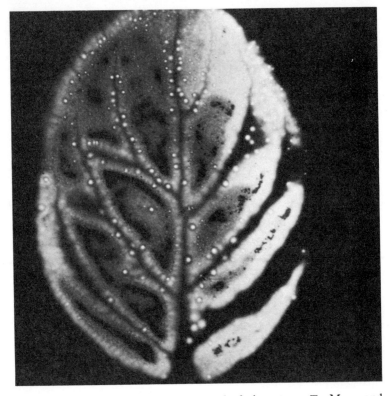

Figure 21. Electrophotograph, intact leaf (courtesy, T. Moss and K. Johnson)

ance of the vivid red blotch has appeared with several varieties of leaves, when gashed.

Regarding research on leaves, the Soviet claim which most intrigued us was that of the "phantom leaf" or "lost leaf" effect. According to Ostrander and Schroeder (1970) and Tiller (1972), when from 2 per cent to 10 per cent of the leaf is cut away, the Soviet investigators have been able, in their Kirlian photographs, to obtain pictures of the *cut-away* section of the leaf. This would be, according to one interpretation of the Soviet literature, the bioplasmic body of the leaf.

A replication of this experiment was tried in our laboratory early

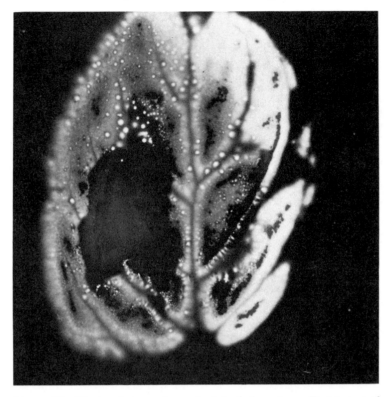

Figure 22. Electrophotograph, gashed leaf (courtesy, T. Moss and K. Johnson)

in this research. With our standard apparatus, no "phantom" or bioplasmic body of the leaf was visible. However, several extraordinary changes took place in the leaf after surgery. The spine of the whole leaf photographed as black and clear; in the cut leaf, the spine seemed to fill up with strange blue "bubbles." Also, in the whole leaf, there were just a few black patches on the surface geometry. After surgery, however, the black patches became numerous.

We cannot yet interpret these results, but we believe that useful and perhaps important information about the life process of leaves and plants (including manifestations of disease) can be

learned through careful studies of such photographs by biologists and botanists.

In later work, cutting very little from the leaf, we have still not observed evidence of the "phantom." In the most recent report from the Soviet Union (Herbert, 1972), a picture of the "phantom" is reproduced, with the statement that this phantom "may have a normal cause, but further research is required before we know how to interpret the effect."

Let us proceed now to the studies we have done with human S's. As reported, more than 500 persons have been photographed in our laboratory. After intensively examining these photographs, we have come to believe that each S reveals in his corona distinctly different patterns from every other S. In fact, just as there are no two fingerprints alike, so there seem to be no two fingers with the same aura. Furthermore, after studying certain persons repeatedly over months, and under various conditions, it became clear that each S's photographs can change dramatically from day to day, and from condition to condition. It is our standard procedure to take at least three photographs of the same condition, one after the other (in a period of seconds), to make sure that the photographs reveal a similar pattern. In other words, all three photographs almost invariably show a particular condition. For example, on certain days one S in three different photographs shows a brilliant, wide blue-and-white corona, with clearly visible fingerprints. On another day, the same S reveals a similar wide and brilliant aura, but with no fingerprints visible. On still another day, there is no aura but only the red blotch. And occasionally, both the corona and the blotch appear simultaneously. What is happening?

From time to time different hypotheses were offered, and then tested. One hypothesis suggested that the variations between the red blotch at one end of the continuum and the blue-white corona at the other end might be due to changes in galvanic skin response (GSR), and that, therefore, what these photographs reveal, visibly, might be the differences in skin resistance. A series of tests was then conducted in which S's were hooked into a GSR apparatus and photographed normally; at this point they were repeatedly photographed as their GSR either rose or fell sharply. After several S's were studied in this way, it became evident that there was a

zero correlation between GSR and the quality of the corona. That is, when the GSR dropped precipitously, there could be a brilliant blue-white aura on the photograph—but on another occasion, when the GSR dropped abruptly, there would be revealed the red blotch on the photographs. Thus, the GSR interpretation proved invalid; skin resistance is *not* what the photographs reveal.

A study was also inaugurated to learn the effects of alcoholic intoxication on the aura. A medical student bravely volunteered to come into the laboratory and get as drunk as he pleased. The conditions were that he could inbibe his favorite drink (i.e., bourbon), but that he must drink one ounce every fifteen minutes —until he wished to stop. The first photograph taken, of course, was before he had any alcohol at all. This initial photograph can be seen in *Figure 23*. This type of small, sketchy corona has come to be regarded as a sign of nervousness or anxiety in the *S*. After the *S* imbibed one ounce of bourbon, the picture in *Figure 24* was secured. One ounce of alcohol clearly changed the emanation. After 17 ounces (the maximum), the photograph shown in *Figure 25* was taken. Now the *S* looks (and in fact was!) "all lit up."

As a result of this study, it was suggested that what the photographs reveal might be the state of vasodilation or vasoconstriction. To test this hypothesis, another series of studies was undertaken with the generous assistance of E. Douglas Dean, and his plethysmographic equipment (which he brought from Newark to Los Angeles for this express purpose). With each sharp vasoconstriction, a photograph was taken of several *S*'s, to contrast with the normal, unconstricted state. And again, there proved to be a zero correlation between the aura and blotch with either vasoconstriction or vasodilation. A brilliant corona was obtained in one *S*, both with dilation and constriction. With other *S*'s, vasoconstriction showed the aura sometimes, the blotch at other times. Once more, we had learned what the photography does *not* portray: it does *not* reveal the state of the peripheral vascular system.

A third hypothesis, offered by a few psychophysiologists, was that the bubbles and flares emanating from the fingertip were actually tiny beads of *sweat*. To study this possibility, we attempted two methods of producing sweat on the fingertips. One

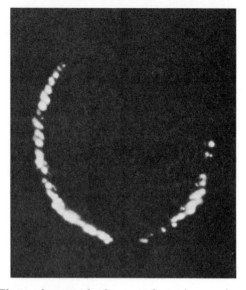

Figure 23. Electrophotograph, finger pad previous to bourbon (courtesy, T. Moss and K. Johnson)

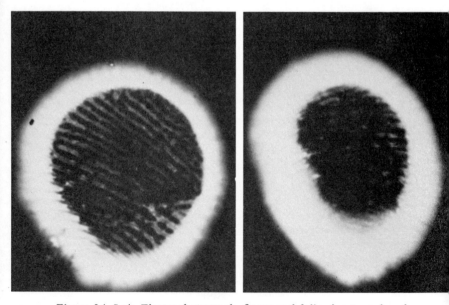

Figure 24. Left: Electrophotograph, finger pad following 1 oz. bourbon (courtesy, T. Moss and K. Johnson).
Figure 25. Right: Electrophotograph, finger pad following 17 ozs. bourbon (courtesy, T. Moss and K. Johnson)

method was to photograph *S*'s in their normal (nonsweaty) state; we then encased their hands in a plastic bag until the entire hand became damp with sweat. At this time, the plastic bag was removed and the fingertip was immediately photographed.

On photographing this type of sweaty finger, we *invariably* found the red blotch. This was cause for exhilaration—even though the results were opposite to the predictions of the physiologists, who had maintained that the bubbles, and not the blotch, were beads of sweat. The exhilaration was due to the fact that we thought we had solved the mystery of the red blotch: it was sweat.

The exhilaration lasted only a short time. In another series of experiments we asked *S*'s to do strenuous exercise, until sweaty. We learned that after this exercise, *S*'s generally (but not invariably) produced a brighter, wider corona than in their normal states. If these *S*'s had revealed a blotch *before* exercising, the blotch was replaced by the corona after exercising and sweating. After exercise, we have never obtained a photograph showing blotches. Yet we knew that the sweaty finger produced by the plastic bag was always a blotch.

Is it possible that there are two kinds of sweat? One type of sweat was clearly induced artificially by being encased in the plastic bag (and therefore not generated internally), whereas the other type of sweat was induced through physical exertion, involving the entire organism. Two types of sweat? Unfortunately we cannot yet answer that intriguing question.

A fourth hypothesis suggested that the photography reveals changes in skin temperature. To study this possibility, we again devised two different types of experiments. In one study, *S*'s were asked to immerse their hands in hot water for as long as possible; immediately after drying the hand, the finger pad was photographed. Then the same *S*'s were asked to immerse their hands in ice and water for as long as they could tolerate the cold, after which photographs were again taken. There were no consistent differences observed in the emanations between the extreme heat and the extreme cold. Each *S* revealed idiosyncratic changes—or no changes at all. In another study of temperature, thermisters were attached to the finger, and with changes of skin temperature (both up and down), photographs were taken. And again, there

were no consistent differences observed in the photographs between high and low temperature, as reported by the thermisters.

It can be stated, then, with some degree of certainty, that we have learned what is *not* revealed in these pictures. This photography does not portray such physiological parameters as GSR, skin temperature, peripheral vascular changes, or sweat.

And the question still remains: what does this photography reveal?

It was decided to examine psychological, rather than physiological states. And is particular to examine different states of consciousness, such as those induced by drugs, hypnosis, trance, meditation, and Yogic exercises.

Our pilot studies with drugs have included tranquilizers such as Valium, energizers (e.g., amphetamines), pain relievers, and alcohol, as already mentioned. Our principal drug study, still in progress, is with marijuana intoxication (as part of a research project for the National Institute of Mental Health). Thus far, more than 65 S's have been photographed in their normal, pre-drug state, and then photographed again under marijuana intoxication. In general, with the drug intoxication, we have found an increased brilliance and width of the emanations. But, as has been typical with this research, there have been those paradoxical cases in which the corona has diminished or remained unchanged during the experimental condition (supposedly the marijuana state). However, since this is a double blind study, with some S's receiving a placebo rather than marijuana, we do not as yet know which of these 65 S's were actually intoxicated—nor will we obtain that information until the study is completed.

Considerable research time has been devoted to investigating the effects of both hypnosis and "animal magnetism" (i.e., mesmerism). In general, we have found an increased brilliance and wider aura under hypnosis—but, again, with at least one notable paradox. Our best S, for both hypnosis and "animal magnetism," usually shows, when in trance, an enormous red blotch, rather than the corona we have come to expect with hypnosis. This may be a function of the depth of the hypnotic state, but since we have used no index, thus far, to record hypnotic depth, this cannot be stated as an empirical finding.

Another exceptional S who has devoted much volunteer time to

this research is a young and gifted psychic who can go into a trance voluntarily, through a type of hyperventilation. Repeatedly, in his normal state, he shows a small red blotch which, under his self-induced trance, changes dramatically into a wide blue-white corona.

In those *S*'s who have come to the laboratory to be photographed before and during the state of meditation, we have similarly found an increased, brighter aura in meditation. Finally, we have been fortunate in finding several *S*'s who can, voluntarily and in full consciousness, increase the width and brightness of their corona. For the most part, these *S*'s have been psychologists and students majoring in psychology who have been studying the bioenergetic therapy of Wilhelm Reich (1949) and Alexander Lowen (1967). According to their subjective reports, they have learned to "direct the energy flow" into the tips of their fingers, although they cannot say by what process this change occurs. Similarly, some *S*'s who practice Yogic breathing exercises (i.e., pranayama) can increase the size of the corona after this form of breathing.

In summary, we believe that states of *relaxation* induced by hypnosis, meditation, and drugs produce, for the most part, a more brilliant, wider corona. In states of arousal, tension, or emotional excitement, however, we have come to expect an appearance of the red blotch.

To test this latter hypothesis, we have been fortunate in finding one person among our colleagues who can invariably change his blue-white corona to the red blotch by deliberately making himself angry, or creating in himself what he calls "a state of goosebumps." Thus, it seems that emotional arousal may in part be responsible for the blotch. But, unhappily, we cannot define nor do we really understand what is meant by "emotional arousal." It has been customary, in psychology, to think of emotion in terms of its physiological concomitants; certain psychophysiologists have attempted to define emotion as sympathetic rather than parasympathetic nervous activity. Yet, in our studies, such sympathetic activities as GSR, vasodilation, and sweating have not correlated with the blotch!

Let us proceed now to the research that we have found to be most fascinating—the work that deals with the interactions be-

tween people. This phase of the research began (as happens so often in scientific research) through an accidental discovery. In the early days of the work, it was the custom for one person to serve as the "photographer" during the course of the evening. Being the "photographer" meant being the only person in the isolation booth (with the exception, of course, of the S whose pictures were to be taken). It was the photographer's function to give S directions, and when the finger was placed in position, to press the switch for the one second flow of current. On one such night, the photographer was called away while he was taking a series of six photographs of S in his normal condition. Another photographer replaced him to take the remaining three pictures that were required. Although nothing had been changed, except the removal of a male photographer for a female one, the three pictures taken by the female differed dramatically from those taken by the male. The female photographer elicited from the male S a much brighter and wider aura.

After this accidental finding, several experiments were conducted in which all variables remained constant—except that the photographer was deliberately changed in the middle of the photographic process. It has been a consistent finding that there is a striking difference in the aura of the same $S,$ over just a few minutes' time, when different photographers take the picture. Sex differences are important, but are not the only important variable. Close male friends seem to generate brighter coronas than two male strangers working together. A strict authority figure, such as an elderly experimenter, will usually produce a much smaller corona than the informal, friendly research assistant who replaces him. We believe this photography may be revealing the interaction of persons on a nonverbal, invisible, possibly electrical plane.

Having observed this interaction between people, other types of interaction were explored. It was learned, for example, that the simple act of touching someone on the forehead for thirty seconds before the picture was taken would clearly alter the resulting photograph—but not always in the same direction. Sometimes the touch would increase the corona but at other times would decrease it, for reasons we do not as yet understand.

Similarly, a few pilot studies with "psychic healers" were un-

Figure 26. Electrophotograph, finger pad of Krivorotov, state of rest (courtesy, V. G. Adamenko)

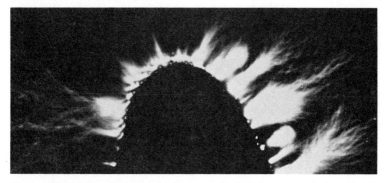

Figure 27. Electrophotograph, finger pad of Krivorotov during "healing" (courtesy, V. G. Adamenko)

dertaken to learn the interaction between "healer" and "healed." In these studies, both the healer and the patient were photographed before, during, and after the healing took place. We found results similar to those of Adamenko (1970) who published pictures of Dr. Krivorotov's thumb taken through a microscope when the healer was in a state of rest (*Figure 26*), and again after he was told to act as if he were "healing" someone (*Figure 27*). The "healing" picture shows a *decrease* of flares

emanating from the thumb as against the resting condition. In our research with four S's who claim to be "healers," we have consistently found that in a state of rest, the healer's aura is much larger and brighter than during or after healing; whereas the patient's corona increases sharply over his pre-healing corona— as if an actual transfer of energy were occurring between the healer and his patient.

There remains one last area of preliminary study to be reported: the possibility of a correlation between radiation photography and acupuncture. This is a subject discussed by T. C. Inyushin (1969) at length in a recent symposium. This research suggests that acupuncture points become visible through Kirlian photography. Using our aparatus, we have reached no final conclusions regarding this claim. However, in working with a skilled acupuncturist, we have observed dramatic differences in the corona before and after treatment in which a needle, or needles, were inserted into one or more acupuncture points. But, again, this is not an invariable effect; rather, it depends on the specific acupuncture point being treated. With certain points, pierced with a needle, there is no discernible change in the aura, but with other points (usually related to specific physical complaints), an increased brightness and clarity of the corona is obtained. Thus, although our research has only begun, we have learned that the insertion of the needle—with the ensuing pain—does not necessarily cause a change in the photographed emanations. This seems to rule out *pain* as a possible answer to the question as to what these photographs reveal.

DISCUSSION

It is evident that many years of exploration lie ahead. Soviet investigators have already been able to study these phenomena with highly sophisticated equipment such as electron microscopy, motion picture techniques, and closed circuit television. By comparison, our equipment is primitive. Even so, it is clear to us that radiation field photography reveals a highly complex, perhaps still unknown phenomenon which may be linked to Inyushin's concept of the bioplasma body. It may even be related to the invisible energy system described in the voluminous literature on acupunc-

ture, and described in ancient Indian texts, such as the Bhagavad Gita. Even if the phenomenon is "nothing but" a corona discharge, it would seem that the changes which occur in the corona discharge under varying conditions would make this commonplace phenomenon worthy of intensive study.

At the present time it is impossible to draw any conclusions about this research, except one. Whatever these pictures reveal—corona discharge or bioplasma—the changes which have been observed to occur in organic materials demonstrate that a most interesting, still undeciphered story is being told. And there lies the challenge.

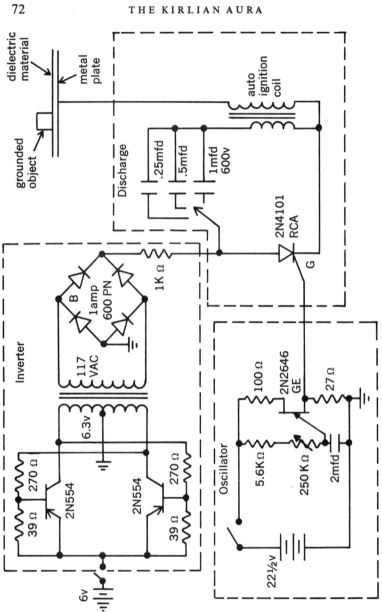

Figure 28. A portable Kirlian device (courtesy, R. Martin)

A Portable Kirlian Device

Robert Martin

I have constructed a portable D.C. Kirlian device that overcomes many limitations of an A.C. unit (*Figure 28*). Even though modern man is never far from an A.C. outlet, there are instances where a mobile D.C. unit would be valuable, e.g., photographing Yaqui Indians. Another problem with the A.C. unit is the possibility of electric shock. Even low amperage can, under certain conditions, be hazardous—especially if the experimenter lacks knowledge of electronics.

Following is a description of a Kirlian device that overcomes these problems. Because this device utilizes batteries, it is portable and shock hazard is reduced. In addition, it has a variable pulse rate, variable output voltage, and is easy to construct. The D.C. device consists of three parts: (1) an inverter, (2) a high-voltage discharge section, and (3) an oscillator firing circuit.

Inverter
The inverter converts 6 volts D.C. (from a lantern battery) to approximately 200 volts A.C. This A.C. output is rectified into pulsating D.C. by the bridge rectifier B; this is used to charge the discharge capacitor.

Ordinary germanium PNP power transistors are connected so that they alternatingly switch on and off; this causes a pulsating voltage across the transformer (an ordinary filament transformer connected in reverse). The primary voltage is magnified by the turns ratio of the transformer and appears across the secondary coil as a much higher voltage.

Oscillator Firing Circuit
The oscillator is simple. It uses a small 22.5-volt battery and a unijunction transistor (almost any will work). The 2 mfd electrolytic capacitor is charged through a resistor and a potentiometer.

The rate of charge is controlled by the potentiometer, thereby determining the rate of oscillation. When the voltage across the capacitor reaches a certain value, the unijunction transistor "fires"; this partially discharges the capacitor and generates an output spike. The voltage across the capacitor then increases until the unijunction transistor fires again and repeats the cycle.

High-voltage Discharge Section

The discharge section of the circuit consists of three components: (1) a capacitor, (2) a silicon controlled rectifier (SCR), and (3) an automobile ignition coil. The SCR acts as a one-way switch which closes only when it receives a trigger pulse (applied to the gate G); this pulse is none other than the output of the previously discussed oscillator firing circuit. When triggered, the SCR provides a discharge path for the capacitor which was initially charged by the inverter circuit. The primary coil of the ignition transformer is part of this path. The voltage developed across the primary induces high voltage across the secondary coil. The amplitude of the output can be adjusted by changing the size of the discharge capacitor, ex., 1.0, .5, .25 mfd. The 1 mfd capacitor shown in the schematic provides a hefty spark.

Several of these Kirlian devices have been constructed from parts obtained at common hobby electronic stores.

The device should be grounded when in use; i.e., it should be connected to an infinite sink of electrons, e.g., a cold water pipe. If a good ground is unavailable, any large metal object should do. When photographing people, do not let them come into contact with a real ground.

The secondary of the ignition coil is connected to a metal plate which has a dielectric material placed upon it. The dielectric can be glass, plastic, cellulose, etc. Most often, the photographic film itself acts as the dielectric. Place the object to be photographed in contact with the film. If an object other than a human subject is used, it can be connected to an electric ground, in order to increase the effect. At all times, make sure not to ground a human subject.

This portable D.C. Kirlian device provides greater freedom for a researcher to investigate the Kirlian photographic effect than larger, more stationary instruments.

Cold Electron Emission Patterns Due to Biological Fields[1]

Rodney Ross

Kirlian photography, originally developed in the Soviet Union, has recently been introduced in the United States. Most of the American adaptations of the Soviet equipment take contact photographs with single dielectric devices. My device is somewhat different than the others, as it permits the taking of either contact or noncontact photographs. In addition, it employs a stereoscopic magnification system for direct visual observation up to a power of 60 diameters. This device is quite versatile in its functions and would even permit the taking of motion pictures.

My device functions as either a single or dual dielectric type of mechanism. The single dielectric is used for taking contact prints and is sealed to a parallel copper electrode which is connected to the secondary winding of the generator.

When I wish to take noncontact photographs or to make a direct visual observation of a specimen, a second electrode and dielectric set becomes necessary—one which is completely transparent to light yet able to sustain a high-voltage field. This requirement is easily satisfied by constructing a dielectric plate to which a conductive ring is attached. This ring is then filled with an electrolyte solution and connected to a ground. Using a transparent dielectric, the necessary gap can be set between specimen and upper plate; direct visual observation is then possible.

I am presently working with a power source operating at 60 kilovolts, with a lower frequency than that reported by the Soviet investigators. In addition, I have recently completed work

[1] The preparation of this paper and the project described was made possible by grants from the National Foundation for Gifted and Creative Children, the Foundation for ParaSensory Investigation, and an anonymous donor. The photographer for this project was William DuBois.

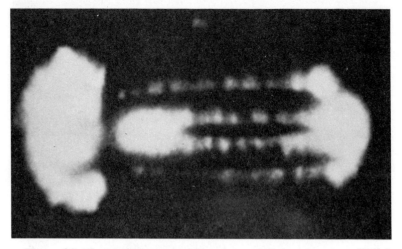

Figure 29. Electrophotograph, tulip stigma; 120 sec. exposure; Kodak Infrared Ektachrome (courtesy, R. Ross)

on a generator which will enable me to vary the frequency of the power source from zero to three megahertz with a square wave oscillation allowing me to scan a large portion of the frequency spectrum for various Kirlian effects. The majority of the specimens which my photographer and I have photographed have been plants (e.g., *Figures 29, 30, 31*) although we have taken some pictures of human fingertips by the contact photography method.

Many intriguing phenomena have been noted while making direct observations of the Kirlian effect under magnification. For example, I once removed an ivy leaf from its plant and placed it between the dielectrics, allowing five millimeters of air between the specimen and the transparent plate. On activating the generator, I noticed many small emissions which would originate within the leaf and travel to the point where it had been severed from the plant. The point of removal always seemed to have the highest concentrations of emissions; all paths of emission seemed to lead toward this point. When I cut away the point of removal, the emission still seemed to flow in the same direction, dissipating into space sooner.

Two days later, I attempted to duplicate these results, using a different ivy leaf. This time I observed an emission which ap-

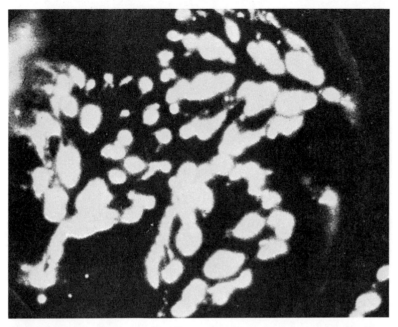

Figure 30. Electrophotograph, three young oak leaves; 56 sec. exposure; Kodak High Speed Ektachrome (courtesy, R. Ross)

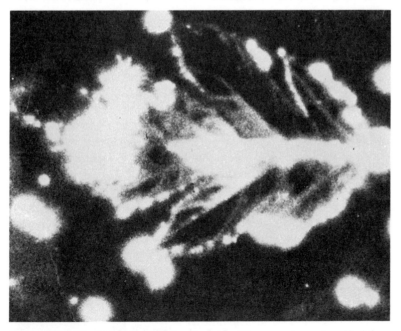

Figure 31. Electrophotograph, oak leaf; 28 sec. exposure; Kodak High Speed Ektachrome (courtesy, R. Ross)

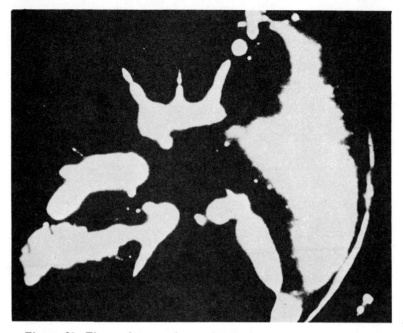

Figure 32. Electrophotograph, cut ivy leaf; 60 sec. exposure; Kodak Infrared Ektachrome (courtesy, R. Ross)

peared to pulsate slowly and regularly in transparent form away from the point of removal.

Soviet investigators have reported a "lost leaf" effect which occurs when 2 to 10 per cent of a leaf has been removed with the Kirlian photograph still revealing the original pattern. I have tried to duplicate these results, utilizing several varieties of leaves, but, thus far, have had no success (e.g., *Figure 32*).

I theorize that the Kirlian photographs are pictures of light emitted by the ionization of air due to cold electron emissions from various specimens. However, the discrepancies in these emissions may be due to an unusual form of energy such as the "bioplasma" suggested by some Soviet scientists (e.g., Inyushin, et al., 1968).

Physicists have divided the world into four types of matter: solids, liquids, gases, and plasma. The so-called "bioplasma" may be a variant of plasma (in which case it would represent sub-

atomic particles present in living organisms) or it may be a fifth type of matter. In either case, "bioplasma" may vary at the slightest change in the condition of the organism. If so, it could affect the cold electron emissions from a specimen, thus altering the pictures taken. In other words, Kirlian photography may lead us into a more profound understanding of the deepest processes of life.

High-voltage Radiation Photography of a Healer's Finger

E. Douglas Dean

The high-voltage radiation photography project at the Jersey Society of Parapsychology in Morristown, New Jersey, utilizes Czechoslovakian-designed equipment. It provides a 10-inch by 15-inch copper plate table, insulated by plastic and varnish. On this is developed 40,000-volt pulsed square waves of about 50 cycles per second at upward of 50,000 hertz frequency. On this is placed Kodak black-and-white 4-inch by 5-inch contrast professional film, emulsion upward, or Ektacolor 4-inch by 5-inch long-exposure film, Kodachrome X twenty-on-a-roll, or a Polaroid color pack of eight, the pack wired directly to the output of the secondary coil. All pictures are taken in a photographic darkroom. The person's finger is placed directly on the film emulsion and conducts the electric current through the body to the feet on the ground (or in the reverse direction).

SUBJECT

The subject for our investigation has been a "psychic healer" by the name of Ethel E. DeLoach (1972). She serves as Executive Secretary of the Jersey Society of Parapsychology. Ms. DeLoach has been doing healing for about five years, the first time being when her daughter was kicked on a leg by a horse. No physician was available. In desperation, Ms. DeLoach decided to try "laying on of hands." Much to her amazement, she felt that her hands were "taken over" and guided to relieving the pain. Her daughter reported relief in a few minutes.

As she practiced it more and more frequently, she began to realize that perhaps there was a relationship between acupuncture and her healing procedures (Duke, 1972; Mann, 1972). About

a year and a half ago, a Japanese patient of hers who had studied acupuncture in Japan spoke of this relationship. Ms. DeLoach practices healing on an intuitive level, following down the meridian lines and pulse areas with her fingers. She has remarked that "the doctors who are working through me guide my hands and touch my fingers." She often feels that her fingernails are guided to the skin of the patient. The realization came a year ago, that these places on the skin were acupuncture points, and she had been using her nails as acupuncture needles. Many of her patients reported feeling needles, and are surprised that no real ones are used.

RESULTS

We took some high-frequency radiation photographs of Ms. DeLoach's fingers. Our results resemble those reported by Soviet investigators. Through Kirlian photography, the thumb of a Soviet healer, Alexei Krivorotov, has been photographed when he is asked to imagine that he is healing a sick person (Adamenko, 1970; Inyushin, 1967). At that time red-orange flares were seen to come out of his thumb which did not appear when the thumb was at rest.

Figure 33 shows Ms. DeLoach's finger at rest. It is her midfinger left hand, taken at high frequency, upward of 50,000 volts. The usual thing about this is that there are two effects. There is an inner ellipse where the healer's finger was pressed down on the photographic negative and then there is an outer ellipse, on the top side of the finger ellipse. I have not seen this in other photographs, but I think the outer one is her nail. It is about the same distance on the film as it would be on her finger and it seems reasonable that if the skin gives flares and emanations, then the nail gives them as well.

Figure 34 shows Ms. DeLoach's finger when she was asked to think of healing, but not to heal. One sees immediately that there are many more of the flares, especially at the bottom of the photograph. Again, there is the inner flesh part of the finger and the top part of the nail.

Figure 35 again shows the healer's finger when she was at rest. This is the mid-finger of her left hand. *Figure 36* shows the finger

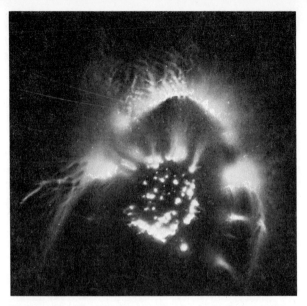

Figure 33. Electrophotograph, healer's finger at rest (courtesy, E. D. Dean)

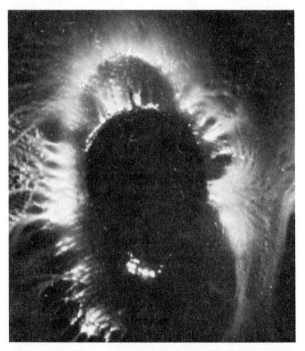

Figure 34. Electrophotograph, healer's finger as she thinks of the healing process (courtesy, E. D. Dean)

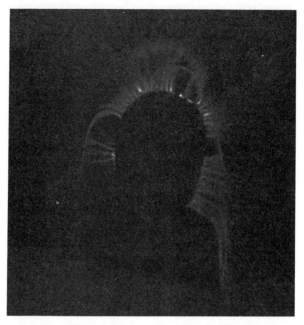

Figure 35. Electrophotograph, healer's finger at rest
(courtesy, E. D. Dean)

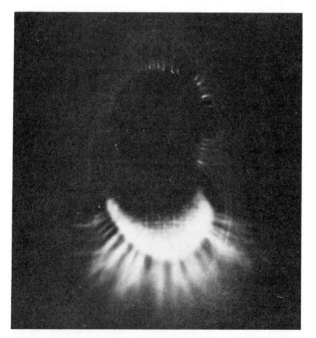

Figure 36. Electrophotograph, healer's finger during the
healing process (courtesy, E. D. Dean)

during the act of healing. Bright orange flares have appeared. (See back cover of this book for color reproductions of these photographs.)

CONCLUSION

This effect has been replicated several times. Our photographs of Ms. DeLoach show a change in flares when she thinks of healing, replicating the Soviet results. During the actual healing process, the flares also change as compared to the resting condition. More work is needed, but tentatively we can state that healing seems to produce an alternative in the flaring pattern.

Field Theory and Kirlian Photography: An Old Map for a New Territory[1]

Stanley Krippner and Sally Ann Drucker

> . . . the bodies which time and nature add to things by little and little, constraining them to grow in due measure, no exertion of the eyesight can behold . . . Nature therefore works by unseen bodies.
>
> Lucretius
> *De Rerum Natura*

The photographs produced by the Kirlians (1961) depict internal as well as external patterns, if the object is a nonconductor of electricity. A typical effect is a "field" which seems to surround the object which has been photographed. It has been suggested that these fields represent electrons which exit from the surface of the object with differing velocities, thus providing a photographic record which yields information about that object. This electric discharge, often referred to as a "cold electron emission" (Moss and Johnson, 1972), is also present in the St. Elmo's fire phenomenon.

A different, but not necessarily contradictory, interpretation of the fields appearing in Kirlian photography has been taken by Inyushin (1967), who hypothesizes the existence of "biological plasma"—ensembles of excited, negatively charged electrons and other subatomic particles which react to magnetic fields. It is felt that biological plasma, invisible to the observer's eye, can be captured on film through Kirlian photography. Whatever the nature of these fields may be, the knowledge of their function is essential to a complete understanding of the phenomena.

[1] The preparation of this paper was supported by a grant from the Foundation for ParaSensory Investigation, New York, N.Y.

Adamenko (1970) has related the changes in the fields of objects photographed by the Kirlians to variations in the earth's electrical fields. Parin (1970:xi) states that most of the external physical factors which have been associated with the evolution of life on this planet are of an electromagnetic nature. Presman's concepts (1970) of the living organism as an energy complex with permeable boundaries resembles Lewin's field theory in psychology (1935). Both Lewin's and Presman's conceptualizations are helpful in suggesting some possible functions of those fields observed in Kirlian photography and the nature of the conversion of a living object's nonelectrical properties into electrical material which can be recorded on film.

LEWIN, PRESMAN, AND FIELD THEORY

Lewin (1936:6–7) saw field theory not as a new system of psychology limited to a specific content, but as a set of concepts through which psychological reality could be represented. Drawing upon the field concepts of such physicists as Faraday, Maxwell, and Hertz, and upon the writings of such gestalt psychologists as Wertheimer, Kohler, and Koffka, Lewin applied his views to a wide range of psychological and sociological phenomena (Hall and Lindzey, 1957:207–208).

A field, according to Lewin (1951), is "the totality of co-existing facts which are conceived of as mutually interdependent." There are three principal characteristics of his theory (Hall and Lindzey, 1957:207):

(1) Behavior is a function of the field which exists at the time the behavior occurs.

(2) Analysis begins with the situation as a whole from which are differentiated the component parts.

(3) The concrete person in a concrete situation can be represented scientifically through mathematics, diagrams, etc.

An individual's total psychological field (i.e., the person plus his psychological environment) may be referred to as his "life space" while everything else is the "outer world" (Lewin, 1936). Lewin's diagram of this concept represents the person and his field:

This circle-in-the-ellipse is a map, or conceptual representation of reality. Like any map, its function is to acquaint its user with new facts about those aspects of reality he wants to explore.

Lewin (1936) has stated that behavior is a function of the life space. However, the boundary between the life space and the outer world is endowed with the property of permeability. Therefore, facts in the outer world can produce changes in the individual's psychological environment—and therefore affect his behavior.

Lewin's concepts bear a striking relationship to those of Presman in his discussion of the biological activity of electromagnetic fields. Presman (1970:18) states:

> Any change in an electric field is always accompanied by the appearance of a magnetic field and, conversely, any change in a magnetic field leads to the appearance of an electric field. Fields such as this, which are related to one another and can be converted to one another, are called electromagnetic fields . . . An electromagnetic field is propagated in the form of electromagnetic waves, the main parameters of which are the wavelength, the frequency, and the velocity of propagation . . .

It has been traditionally held that electromagnetic fields can have a significant biological action only when their intensity is fairly strong and that such action can only be due to the conversion of the electromagnetic energy to heat (Parin, 1970). However, recently collected experimental data from several sources (e.g., Kholodov, 1966; Ravitz, 1970) indicate that electromagnetic fields of weak as well as of strong intensities can have nonthermal effects upon living organisms.

Presman (1964; 1970:82) notes that electromagnetic fields can regulate the spatial orientation of animals, can modulate the rhythm of the organisms' physiological processes, and can affect

the vital processes of various organisms. He (1970:7) further postulates the existence of three communicative functions served by electromagnetic fields:

(1) In the process of evolution, nature has used electromagnetic fields to obtain information about the changes in the environment.

(2) Electromagnetic processes are involved in informational interconnections within living organisms.

(3) Electromagnetic fields facilitate informational interchange among living organisms.

Presman (1970:8) notes that entire organisms are more sensitive to electromagnetic fields than isolated organs or cells. The fact that sensitivity to electromagnetic fields is greater in fairly complexly organized biological systems attests to "organization" as one of the basic principles of life. Thus, a complete understanding of electromagnetic fields will depend upon the investigation of groups, communities, and populations rather than of individual organisms or parts of organisms (Presman, 1970:12).

Information and Kirlian Photography

Kirlian photographic techniques have produced pictures that may illustrate the communicative functions described by Presman. Environmental changes (e.g., sunspots) appear to affect Kirlian photographs. Intraorganism communication may be demonstrated by the difference in the appearance, on a Kirlian photograph, of a leaf's internal structure depending on whether it is healthy or diseased (Kirlian and Kirlian, 1959). Intraorganism connections may have been the reason for the changes noted in some persons' photographs when another person (such as a "psychic healer") is nearby (Ostrander and Schroeder, 1971).

Presman's stress on information theory to explain fields is shared by Lewin, especially in his discussion of permeability. Lewin (1954) has written that there is two-way communication between the organism's life space and the outer world. The boundary between the two resembles a permeable membrane or screen more than it does a rigid wall or barrier. Hall and Lindzey (1957:212) have grasped the importance of this concept:

The implication of a permeable boundary between the life

space and the physical world is of far-reaching significance. Since a fact in the nonpsychological world may radically change the whole course of events in the life space, prediction from a knowledge of psychological laws alone is usually futile.

Kirlian photography may offer the student of human behavior a technique to measure and predict a person's actions on the basis of more information than that yielded by psychological data alone.

Lewin (1951) insisted that nonpsychological facts can alter psychological facts, and suggested that the study of these relationships be termed "psychological ecology." The first step in this study would be an investigation of those facts that exist at the boundary of the life space, since these facts help to determine what is possible and what is not possible. Lewin (1951) used this procedure in his researches on people's eating habits; Kirlian photography could add another dimension to this type of study.

Lewin's concept of "fact" as a basic information datum is paralleled by Presman's discussions (e.g., 1964) of "information," its conversion, its transmission, and its storage. To Presman (1970: 5–6) the biological effects of electromagnetic fields are not so much due to the amount of energy, but the amount of information introduced into a particular system. The information-carrying signal causes a redistribution of the energy in the system itself and regulates the processes occurring in the system. This concept is similar to Lewin's belief (1936) that a state of tension tends to equalize itself with the amount of tension in the surrounding systems; equilibrium is reached when a subsystem in which an unequal amount of tension exists is firmly walled off from other subsystems. Thus, the fields observed in Kirlian photography can be explained on the basis of information theory as representations of processes by which an organism obtains information about its physical environment, by which the organism engages in informational exchange within its own system, and by which information may be exchanged among organisms.

The fields photographed by the Kirlian device may reveal equilibrium states of the organisms being examined. It has been noted that when a bud is cut from a stem, the photographed stem appears to emit flare-like projections (Ostrander and Schroeder,

1971). This phenomenon may be the result of the disruption of the organism's equilibrium and its distribution of information carriers.

Presman (1970:17) describes electromagnetic fields in terms of vectors (i.e., the force with which the field acts on a unit charge situated at a particular point in space) and Lewin (1936) represents many of his concepts (e.g., direction, strength, and point of application) mathematically by means of vectors. In Lewin's diagrams, the direction in which the vector points represents the direction of the force, the length of the vector represents the strength of the force, and the place where the tip of the arrow impinges upon the outer boundary of the person represents the point of application. It would seem as if many of Presman's and Lewin's notions about vectors could be profitably utilized in the study of Kirlian photographs. For example, the change in the Kirlian fields as the result of an emotional change in the person (Kirlian and Kirlian, 1959) could relate to both the psychological and physiological concomitants of the person's emotional feelings.

The effects noted in Kirlian photography could be correlated with verbal reports and with physiological procedures which attempt the measurement of emotionality. Electroencephalographic techniques, hormone production, and pupil dilation could be utilized for this purpose. Another example would be "sentics," a biocybernetic approach which uses a "computer of average transients" to record emotional feelings (e.g., anger, joy, love) through finger pressure; typical finger tracing patterns have been observed for various major emotions in cross-cultural studies (Clynes, 1970; Jonas, 1972).

Kirlian and Kirlian (1959) note that when a person is in poor mental and/or physical health, the photographs taken of that person reflect changes in his field (e.g., in diameter, in color, in regularity). This finding relates to Presman's statement (1970:6) that, in the living organism, systems that handle information are ordinarily shielded from interference from external electromagnetic fields, but in pathological states the barriers break down and more of an influence is exerted by the external forces (e.g., solar flares, lightning discharges). Lewin (1951) has noted that the ordinary boundaries do not function well in pathological states. As the individual grows and develops, greater personal dif-

ferentiation, organization, and integration take place. These processes break down during pathology and sometimes regression occurs. The changes in the organisms' barriers and boundaries discussed by Presman and Lewin may lend themselves to photographic analysis through the Kirlian process. If so, there may be considerable utility of Kirlian photography in the areas of preventive medicine, psychotherapy, and developmental psychology.

CONCLUSION

The development of high-frequency photography by Kirlian and Kirlian may have significant practical applications in science and medicine. The use of field theory in explaining the Kirlian data may be an important step in the understanding of the photographs which have been produced. If the fields on the photographs can be analyzed in terms of the boundaries represented, and the information which is being transmitted within and between boundaries, investigators might be able to develop a better understanding of these provocative phenomena.

Some Energy Field Observations of Man and Nature

William A. Tiller

Since the early 1960s, considerable effort has been focused on the overall study of psychoenergetics by investigators in the Soviet Union (Ostrander and Schroeder, 1970). An organization chart of their activities in this area is given in *Figure 37*. In this paper attention will be focused on only two of these topics, (1) high-voltage photography (Kirlian photography) and (2) acupuncture.

In the following section, a description of some of the Soviet devices and their experimental results will be reviewed. In addition, some English work using D.C. pulses is presented and some American results are discussed to indicate the complexity of the process being dealt with here. In the next section, attention is

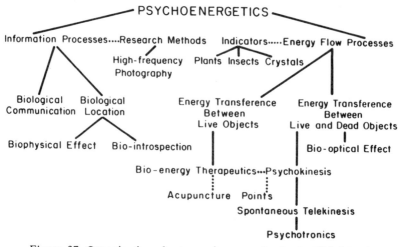

Figure 37. Organization chart, psychoenergetics in the U.S.S.R. (courtesy, E. Naumov)

focused on instruments and experiments for the measurement of electrical resistance, voltage, current and energy emission characteristics of acupuncture points during conditions of well-being, ill health, emotional and mental stimulation, etc. A review of some of the experiments of Kim Bong Han (1963, 1965), which purport to have (a) delineated the morphology and the environmental structure of the acupuncture meridians and the active elements of the acupuncture points, (b) measured the circulation of a fluid within the meridians independent of the other major body circulatory systems, and (c) outlined the biochemical and histochemical study of the overall system, are presented.

Finally, utilizing a colloid stability model, a rationalization of the efficacy of acupuncture point stimulation on the vitality level of particular body glands and systems is presented.

KIRLIAN PHOTOGRAPHY

A. Review of Some Soviet Work

In this section, the important features fall into three categories: (a) the operating characteristics of the electrical power source and the postulated mechanism of device functioning, (b) the configuration and components of the information display and recording devices, and (c) the general experimental results obtained.

(a) V. G. Adamenko (1971) has indicated that the power source for Kirlian photography should be a pulsed high-frequency field, somewhat similar to a radar power source. The pulse characteristics are given in *Figure 38,* and are (i) pulse height=20K— 100 K volt, (ii) pulse width=10^{-4} to 2×10^{-3} sec, generally (as small as 10^{-6} sec in some cases), (iii) pulse repetition rate=60 per sec, and (iv) A.C. frequency=75 to 3000 K hertz. This electric field is applied to a device, such as illustrated in *Figure 39,* producing a discharge phenomenon that appears to be cold electron emission from living systems (because the current/electric field relationship follows the Fowler-Nordheim plot). It is felt that the electron work function varies over the surface being photographed and, in air, the picture of the discharge channel occurs as a result of the positive ions clustering around the channel providing a focusing effect to the electrons.

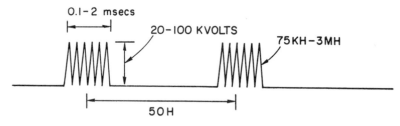

KIRLIAN POWER SUPPLY CHARACTERISTICS

Figure 38. Electrical output properties of the energy source (courtesy, W. A. Tiller)

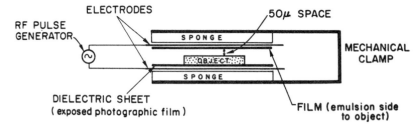

Figure 39. Simple electrode device for taking Kirlian photographs (courtesy, W. A. Tiller)

The Soviet experience was that a single D.C. pulse would not be effective in producing the desired effect and that it would be rather dangerous to use D.C. rather than high-frequency A.C. inside the pulse envelope. Although a static electric field of the same value as used in the A.C. system ($\sim 10^7$ volts/cm) would also yield cold electron emission, the situation is not straightforward as strong polarization of the electrodes would occur (electrolysis). The Soviets feel that it is necessary to have a discharge spacing between the specimen and the film in order for proper channel formation to occur (as a result of positive ion clustering around the electron stream). The electrons exit from the surface

with different velocities and this includes information about the object. If one uses a D.C. power source, equilibration of electrons seems to occur and the image is absent. With D.C., in the first few moments an image appears but then disappears later as equilibration occurs. The H.F. signal is also used in the pulse so that one can decrease the size of the equipment. The use of different frequencies allows one to obtain quite different pictures, presumably associated with different resonances from different cells, etc.; i.e., the electrons can come from different parts of the skin.

Actually, one need use only one pulse to obtain a photograph. The slow pulse repetition rate is to provide low average power. It seems that a pulse duration of about 2×10^{-3} sec is maximum and, if τ is much larger, the image is poor. On the other hand, if τ is too small, the channel discharge process does not have time to develop. (For contact photography, one can use $\tau \sim 2 \times 10^{-6}$ sec.) The total current drawn from the entire surface is less than 1 μ amp so that the actual current in a discharge channel is much less. They suggest that this is the reason for the stability of the cold electron emission.

The average power of a generator is about 1 watt (pulse power is much larger, of course). Thus, quite small generators using batteries, transformers, transistors, etc., can be built and taken out into the field. However, such small generators generally do not have as much stability as one would like.

It has been stated (Adamenko, 1971) that any discharge includes photons but that only discharges in a strong field produce an image. This seems to relate to electron acceleration which leads to photon emission. Of course, even the radiation damage effect of the electrons hitting the photographic grains can be expected to produce massive exposure of such grains.

(b) In the simplest Kirlian device, shaped like a sandwich or parallel plate condenser, the object is placed between the two plates to which voltage is applied. If the condenser plates are too close to the object, there will be no effect on the film. In order to get good pictures, there must be a dielectric gap between the object and the film. The exposure time depends on the film speed and on the power density of the electric field.

To improve the effect and augment it, a fine screen (like a silk screen) may be placed between the object and capacitor plate

(and film). The film is between the condenser plate and the screen. This screen enhances the effect, probably by its serving as a dielectric. One type of effective screen material is film itself that has been completely exposed and developed.

The device can be placed in a clamp arrangement as illustrated in *Figure 39,* the clamp being used to apply a slight but even pressure via the paralon (or sponge) pads. The electrodes are developed X-ray film (AgBr→Ag) and the leads are fastened to them as indicated. The dull matt finish of these electrodes provides poor reflectivity of light and thus is an aid to producing a good image. The spacing between object and film is about 50 microns (can be 10 μ to 100 μ).

To improve the resolution, a layer of saline water or other conductive liquid is sometimes placed between the object and the film. In this case, the film is placed with the emulsion facing away from the object so that the emulsion will not be disturbed. The capacitor plate is then placed outside the film. A further improvement can be made by using the conductive liquid as one of the capacitor plates, thereby permitting better resolution and faster work with the film.

For taking pictures of a section of human skin or other part of the body, only one electrode is needed. In this case, the body acts as ground; i.e., only one half of the device, presented in *Figure 39,* is needed. This same electrode procedure is used for the Kirlian microscope, illustrated in *Figure 40,* when it is applied to the body.

A simple rolling device, which has the advantage of operating at less than 1 watt average power, was also described. It is illustrated in *Figure 41.* In this device, no discharge occurs at points A or C but does occur at point B where the spacing is about 10 microns. The cylinder is rolled at about 10 cm/min and gives a moving line discharge to expose the film in sequence. A device for taking moving pictures is illustrated in *Figure 42.* It utilizes the arrangement of *Figure 39.* Controlled weights are applied to the device and the film is pulled through at some particular speed while the discharge process is going on. The film is rolled in the usual way and all is contained within a casette.

Figure 43 is an illustration of an extremely useful device idea. The previous methods utilized rigid capacitor plates which do not

1. Transitional nut (to microscope tube)
2. Thread
3. Upper half of housing
4. Pin for focusing
5. Thread
6. Lower half of housing
7. Two orifices (ø 4mm) disposed one in front of the other
8. Rubber washer
9. Contact to power source
10. Metallic wire (for protection against circuit disruption because of water evaporation)
11. Thickening in form of a ring
12. Pressing nut, freely revolving
13. Collars
14. Thread
15. Traverse
16. Orifice ø 5mm
17. Bottom of the traverse
18. Glass with thickness 0.6-1.0mm
19. Glass with thickness 0.13-0.14mm
20. Chamber (cell), flooded by water through orifice 7
21. 8-12 times objective
22. Bushing which carries objective
23. Thread (in accordance with microscope tube thread)

Figure 40. Microscope objective lens housing for direct observation of energy patterns (courtesy, W. A. Tiller)

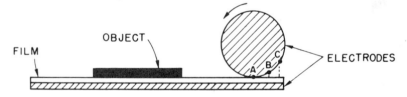

Figure 41. Rolling cylinder discharge device (courtesy, W. A. Tiller)

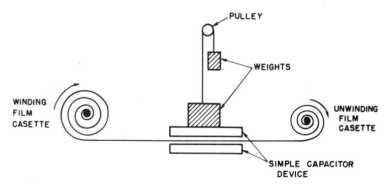

Figure 42. Cinematographic discharge device (courtesy, W. A. Tiller)

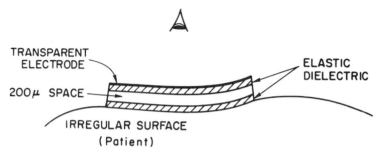

Figure 43. Transparent electrode device for continuous monitoring of energy patterns (courtesy, W. A. Tiller)

allow one to take pictures of objects having irregular profiles. In the new method (Adamenko and Kirlian, 1966), the device takes the shape of the body. The transparent electrode is a silicon organic film; however, many other possibilities exist. With this device, any portion of the body can be photographed directly. In fact, one could make a snug-fitting vest or garment of the material which could then be monitored photographically from a distance or displayed continuously via closed-circuit T.V.

This new method grew out of an earlier idea of Kirlian's (1963) which utilized a conductive transparent material as part of the capacitor, to which a hinged mirror was attached, and a flexible conductive material which is laid upon the object to be photographed. The mirror is concave and acts as a lens, enlarging the object to be studied. The mirror is apparently used for visual examination when not taking photographs. Between the object and the flexible, transparent condenser plate is placed a dielectric net. A photographic plate is placed over the front or top of the conductor so that the prints were merely contact prints without focusing.

The foregoing devices all operate in air at 1 atmosphere pressure. If the pressure is reduced to 10^{-5} mm of mercury, the image is still retained provided the electrode separation is increased to 20–30 cm. At a pressure of 10^{-6} mm of mercury, the image disappears. A visual display system using something like a television

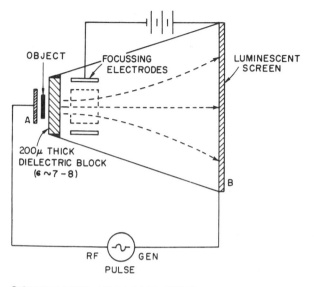

SCHEMATIC KIRLIAN CRT

Figure 44. Cathode ray tube device for taking Kirlian photographs (courtesy, W. A. Tiller)

tube is illustrated in *Figure 44*. In this CRT device, electrons from the object impinge on a 200-μ thick dielectric film and their charge pattern induces charge polarization on the other side of the film which, in turn, affects the preferential geometry of electron emission from the film. Thus, the eventual image on the screen is indeed that of the object. This is a very important phenomenon which allows many interesting modifications of device design.

The methods have been developed for image amplification (magnification). In the first case, they use cold emission obtained in the small spacing device (50 μ) of *Figure 39* with a high electric field at the edges, $E_e \sim 10^6$ V/cm. However, E is caused to decrease in the middle to $E_M \sim 10^4$ V/cm (see *Figure 45*). Thus, the magnification, μ, is given by

$$\mu = \frac{E_e}{E_M}$$

100 THE KIRLIAN AURA

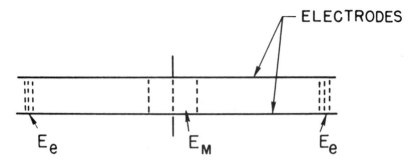

Figure 45. Magnification technique by using different electric fields at the edges, E_e, and at the middle, E_M, in the device of *Figure 39* (courtesy, W. A. Tiller)

They have obtained values of $\mu \sim 340$. The second method is carried out in a CRT type device as illustrated in *Figure 46.* The short electrode (cathode) has a field E_1 and the larger electrode (anode) has a field E_2 ($E_1 \sim 10^6$ V/cm, E_2 is smaller). In this case, the magnification, μ, is given by

$$\mu = \frac{E_1}{E_2} = \frac{S_2}{S_1}$$

where S_1 and S_2 are the tensions of the two electrodes ($S_1 E_1 = S_2 E_2$ from Gauss's law and charge conservation).

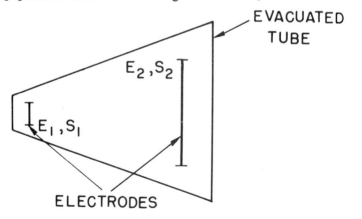

Figure 46. Magnification technique using electrodes of different area in a CRT tube device (courtesy, W. A. Tiller)

Using the T.V. tube type of device, one might expect that the use of electron lenses would allow one to build an electron microscope with very high magnification ($\sim 10^4 \times$). However, because of the high vacuum needed in such a device, a severe limitation exists. At 10^{-7} to 10^{-8} mm of mercury pressure, one gets no image because of the loss of channeling ions, but at 10^{-4} to 10^{-3} mm Hg, one does not even need a lens.

It is generally quite inconvenient to be performing these experiments in a darkroom. This procedure can be avoided by utilizing an aspect of the technique illustrated in *Figure 44;* i.e., since an image of the object's energy pattern can be transferred through a thin dielectric film, it should be possible to use either a nontransparent envelope enclosing the sample or a nontransparent envelope enclosing the film. This is illustrated in *Figure 47*. This technique is in common use in the Soviet Union and greatly increases the practicality of the device for use in air under normal illumination.

(c) On the Kirlian photographs one sees an image of the structure of the surface plus a surrounding halo due to a high-fre-

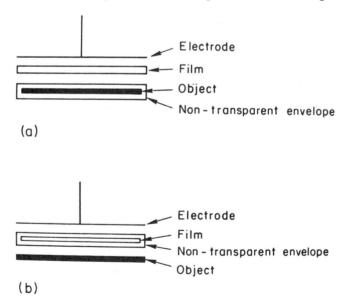

(a)

Electrode
Film
Object
Non-transparent envelope

(b)

Electrode
Film
Non-transparent envelope
Object

Figure 47. Schematic illustration of the envelope technique for taking photographs in a lighted room (courtesy, W. A. Tiller)

quency discharge. Both the dimensions of the halo and the overall brightness of glow change in accordance with changes in the physiological state of the organism. Different sections of skin surface are found to emit radiation in characteristically different colors: the heart area shows as dense blue, the hip shows as an olive, the forearm shows as greenish light blue (Kirlian and Kirlian, 1961). As a result of sudden emotional excitement (fear, pain, etc.) the color of the related section changes.

Using a high-magnification system, one sees discharge channels arranged on the background configuration of the skin and they exhibit a variety of energy emission 'characteristics (Adamenko, 1971). They may be point-like, crown-like, flare-like, or clot-like. They may have different coloring such as sky blue, various shades of lilac or yellow, and they may be bright or faded. Some of the channels glow constantly, some are twinkling, some flare up periodically, some are stationary, and some are moving, changing always from place to place. In certain sections of the skin, one sees immobile flare-up points which exhibit a definite rhythm and are light blue or golden in color. Besides these points, there are faded clots of indefinite form which are constantly changing, taking from time to time a sphere-like form. Some clots are continually spilled out from one point of the skin onto another where they are absorbed. The spilling out of one clot does not take place until the previous clot has been absorbed. In certain cases the luminous clots are not oriented in their movement. They slowly move between the flares and finally are extinguished with a little burst and seem to dissolve into space. The colors of the clots are generally milk-light blue, pale lilac, or gray-orange. In many respects these flares and clots resemble the plasma behavior often observed in observations of the sun.

They have found that a withered leaf showed almost no flares and that the clots barely move. As the leaf gradually dies, its self-emissions also decrease correspondingly until there is no emission from the dead leaf. Likewise, the finger of a human body, dead for several days, exhibits no distinctive self-emissions. The self-emission of living things seems to be a direct measure of the life processes occurring within their system.

The structure and emission characteristics of these discharge channels can be utilized for an objective evaluation of the physio-

logical state of the living organism, for diagnosis of body health or pathology, for registration of the emotional state and also for the control of the system's response to various radiations. For example, during the radiation of living objects with a laser (λ=6328 Å), one observes a sharp increase in the intensity of discharge flaring. However, daylight radiation (incoherent radiation) of the same intensity does not cause any changes in the discharge process.

A spectral investigation of the high-frequency discharge glow from the leaves of plants revealed the existence of a series of peaks (4200 Å, 4250 Å, 4550 Å, 4750 Å) and several small peaks in the red part of the spectrum. If the plants were irradiated by a laser with λ=6328 Å, then the glow spectrum from the leaves was altered in the blue and green regions so that characteristic peaks appeared at 5100 Å and 4800 Å and the spectrum shifts in the range 4400 Å to 4500 Å. However, the number of peaks in the blue part of the spectrum remains unchanged. With the skin of animals (rabbit, mainly), the peaks are found in the range 4950 Å to 5000 Å, and the short-wave portion exhibits a peak structure coinciding with that from leaves.

If one photographs, on the same film at the same time, fingers from two different people, then a crown discharge is seen around each finger. As the two fingers are brought closer together, the crowns of discharge deform and leave a small gap between them rather than interpenetrate. Using the fingers of three people, one again sees crown deformation and no penetration.

When observing the palm of a healer as he begins a healing session, one initially sees many points flaring, then fewer points are flaring but the area of discharge around the remaining points is larger (with a greater flare intensity) and eventually an area the size of a dime in the center of the palm becomes luminously brilliant. At this point, the healer is optimally attuned and the patient feels what is usually described as "heat" in that area of his body to which the healer is directing energy. By careful study of the location of the major flare points on the body, the Soviets have shown them to correspond to the active points marked on the Chinese maps of acupuncture points.

In concluding this section we should mention perhaps the most interesting and exciting experimental observation. In *Figure 48,* a photograph of a whole leaf is given, showing the edge halo and

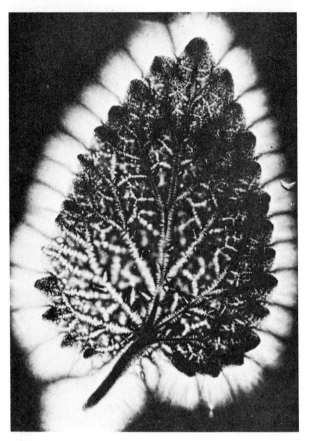

Figure 48. Electrophotograph of a whole leaf (courtesy, V. G. Adamenko)

inner light structure. It has been claimed that if 2 to 10 per cent of a leaf has been cut away from one edge, the photograph shows not only the portion of the leaf remaining but also an energy pattern from the portion of the leaf that has been physically removed. In *Figure 49* we see such a cut-leaf photograph with the right-hand edge of the leaf removed and we note the remaining radiation pattern (albeit altered in contrast). It has been suggested (Adamenko, 1971) that the number of radiation sources in the leaf may be so numerous as to produce sufficient redundancy of information that, when a portion of the leaf is re-

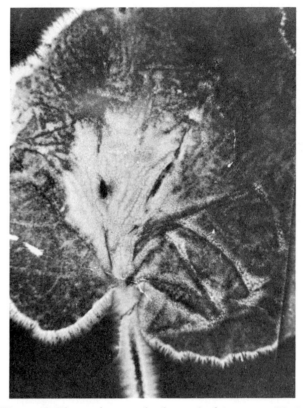

Figure 49. Electrophotograph of a cut leaf (courtesy, V. G. Adamenko)

moved, the lost sources do not significantly disrupt the multiple array pattern. It is also claimed that when one erases a person's fingerprint (by sanding it off), the Kirlian photograph clearly reveals the fingerprint (probably because the energy flare points are located only along the dactyloscopic design of the skin).

The Soviet investigator V. M. Inyushin (1970) has suggested that in living systems there is a single system of elementary charged particles which is dominant in all biodynamic relationships of the living organism. He has called this hypothesized system of elementary particles "biological plasma." This biologi-

cal plasma, as distinguished from nonorganic plasma, is a structurally organized system and the chaotic thermal randomization force is reduced to a minimum; i.e., the entropy is minimal. This biological plasma is found to be strongly influenced by changes in temperature and other environmental factors.

B. Review of Some English and American Work

Milner and Smart (1972) have, for some years, been experimenting with high-voltage photography using a sandwich type device similar to *Figure 39*. However, their work differs significantly from the Soviet work in that they use a D.C. pulse technique and control the process by controlling the slope of the leading and trailing edges of the pulse as illustrated in *Figure 50*. They are unable to detect any energy in the visible range; however, there is abundant new information to be found in the far ultraviolet. The pulse voltage used with their technique is in the range 5000 to 20,000 volts, and great care must be exercised during the course of experimentation, because of the significant electrical power involved.

Using the arrangement of *Figure 50,* during application of the voltage across the empty cell, nothing visible occurs in the air gap during the voltage pulse, but one finds that the photographic emulsion has been exposed on both the +ve plates and the —ve plates, as illustrated in *Figures 51* and *52*. The energy patterns on these complementary plates are quite different even though they are located only 75 μ apart. Steepening the rate of field decrease on the trailing edge of the pulse leads to *Figures 53* and *54* for the +ve plates where *Figure 54* had a much more rapid rate of decrease than *Figure 53*.

Inserting a leaf or spray of leaves into the sandwich leads to *Figure 55* for the +ve plates. Here, using a rapid pulse, the leaves are hardly registered and are separated by a type of void space from the surrounding "empty sandwich" pattern. With a more prolonged pulse, areas of the leaves become luminous and bright balls of plasma gather at the tips of the leaf serrations and begin to become detached and freed into the surrounding atmosphere (*Figure 56*). Maintaining the voltage for increasingly longer periods of time leads to the formation and detachment of more of these bright balls until the flow becomes exhausted and the leaf reverts to

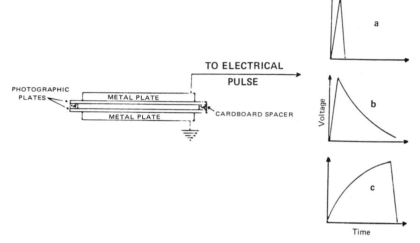

Figure 50. The method of exposing the photographic plates to a pulse of electricity with three of the types of pulse employed: (a) a rapid rate of pulse increase and decrease, (b) a rapid increase and slow decrease, and (c) a slow increase and rapid decrease (courtesy, W. A. Tiller)

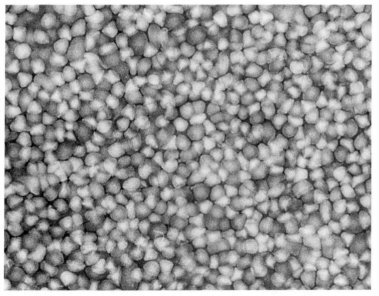

Figure 51. Photographic result on positive side of "sandwich" with intermediate rates of pulse increase and decrease (courtesy, W. A. Tiller)

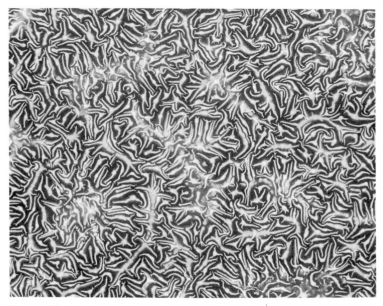

Figure 52. Photographic result on negative side of "sandwich" (courtesy, D. F. Milner and E. F. Smart)

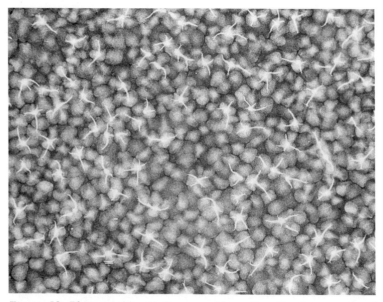

Figure 53. Photographic result on positive side with steeper rate of pulse decrease than in *Figure 51* (courtesy, D. R. Milner and E. F. Smart)

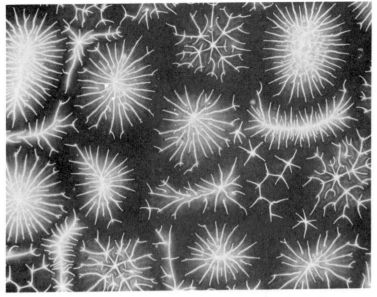

Figure 54. Photographic result on positive side with still steeper rate of pulse decrease than in *Figures 51* or *53* (courtesy, D. F. Milner and E. F. Smart)

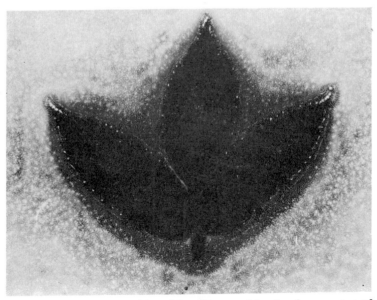

Figure 55. Result on positive side with a rapid pulse for a spray of leaves in sandwich (courtesy, D. F. Milner and E. F. Smart)

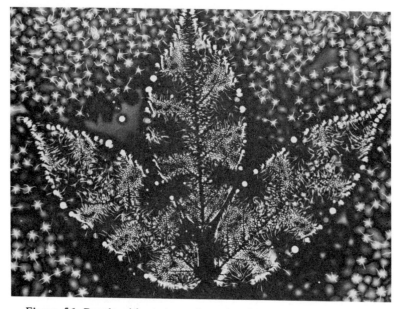

Figure 56. Result with more prolonged pulse (courtesy, D. F. Milner and E. F. Smart)

Figure 57. Result with still more prolonged pulse (courtesy, D. F. Milner and E. F. Smart)

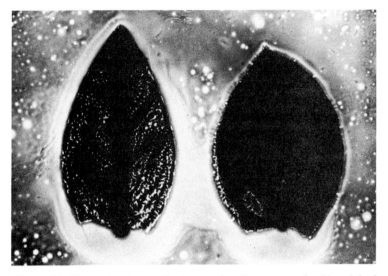

Figure 58. Example of transfer-interaction between a freshly picked privet leaf (on right) and a dying leaf picked twenty-four hours earlier (courtesy, D. F. Milner and E. F. Smart)

its original "dark" state (*Figure 57*). In *Figure 58,* we see an example of an energy transfer-interaction between a freshly picked privet leaf (right) and a dying leaf picked twenty-four hours earlier.

Obviously, we are dealing here with a very complex phenomenon. Some of these results are at considerable variance with those of section A; however, they will eventually help us to understand the phenomena involved in this process more completely.

From this work, we begin to suspect that dielectric breakdown between heterogeneities in the plates may be playing an important role. In addition, bombardment of the two plates by different types of ions (+ve and −ve) may be playing a role in the different photographic effects produced on opposite plates. This would be accentuated by surface irregularities (Soviet studies have shown that a surface roughness of 3.2 microns can be observed on exposed film with the unaided eye).

H. C. Monteith (1972) has built what is perhaps the simplest and cheapest high-voltage device for illustrating the photographic

effect.[1] Its components include:

1. Any six-volt source that can deliver at least four amperes,
2. A capacitor used in conjunction with the auto-ignition coil,
3. An auto-ignition coil,
4. A six-volt vibrator used to power auto-radios (only one set of contacts need be used),
5. The object being photographed,
6. Photographic film (Land type 58 is one of the best to use with this simple circuit—this is color film but it is slow and seems to be relatively insensitive to voltage breakdown across the capacitor but very sensitive to emission from the object),
7. A capacitor plate at the high side of the emission coil (about 34,000 volts placed on the plate),
8. A grounded capacitor plate, and
9. A variable resistor to give some control of the output voltage.

From such a simple device one cannot anticipate much stability or controllability of device operation.

Monteith (1972) found that a live leaf gave beautiful and varied emissions but a dead leaf gave, at most, only a uniform glow (generally, it did not expose the film at all). Even when a dead leaf was thoroughly wet with water, in no way was the self-emission increased.

In the high-voltage device designed by Johnson (1972) and used in association with Moss, the A.C. field was of low frequency ($\sim 10^2$ to 10^4 hertz) in contrast to the Soviet work ($\sim 10^5$ to 10^7 hertz), and yet good photographs have been obtained. They find that, with the same object, a change in the frequency leads to alternate zones where pictures appear and do not appear depending on the frequency range. This suggests that some type of harmonic or wave diffraction effect is operative here.

The Stanford device, assembled by the author and his student, Mr. D. Boyer, was designed to approximate the Soviet technique. It consists of six main components: (1) a square-wave pulse generator and (2) a variable frequency oscillator feeding into

[1] The schematic for another U.S. device, designed by Robert Martin, appears in Figure 28, p. 72.

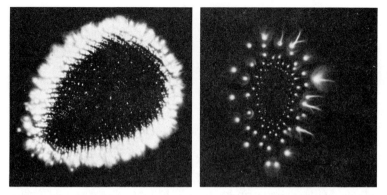

Figure 59. Left: Electrophotograph from Stanford equipment, finger pad (contact print); 100 μ sec pulse width, 20 hz rep rate, 2 sec. exposure (courtesy, W. A. Tiller)

Figure 60. Right: Electrophotograph from Stanford equipment, finger pad (contact print); 100 μ sec pulse width, 1 hz rep rate, single pulse exposure (courtesy, W. A. Tiller)

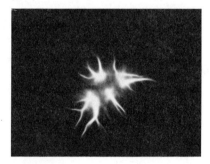

Figure 61. Electrophotograph from Stanford equipment, finger pad (long separation distance); 100 μ sec pulse width, 20 hz rep rate, very short exposure (courtesy, W. A. Tiller)

(3) a special mixing oscillator and outputting into (4) a tank circuit for stepping up the voltage. The system is monitored via (5) an oscilloscope and utilized via (6) the electrode and photographic unit. In *Figures 59* and *60* are given examples of fingerprints under various conditions using 1 megahertz as the R.F. signal. In *Figure 60* the exposure was short enough to see the point emission on the finger. In *Figure 61,* the finger was held

at a greater spacing from the film so that discharge only occurred at one point (note the similarity to some of Milner and Smart's photos). From our initial experiments it is clear that much careful standardization of techniques and control of variables will be needed before cogent statements can be made concerning the interpretation of photographs.

C. Some Theoretical Background

Most work on field emission has been carried out with metals and it seems beneficial to use this material for illustrative purposes (since we know so much more about metals than we do about living systems). At zero field, the electrons are bound inside the metal by a potential barrier equal in magnitude to the work function (*Figure 62*). As the external electric field is increased, the thickness of the potential barrier decreases. Due to the stimulation by the applied field, E, the electron emission is restricted to electron energy levels below the Fermi level ($\epsilon=0$), and the maximum of the distribution curve of the emitted electrons occurs at an energy about one volt below the Fermi level. This observation supports the hypothesis of wave-mechanical tunneling of the electrons through the potential barrier rather than over it as in thermionic or photoelectric emissions. Here, no energy needs to be added to the cathode to cause field emission.

The usual theoretical development for metals assumes the following: (1) a simple one-band electron distribution using Fermi-Dirac statistics, (2) a smooth plane metal surface where irregularities of atomic dimensions are neglected, (3) a classical image force, and (4) a uniform distribution of work function. Under such assumptions, one has a situation like that illustrated in *Figure 63*. Within the metal (at left of *Figure 63*), the significant quantity is the electron supply function $N(T,\epsilon)$ where, at a given temperature, T, it measures the relative number of electrons whose kinetic energy normal to the surface is ϵ. At higher temperatures ($T>0$), $N(T,\epsilon)$ requires a thermal tail which lifts an increasing number of electrons to higher energy levels where emission is more readily achieved. We find that

$$N(T,\epsilon) = \ln\ (1+e-e/kT. \tag{1}$$

Electrons impinging on this barrier from inside the metal have

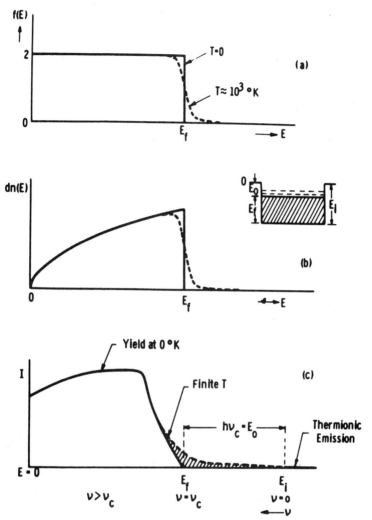

Figure 62. Fermi-Dirac distribution of electron energies in metals and its consequences for the photoelectric effect. (a) Probability function of occupancy for cells in phase space with various energy E (including a factor of two for electrons of opposite spin). (b) Number of electrons in various energy intervals beween E and E+dE. Insert shows energy level diagram with respect to vacuum. (c) Photoemissive yield for absolute zero and finite temperatures versus frequency (from right to left). Scale of "forward" energies of metal electrons is superimposed (from left to right) (courtesy, W. A. Tiller)

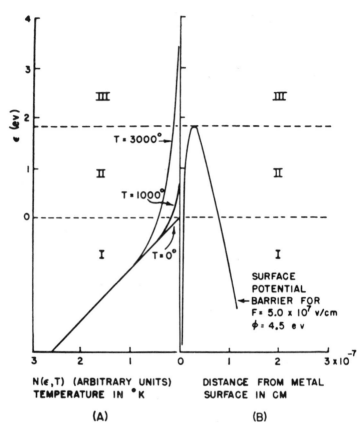

Figure 63. Schematic drawing showing, on the left, the electron supply function $N(\epsilon, T)$ in a metal for several values of the temperature, T, and, on the right, the potential barrier for a typical value of the electric field, the vertical line at 0 representing the metal surface. Region I, below the Fermi level at $\epsilon = 0$, corresponds purely to field emission; Region III, above the barrier, corresponds purely to thermal emissions; Region II, between the Fermi level and the top of the barrier, corresponds to mixed emission (courtesy, W. A. Tiller)

a certain probability of penetrating the barrier and appearing outside the metal. This probability is given by the transmission coefficient D where

$$D(F,\epsilon,\phi) = \exp\left[\frac{-6.83 \times 10^7 \ (\phi-\epsilon)^{3/2} f(y)}{E}\right] \quad (2)$$

where ϕ is the electron work function in eV, E is the electric field in volts/cm, ϵ is in eV, and $f(y)$ is a dimensionless function of the variable $y = 3.79 \times 10^{-4} \ E^{1/2}/(\phi-\epsilon)$, which takes care of the image force.

Multiplying the number of available electrons at a given energy level by the transmission coefficient and integrated over all energies must yield the emission current, J, given by

$$J \ (\text{electrons/cm}^2-\text{sec}) = \int_{-\infty}^{\infty} C \ N(T,\epsilon) \ D(E,\epsilon,\phi) \ d\epsilon \quad (3)$$

where $C = 4\pi \ m \ kT/h^3$ (k=Boltzmann's constant, h=Planck's constant, and m is the mass of the electron). When T=0, one obtains pure field emission with no electrons surmounting the barrier and the above equation can be integrated to yield

$$J = \frac{1.5 \times 10^{-6} E^2}{\phi} \exp\left[\frac{-6.83 \times 10^7 \phi^{3/2} f(y)}{E}\right] \quad (4)$$

In *Figure 64* the change in spectral distribution of emitted electrons with both field E and temperature T has been given, in correspondence with *Figure 63,* to illustrate the types of variations to be expected from these parameter changes. As is well known, it is the local field E that is important in eq. (4) rather than the macroscopic field so that, for rounded or sharply pointed electrodes, the local field may be much larger than the macroscopic field (the point effect of emission). Obviously, with living systems as cathode material, we should be able to dispense with the image force effect and, if emission occurs only from the acupuncture points, J should be reduced by a factor β to account for the fraction of the surface that is emitting electrons. In addition, if a point effect is involved in the emissions, we should use a local field ϕE rather than the macroscopic field E. Incorporating these effects leads to an alteration of eq. (4) to the form

Figure 64. Theoretical energy distributions for emitted electrons at indicated fields and temperatures, for $\phi=4.5$ eV, with amplitudes arbitrarily normalized to a common maximum (courtesy, W. A. Tiller)

$$J=\left(\frac{1.5\times10^{-6}\beta\phi^2E^2}{\phi}\right)\exp\left[\frac{-6.8\times10^7\phi^{3/2}}{\phi E}\right] \qquad (5)$$

Many of the features observed in field emission of electrons can be studied in a more subtle way by the investigation of photoelectric emission. In fact, combining photoelectric and field emission may provide a very powerful tool for investigating electron energy states inside living systems. Thus, it seems of value to briefly review the basic ideas concerning photoelectric emission (Garbuny, 1965).

The electrons, free inside a metal, find themselves bound by a potential energy, E_i, with respect to a vacuum (see *Figure 62*). The total energy of the electron is the sum of the potential energy E_i and the kinetic energy E which is distributed according to the Fermi-Dirac law. At T=0, the highest total energy equals $-E_i+E_f$ (represented by $\epsilon=0$) and it is this amount at least which must be supplied by a photon to eject an electron.

In other words, the threshold energy or work function at absolute zero is given by

$$E_0 = e\phi = E_1 - E_f \tag{6}$$

where ϕ represents the work function in volts.

At long wavelengths above the threshold, $\lambda_c = ch/E_0$, there is no photocurrent at $T=0$. When the energy is increased to and above the value of the work function $E_0 = h\nu_c$, photocurrent begins to appear, and it will grow as at larger energies a greater population of electrons becomes eligible for ejection. Ultimately, a type of volume effect will interfere since shorter wavelengths may penetrate deeper into the metal, producing photoelectrons which cannot reach the surface.

The existence of a forbidden gap E_g between an almost empty conduction band (such as found in insulators) produces conditions for the photoelectric effect which differ considerably from the behavior of metals. Perhaps the most significant feature of the bound electron structure is the virtual absence of inelastic scattering between electrons for certain ranges of energy (very long photoelectron range~500 Å for insulators and encounter losses only by lattice scattering-photon production). Thus, the photoemissive yield can be high (requires a sufficiently small electron affinity E_a, which is the energy difference between the vacuum level and the bottom of the conduction band).

The probability of finding electrons in the conduction band of semiconductors and insulators because of thermal excitation is negligible for $kT << E_g$ and thus, photoelectrons from these materials normally originate in the valence band region unless there exist F-centers and other intermediate levels. Whereas, at $T=0$, the most energetic photoelectrons come from the Fermi level, in semiconductors and insulators, they originate at the top of the valence band which lies deeper by an amount $e\delta$. Thus, the retarding potential $-E_t$ at which the onset of photoemission is noticeable is different for the two cases (*Figure 65*).

$$-E_t = h\nu - e\phi \quad \text{(metals)}$$

$$-E_t = h\nu - e(\phi - \delta) \quad \text{(semiconductors).}$$

Since the function for the density of states differs for metals

Figure 65. Density of energy states and electron distribution in (a) metals, (b) semiconductors and (c) insulators, and (d) the respective normalized photoemissive yields at retarding potential. A coincidence of the Fermi level and the same $h\nu$ has been assumed for the three cases (courtesy, W. A. Tiller)

and semiconductors, the corresponding voltage-current characteristics vary distinctly in the slope with which the yield curve rises from zero. The first derivative of the yield curve (I versus ν) is a measure of the energy distribution with which electrons leave the surface.

As the energy hν of the incident photon is increased, the energy distribution of the photoelectrons also increases at first but changes rather abruptly to low values for certain "second" thresholds of frequency (due to an inelastic collision process between a photoelectron and an electron in the valence band). For insulators, one finds photoemission enhancement in the presence of F-centers and secondary processes like excitons. An understanding of the important electron scattering processes in living systems should lead to an understanding of the bioplasma postulated by Inyushin if electrons are the key energy conversion particle involved here.

D. Some Questions

(1) One basic Soviet idea seems to be that electrons are liberated from the material by field emission and accelerated across the air gap to give off bursts of light on collision with air molecules. This light is found to be in the visible range ($\nu \sim 10^{14}$ sec^{-1}). However, calculating the amount of electron energy gained between collisions which can be converted on collision into a single photon, it is found to have a frequency in the γ-ray range ($\nu \sim 10^{17}$ sec^{-1}). We can see this from the energy balance equation

$$h\nu \approx eE\lambda_e \qquad (7)$$

where h is Planck's constant, e is the electron charge, E is the electric field, and λ_e is the electron mean free path. Using $\lambda_e = 0.25$ microns and $E \sim 10^7$ volts/cm yields $\nu \sim 10^{17}$ sec^{-1}. Thus, we must ask ourselves the question of how the visible E.M. radiation is generated. At the very least, the process must be considerably more complex than we presently envision. In addition, this computation suggests that shielding should be added around the device to protect the experimenters from the γ-ray dosage.

(2) If we look at the period of the R.F. field ($\tau/4 = 10^{-6}$ sec for 250 KH), we can ask how far an electron travels in a quarter period, and gain some insight into the dominance of the initial energy states of the emitted electrons in the overall photon yield of the process. If, for simplicity, we assume electron

emission with zero velocity, the maximum velocity of the electron just before a collision is given by

$$\tfrac{1}{2}mV^2 \approx eE\lambda_e \tag{8}$$

where m is the mass of the electron and V its maximum velocity. Using the same value of E as above, we obtain $V \approx 8 \times 10^8$ cm/sec, so that in 10^{-6} sec (one quarter period), the electron would travel about 800 cm or about 3×10^6 mean free paths, if it did not reach the anode first. Thus, at a minimum, it would seem that the electron suffers about 10^2 to 10^3 collisions and emits 10^2 to 10^3 photons during its flight path from cathode to anode ($\lambda_e = 0.25 \times 10^{-4}$ cm and the electrode spacing $\sim 50 \times 10^{-4}$ to 100×10^{-4} cm). How, then, can the light generated in the process be so sensitively related to the living organism's condition when 1000 photons are generated by collision events compared to only a few that can probably be directly correlated with the emitted electron condition from the living system? Perhaps this result is again telling us that more than electrons are involved here, or that they are involved in a far more complex manner than we presently imagine.

(3) The Soviet work has produced the "lost leaf" effect, whereas the American work has not. Is this due primarily to differences in the type of equipment involved or are there procedural differences of which we are not yet aware? This single observation is of such vast importance to both physics and medical science that no stone should be left unturned in seeking the answer!

(4) The shapes and forms observed in the English work are fascinating and suggestive of other characteristics to nature than we are presently considering. What is the comparison to the Soviet work; are the operating mechanisms the same?

ACUPUNCTURE

Acupuncture is the ancient Chinese art of preventive medicine —the initial idea being that people would go to the doctor about once every quarter year and have their circuits balanced using acupuncture stimulation, and then they were not supposed to become ill. One would pay the doctor for this. If one ever became ill, then the doctor paid him by spending time free of charge to

cure him. The principal theory, at a fairly simple level, indicates there are twelve main meridians in the body which are energy circuits, something like electric wiring—an analogy often used by Westerners. There is thought to exist a deep inner circuitry connected to the acupuncture points. The connections appear to occur via an energy field condition rather than obvious "wiring." For health and well-being of the body, it was felt essential that there be sufficient energy in these circuits and that they be balanced with respect to each other; i.e., that there be an equalization of energies. These were thought to be the key aspects, and the function of the acupuncture stimulation was primarily to take energy out of one limb of the circuit and put it into another—to shift these energies around so that one obtained a balanced system. Disease arose as a result of any major imbalance via what might be thought of as an irrigation principle; i.e., if there was not enough energy flowing in one meridian then the glands associated with that circuit had an altered energy terrain and the environmental energy fields were such that the soil became more favorable as a nutrient for bacteria to grow and thrive. This altered energy condition led inevitably to manifestations of disease at the physical level.

It appears at this point that there may be a fourth circulatory system in the body on an equivalent level with the blood, the lymph, and the nerves, and it is one that we know practically nothing about. I had the fortunate experience to be acupunctured while living in England for a year. I visited a doctor in London, and the acupuncture treatment led to a very quick cure (three visits) of an indigestion problem which I had had for eight months. The doctor had a device wherein one electrode was held in one hand and the other electrode moved over the body. The electrodes were connected to each other through a special amplifier. Then, when she touched certain points on the skin, the needle would swing up-scale abruptly. This would detect the acupuncture points, and the degree of reading on the meter indicated whether there was sufficient energy in that circuit or not. Later, in the U.S.S.R., I saw the tobiscope, which is a smaller device based upon the same principle.

It was interesting to note that, when there was an imbalance in the circuitry and a needle was inserted in the appropriate

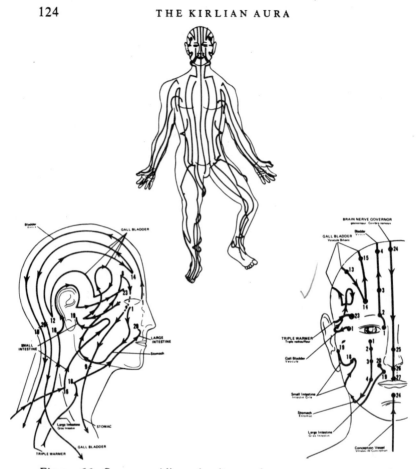

Figure 66. Some meridian circuitry and some acupuncture points in the body (courtesy, W. A. Tiller)

point, there is almost a suction force holding the needle in the point until the necessary stimulation and energy transfer has occurred. If one tries to pull the needle out too soon, it does not pull out easily and the skin pulls up around the needle. One must exert a considerable force to remove a needle under this condition. However, when balance has occurred, the needles withdraw with no difficulty; in fact, they fairly leap out. Of course, this balance is often temporary and energy changes occur in many circuits for up to weeks after a treatment.

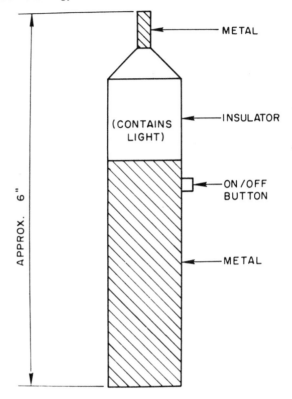

Figure 67. Schematic drawing of the Adamenko tobiscope (courtesy, W. A. Tiller)

In *Figure 66,* some of the meridian circuitry is illustrated both in the body generally and in the head; certain acupuncture points are also given. In *Figure 67,* a drawing of the Soviet tobiscope is given. With this instrument, one holds the metal portion at the back, pushes the "on" button, makes contact with the individual with the other electrode, and also makes contact with the individual's skin with the other hand. Thus, there is a complete circuit here that, for the normal skin resistance, is about one million ohms resistance, and nothing special happens to the device. However, if an acupuncture point is contacted, the resistance drops to 50,000 to 100,000 ohms, and

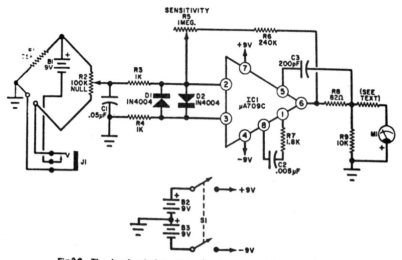

Fig.20. The low-level d.c. error signal generated in the bridge is amplified by the high-gain IC amplifier and displayed on the meter.

PARTS LIST

B1-B3—9-volt battery
C1—0.05-µF capacitor
C2—0.005-µF capacitor
C3—200-pF capacitor
D1,D2—1N4004 (or any silicon diode)
IC1—Integrated circuit (Fairchild µA709C). See text.
J1—Modified closed-circuit jack. See text.
M1—0-1-mA meter with series resistor (2500 to 3000 ohms) to measure 3 volts.
R1—75,000-ohm, ½-watt resistor
R2—100,000-ohm potentiometer

R3,R4—1000-ohm, ½-watt resistor
R5—1-megohm potentiometer (miniature preferred)
R6—240,000-ohm, ½-watt resistor
R7—1800-ohm, ½-watt resistor
R8—82-ohm, ½-watt resistor
R9—10,000-ohm, ½-watt resistor
S1—D.p.s.t. switch
Misc.—Eight-pin TO-5 socket (for IC1), two 1"-square pieces of heavy copper or two large foreign coins, pair of bicycle clips, length of insulated wire, battery clips (3), case as desired, mounting hardware, etc.

Figure 68. Circuit diagram (courtesy, R. E. Devine)

this resistance is so arranged in the circuit that it upsets a bridge balance. A signal enters an amplifier where it amplifies the voltage and lights the bulb contained in the insulator section of the device (Adamenko, 1971). This makes the section glow. A simple but effective circuit for this purpose was presented by Devine (1970:117) and is illustrated in *Figure 68*. The author has used such a device for the successful location of acupuncture points. Devine calls this a "Psych-Analyzer" device. To actually measure the resistance, an electrometer is beneficial. To eliminate pressure effects, merely place blobs of EKG sol

on the acupuncture points and merely insert the electrodes into the sol without actually touching the skin.

The Soviet work showed that there are shunt paths in the body—low-resistance paths connected to each of the acupuncture points. They found that by connecting electrodes of different materials to two acupuncture points (e.g., silver and nickel electrodes), one can develop a voltage of 50 millivolts between acupuncture points, and can draw a current of up to 10 microamperes from these electrodes. By connecting many such electrodes in series, one can obtain the order of a volt from one's body, which can be used to run little electrical devices, if you like. Thus, our body constitutes a significant battery which is an indication that a fairly good electrolyte exists inside our system.

The North Korean, Professor Kim Bong Han, performed an experiment in which he injected radioactive phosphorus into an acupuncture point and looked to see where it went in the body. He found it went primarily along that particular meridian rather than laterally. He also monitored the other acupuncture points along that meridian and found a high concentration of radioactivity there. The Kim Bong Han experiments will be discussed briefly later; for a more complete treatment of the subject, the reader is directed to another work by this author (Tiller, 1972).

The Soviet researchers performed an experiment on what they call the "semiconductor" effect using a manual healer (Adamenko, 1971). Suppose one takes an acupuncture point on the left side of the body and the symmetrical one on the right side, and measures the resistance from left to right. A value R will be obtained. Then, switching the electrodes around and measuring from right to left, R, or a different value, R', may be obtained. If the person (or gland) in that meridian is healthy, then the reading will be the same ($R=R'$). However, if the gland is unhealthy and the point is associated with that gland, there will be a difference in the resistance ($R'\neq R$). The difference ($\Delta R = R'-R$) is what is called the semiconductor effect. To perform the healer and patient experiment, they measured the patient before treatment and obtained the data given in *Figure 69;* they also measured the healer before treatment. The healer was going to project energy via his hands to the individual. They found

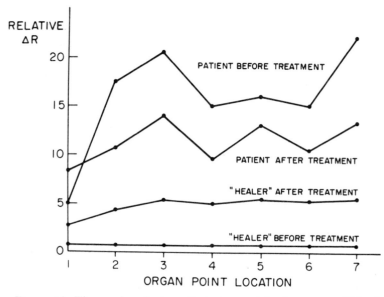

Figure 69. The semiconductor effect observed in "paranormal" healing (courtesy, W. A. Tiller)

that, after the treatment, the patient's energy circuit came more into balance, but the healer's became slightly imbalanced. Thus, it seems that the healer gave up a particular kind of energy in a particular location of his body in order to balance the circuitry of the ill individual. This is indeed a new type of energy that could not be detected before.

Soviet investigators also did some monitoring of acupuncture points in order to indicate the various hypnotic states of an individual (Adamenko, 1971). The acupuncture point resistance changes with the state of consciousness as indicated in *Figure 70*. They find that the best hypnotic subjects, of course, manifest the strongest stimuli, i.e., produce the strongest effect that they monitor at the acupuncture points. A person who is not hypnotizable at all produces no change in resistance between the various states. Thus, one is able to obtain a cause-effect relationship which connects certain mental characteristics and these physiological readings. *Figure 70* presents data from the ordinary waking

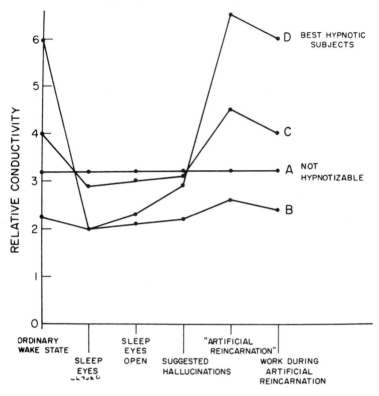

Figure 70. Relative conductivity indications versus hypnotic state of the subject (courtesy, W. A. Tiller)

state, sleep (eyes closed), sleep (eyes open), hypnotically suggested hallucinations, hypno-production ("artificial reincarnation"), and work during hypno-production. Hypno-production involves telling a hypnotized subject he is a prominent person (e.g., Rembrandt, Einstein) to stimulate his creative work.

Professor Kim Bong Han (1963, 1965), who has been working with a team of research workers, has shown that there are four main types of meridian subsystems in the organism. The original works by Kim seem to be almost impossible to obtain. However, Rose-Neil (1967) has presented an excellent review (from which the following material is extracted). The original work deals with the "Kyungrak" system, which may be equated with the "merid-

ian" system. The first of the meridian system is called the Internal Duct System. These ducts are found free-floating in the vascular and lymphatic vessels. The ductules ramify so that the path of the containing vessels are completely followed. Flowing in all ductules is a fluid or liquor. In the Internal Duct System the liquor generally follows the blood or lymph flow, but in some cases it runs in the opposite direction. Also, these Internal Ducts penetrate out of the vessels. These facts lead to the conclusion that the formation of the Internal Ducts is different in the origin from that of the blood and lymph vessels. The second series of meridians is the Intra-External Duct System. These are found on the surface of the internal organs and they form a network which is entirely independent of the vascular, the lymphatic, and the nervous systems. The third series is the External Duct System. These run alongside the outer surface of the walls of the vascular and lymphatic vessels. These ducts are also found in the corium and are here known as the Superficial Duct System. It is this latter system with which we are most familiar in acupuncture. The fourth series of ducts is known as the Neural Duct System. These are distributed in the central and peripheral nervous systems.

All of the various duct systems are interlinked together via the connection of the terminal ductules of the different systems, very much as in the case of the arterioles which link with the venules bringing together the arteries and the veins. Spaced at intervals along these meridians or ducts are small corpuscles. Each duct or meridian may contain scores of ductules which measure on the average 0.5–1.5 microns across although some are as small as 0.1 μ and some as large as 5 μ.

Kim Bong Han has shown that myeloid and lymphatic elements exist in the ducts. When erythrocytes in the bone marrow and the peripheral blood systems are killed with phenylhydrazine, activity in the corpuscles increases and they enlarge. On the contrary, anemia develops when the Internal Duct System is injured. This suggests that hematopoiesis is one of the functions of the internal meridians. To show the control of the meridians over a particular organ, Kim severed the portal duct of a frog and found that histological changes soon took place in the liver. The cells enlarged and the cytoplasm very soon became turbid. Within three

days serious vascular degeneration took place throughout the whole liver. Many other experiments confirmed these results.

Kim conducted a series of tests to establish the constituents of the duct liquor. He isolated nearly as much hyaluronic acid as is found in sperm; twenty different kinds of free amino acids, including all of the essential ones; sixteen different free mononucleotides, corticosteroids, ketosteroid, estrogen, and adrenalin. Over twice as much adrenalin was isolated as is found in the blood and in an acupoint over ten times as much was found. Kim further isolated deoxyribonucleic acid and ribonucleic acid from the liquor. Paper chromatograms of the bases of deoxyribonucleic acid showed: 1. guanine, 2. adenine, 3. cytosine, 4. thymine. Paper electrophoregram of ribonucleic acid mononucleotides showed: 1. cytidylic acid, 2. adenylic acid, 3. guanylic acid, 4. uridylic acid.

The existence of hyaluronic acid, cortical and medullary hormones, and estrogen suggest that the meridian system is closely associated with the endocrine system.

To investigate the liquor flow, Kim injected radioisotope P^{32} into an acupoint. Microautoradiography was possible in two hours in the external corpuscles. No P^{32} was detected in the blood vessels. P^{32} injected into an internal corpuscle was quickly labeled in the internal ducts but only slowly found its way to the superficial system. P^{32} injected into the ear vein could hardly be detected anywhere in the meridian network. These experiments show that the meridian system is independent of the vascular system and that the meridian liquor flows from the acupuncture points inward to the deeper ducts and corpuscles and finally outward again. Kim has shown that the terminal ductules reach the tissue cell nuclei. He further experimented with the cutting of the perineural duct of the nervous system to establish any alteration of the bending reflex of a frog. A solution of 0.5 per cent of sulphuric was used. The results were as follows:

Changes of Spinal Reflex Time After Cutting Duct

No.	Time after cutting	Average reflex time (sec) based on six experiments	Control group
1	Normal	2.5	—
2	30 minutes	11.5	2.5
3	12 hours	6.3	2.3
4	24 hours	8.7	3.0
5	36 hours	10.3	3.0
6	48 hours	11.3	3.1

Kim concluded that not only is the meridian system interlinked but that all cell nuclei are interwoven into the same system. Working on the embryonic chick, Kim found that basically the meridian ducts were formed within fifteen hours of conception by which time the primordia of organs are not yet formed. This suggests that the function of the meridian system exerts an influence upon the differentiation of cells. Further, the positioning of the meridian system in the embryo is completed earlier than any of the other organistic parts.

Having conducted experiments on mammals, birds, reptiles, amphibia, fish, invertebrates, and hydra, Kim suggests that the meridian system exists in all multicellular structures, both animal and vegetable.

Unique granules circulate in the duct liquor. These granules have been named Kim Bong Han Sanal. The Sanal develops into cells and after an elapse of time converts back into Sanal. There is a continuous renovation of cell tissue which is controlled by the meridian system. Sanal contains D.N.A., R.N.A., and protein. Kim has been able to grow *in vitro* cells from Sanal. The process is that Sanal flows in the meridian liquor. It forms by fusion into a cell and after a limited life bursts through the cell membrane to recirculate in the ducts as Sanal.

In the course of the formation of a cell from Sanal the content of D.N.A. is increased sixteen times, R.N.A., nine times, and protein nitrogen thirty-two times. Besides his discovery of cell formation from Sanal, Kim made important observations concerning cell division. When the cell is a stable unit, the Sanal is in a fused state. During cell division it breaks down in such a way as is suggestive of the behavior of chromosomes. If the cell

is fixed after the nuclear membrane has broken down, the Sanal gives every appearance of chromosomes and they are the same in number, as is usually found in the cell of the animal under investigation. Kim claims that chromosomes appearing at cell division are Sanal, and cell division is a specific form of movement of Sanal. The inheritance of life attributed to chromosomes is an aspect of Sanal and part of the organization of the meridians.

The cell theory holds that the cell is the uniting morphological and functional unit of the organism and that cells are formed only from cells through cell division. The Kim experiments are inconsistent with this theory. Kim used P^{32} to identify Sanal extracted from an acupoint. The extracted Sanal was injected into different parts of the circulating ducts. Within forty-eight hours, tagged Sanal could be detected among cell tissue. This experiment suggests that Sanal from the corpuscles eventually becomes part of the cell tissue. These observations were confirmed with many experiments, including those on the ovary, the suprarenal body, the liver, the kidney, and the lungs.

Kim considered that as the various acupuncture points have specific connections with relevant bodily organs and functions, then Sanal taken from different parts should produce different types of cells. He conducted a series of 344 experiments, taking Sanal from 79 different acupoints. As was expected, different cells were formed in accordance with the foci of those points. Kim's final series of experiments of which I have knowledge concerns the photochemical influence of light in the epidermis. Sanal cultivated under normal light grew 104 cells in 96 hours, whereas in a dark chamber only 32 were formed. He attributed the few cells which did grow in the dark as having already been under photochemical influence of light in the superficial corpuscles before being extracted from the ducts.

From all the available information, there appear to be several ways in which one can produce acupuncture stimulation. It appears all one needs to do is stimulate, sufficiently, the acupuncture points. This can be done by chemical stimulation. That is the weakest method. It can be done by manual massage, which is the next most satisfactory method. It can be done via the acupuncture needles, which is better still. It can be done by the injection of electrical energy; this is the next best method, but this requires

sophisticated understanding of the process. The next most successful method is to use a laser beam which, again, requires sophisticated equipment and understanding. Finally, there is the psychic energy (or "bioenergy") injection, which seems to be the best procedure for bringing about this bodily balance in many cases, if the services of an appropriate "psychic healer" can be obtained.

In conclusion, let us consider a very simple model of what might be happening during acupuncture and maybe how it relates to the anesthesia situation. The energy "Ch'i" is thought to flow in the meridian circuitry. Think of it, if you like, simply as a fluid flowing along a river bed. The fluids in the body all contain colloids (Sanal granules) and these are important energy components in the body. Let us propose that if you upset the energy fields of the body, then you produce what is called colloid instability. You generate an agglomeration phenomenon rather than a stable dispersion; thus, the colloids build a type of "raft" and the rafts become hung up in the fluid stream at various obstruction points. This, then, requires an enhanced pressure to move the fluid. Such a condition produces an imbalance between two limbs of the fluid circuit. The function of the stimulation at the acupuncture points is most likely to break up the rafts. Probably what happens is that these stimuli produce a type of capacitive energy effect in the vicinity of a point, which generates a force to move or break up the rafts. This probably alters the local energy field which breaks up the rafts via a shock discharge allowing the fluid to get moving again and develop momentum. When moving, the fluid has less inertia, and that is what starts to bring about the balance of the circuitry.

If we look at the situation of anesthesia via needle insertion in a particular point, we expect that this may divert the flow of energy into other subsidiary channels. In turn, this produces a field effect which can act in at least two ways. It may act on the various important nerve centers so that the local energy fields are reduced to such a point that the nerve firing does not occur. That is one possibility! The other relates to transmission line blockage; the nerve signals that normally go to the brain and tell you that you are being hurt or cut open or what-have-you are blocked so that, although the nerves are firing, the information does not get through. In addition, one must go deeper into this

because one has to understand why we have a type of steriliza-
tion effect here. We hear of people eating oranges during surgery.
It seems quite remarkable that this absence of what we think of
as the need for sterilization in the operating room does not lead
to any problems. This may be because we are dealing with
another level of energy, which produces effects that do not require
the normal sterilization procedures.

CONCLUDING PHILOSOPHY

The flux of world-wide investigation and activity in the area of
psychoenergetic fields and phenomena has been such that man-
kind has now exceeded the "critical mass" condition for a self-
sustaining reaction. We can now anticipate a continued growth
of awareness and perception relative to this domain of nature.
Such an activity does not deny the validity of our present knowl-
edge of the universe, nor does it pose a threat to what I shall
call conventional physics. Rather, it calls for an extension, or
expansion, of present laws to reliably model behavior in the ex-
panded domain of variable space that circumscribes psychoener-
getic fields (since we presently have some small ability to
monitor this aspect of nature). Here, one should reflect on the
example of Newton and Einstein. Newton's work on gravitation
was not shown to be wrong by Einstein, but merely limited to a
domain of variable space in nature far removed from speeds
approaching the velocity of light. The laws of Einstein reproduce
the laws of Newton in the appropriate limit of small velocities.

In the decades and centuries ahead, we would hope to follow
and extend Einstein's example and develop quantitative laws
that reliably model nature in the psychoenergetic domain and
which simplify, in the appropriate limit, to our present physical
laws of nature.

We may liken conventional scientific understanding of the
universe to the visible tip of an iceberg. We have come to know
that exposed tip fairly well. However, most of nature is still hidden
from us and we know it not. History contains references and
speculation to many aspects of the hidden iceberg and very re-
cent research, especially that fine work being carried out in the

Soviet Union, suggests some fascinating characteristics. Let me touch briefly on some of these:

1. From experiments on telepathy, psychokinesis (PK), manual healers, etc., we seem to be dealing with energy fields completely different from those known to us via conventional science.

2. From experiments on PK, radionics, etc., the cause/effect relationships seem to follow a different path or "field-line" than we are used to dealing with in the conventional space-time frame of reference.

3. From a large variety of experiments, we find indications for a level of substance in nature that exhibit (a) characteristics that are predominantly magnetic, as distinct from electric, in nature; (b) an organizing rather than a disorganizing tendency as the temperature increases (in seeming violation of the second law of thermodynamics for the physical universe); (c) a radiation pattern or hologram of energy that acts as a force envelope for the organization of substance at the physical level.

4. From experiments on plants, animals, and humans, evidence is mounting that there is an interconnection at some level of substance between all things in the universe.

5. Some indications point to the existence of energy manifestations at uniquely different levels of substance which are stable in different space-time frames than we are familiar with. This leads to the suggestion that space and time might be constructs of waves at these deep levels of substance (e.g., "mind" and "spirit" levels).

In this paper we have seen that both topics discussed here, high-voltage photography and acupuncture, open a door for us into vast new realms of man and nature. Let us go forward with care, courage, and enthusiasm, performing our work thoughtfully and rigorously. It is far too important to deserve any less than the very best of our abilities to provide a firm and reliable foundation of understanding in this area. The techniques of analysis and experimentation and the standards of quality synonymous with conventional science serves as a meaningful guide to us. Let us be open-minded and flexible in our seeking but let us also require extensive proof before we rest to enjoy the satisfaction of a completed task.

Acupuncture and the Human Galaxy

Corinne Calvet

The art of acupuncture
Is a method of re-establishing equilibrium
In a body that has lost its balance.

Two conditions can upset the equilibrium of the body's organs:
An organ can become overactive or underactive.
In either case,
The organ is not performing properly
And an imbalance
Is created in the meridians, or bodily channels.

The human body,
Like everything else in nature,
Is subject to certain governing principles.
All the principles of nature are derived from one basic law—
The oscillation of Yin and Yang.

The mutations of Yin and Yang represent the universal force, or
 Tao.
In the Tao, Yin is receptive and Yang is active.
Their function is mutation
And the result of their interaction is continual creation.

In every element of life
There is both Yin and Yang.
In one is contained the seed of the other.
In life is the seed of death;
In death is the seed of life.

In order to understand acupuncture,
We must employ a viewpoint
Large enough to encompass the principles of the Universe.
If we look at the structure of a galaxy
We find that it is a complex system.

The Arica Institute speaks of Trialectics.
A galaxy is a trialectic process.
Inside a trialectic process
There are billions of smaller processes going on.
Each process consists of essentially the same structure.
In each structure
There is a changing and transforming of energy.

A trialectic process consists of four parts:
Active,
Receptive,
Function,
And result.
Evaporation of water into vapor is an example of the process.
The active part is sunlight.
The receptive part is water.
The function is evaporation.
The result is vapor.

If we look at the structure of atoms, we find that
In between the protons and electrons
There is immense distance.
In between the protons and electrons
There is emptiness.
Emptiness attracts energy.
Lower energy—that which is not vibrating at a high frequency—
Creates a type of density.
We can call this density a Material Manifestation Point or MMP.

All MMPs are subject to given principles.
All MMPs mutate into other MMPs.
In a mutation
The equilibrium is internal.
The absence of internal equilibrium provokes malfunctioning.

Any MMP can mutate to a higher or lower MMP.
In the case of the human organism
Symptoms of sickness appear
When there is an absence of mutation.

Everything is the seed of its apparent opposite.
Antagonism does not exist in nature.
In nature there is only circulation.
Antagonism only exists
When the flow of energy is blocked.

The higher the MMP
The fewer principles it is subject to.
Higher MMPs
Are those which have less internal movement
And, therefore, greater external energy flow.
Lower MMPs
Are those with greater internal movement
And, therefore, less external energy flow.

The MMPs of the Universe are pre-established.
Moving through different MMPs,
The function changes
And the density of matter changes.
It takes a long time
For a rock to disintegrate.
Scientifically,
One can measure density in terms of wavelengths.
In subatomic structures
One can measure the wavelengths of the different particles
In the nucleus of an atom.

In a galaxy
There is constant equilibrium
Throughout the complex trialectic process.
Therefore, to understand a galaxy,
One must look at the entire process
And not only the individual MMPs.

Acupuncture
Treats an illness of the body's organs
By re-creating a proper equilibrium.
In so doing
The density of the MMPs is balanced,
Using as function the
Acupuncture needles,

The moxas,
Massage, heat,
Or high-frequency sound.

Sickness is an unnecessary structure.
This structure
Interferes with the circulation of energy among the MMPs.
The MMPs in the body's organs
Are related
Through the high-energy channels of emptiness called meridians.

Like all MMPs,
Acupuncture points are pre-established.
Sickness
Is slowed-down energy.
Sickness
Is a lack of equilibrium.
Sickness
Brings about a chain reaction, known as symptoms.
Acupuncture
Brings Yin and Yang into balance.

The human galaxy
Contains many trialectic processes.
Yin is receptive.
Yang is active.
Acupuncture is the function.
Good health is the result.

Chinese Acupuncture and Kirlian Photography[1]

Jack R. Worsley

Acupuncturists have been talking for nearly five thousand years of "Ch'i"—the "vital energy" or "life force." Now, in the twentieth century, Kirlian photography and other forms of scientific research are making it visible to all, demonstrating in Western scientific terms the validity of these traditional Chinese beliefs.

Meridians and Acupoints

The theory of acupuncture says that energy flows along specific pathways or "meridians" connecting the organs deep in the body with the acupoints on the surface of the body. Soviet experiments are now demonstrating that this energy does indeed take interior pathways and does not travel along the surface of the body. The channels of light leading to the surface of the body that show up under Kirlian photography seem to relate to the Chinese chartings of the "meridians" or "energy pathways." The flares in Kirlian photographs often seem to issue from the acupoints.

Positive and Negative Yang and Yin

The Chinese have stated that this vital energy is polarized into the positive and negative Yang and Yin and that this is quite separate from the electrical energy in the body. Scientists at Kazakh State University, U.S.S.R., found that this newly visible body was indeed polarized but not electrical. (The Kirlians noticed that the light flares seen coming from the body seemed to be of two basic colors: blue and reddish yellow.)

Interplay Between Mind, Body, and Cosmos

The Chinese had always said that there is a constant interplay between the mind, the body, and the environment. All three are linked by the vital energy. Further, the positive and negative

[1] Copyright © 1972 by J. R. Worsley

aspects of the one vital energy are constantly fluctuating as they are affected by the continuous shift of things—by changes in the weather, the seasons, moon phases, etc. They are also influenced by moods, emotions, thoughts, mental disturbances, and physical illnesses.

The findings of the researchers in Kazakhstan are in agreement with these assertions. The "bioplasmic body," as some Soviet scientists have called the "energy body," is seen to be affected by the atmosphere and by other cosmic occurrences. Disturbances of the sun, for example, change the whole plasmic balance of the universe resulting in measurable physical changes in organisms (Kirlian and Kirlian, 1959).

The Highest Form of Medicine

Acupuncture has always stated that the highest healing science works with the invisible Ch'i energy and not with the physical body. Thus, a master of acupuncture is able to prevent disease occurring in the physical body by noting and correcting any imbalance that appears in this vital energy of a person.

One of the developments that impressed the Kirlians was the fact that they could foresee disease in the energy body of an organism, and many Soviet physicians have been quick to realize the importance of such information. They saw that a knowledge of acupuncture would help them to interpret the changes seen in the energy pattern (e.g., changes of color, changes of intensity of light) and lead them to diagnose the type of illness that would appear in the physical body if the energy were not restored to its normal state.

Each Individual Is Unique

Acupuncture has always believed that each individual as a whole is unique. This uniqueness characterizes the pattern of his vital energy as well as his mind and physical body. Consequently, no two patients can ever be treated alike. Each must be viewed as a whole and separate organism, joined by the vital energy in a unique relationship with the whole creation.

The energy body photographed by the Kazakhstan scientists is not a chaotic system. It is well organized, having a definite shape and being quite specific for each different organism. (Just as an

oak leaf is recognizable as an oak leaf and no other leaf, so too is the energy body of an oak leaf recognziable as the energy body of an oak leaf and of no other leaf.)

Renewing the Ch'i Energy

The Chinese say that the Ch'i energy in a person is replenished from the air we breathe and the food we eat. The Kazakhstan photographs indicate that some of the electrons and a certain amount of the energy in the oxygen we breathe is taken into the body. Breathing renews the vital energy and helps to restore any imbalance in the energy body. Perhaps Kirlian photography will be of assistance in observing this process.

In similar ways, the work of Professor Kim Bong Han and his team of scientists in the Democratic People's Republic of Korea is substantiating the existence of meridians and acupoints and showing how the flow of the life force in the meridians affects the body and mind (Tiller, 1972). The Korean research, although extremely complex and detailed, can be explained rather simply.

Kim is explaining in biochemical terms exactly how it is that the "Kyungrak system of ducts"—the acupuncturist's network of meridians—plays so vital a part in the smooth functioning of the organs of the body, and consequently affects the condition of the whole physical body. The practitioner of acupuncture is going directly to a controlling power when he treats a patient through this network of meridians in the body.

There is no denying that the kind of experiments that the Soviets and North Koreans have been carrying out, and that are now being replicated in the United States, appeal strongly to the Western mind. The scientific technological approach persuades Westerners very readily of the truth of their findings, and this is a positive development. Knowledge must always be expressed in the life-style and language of each different culture for it to be accepted and believed.

However, it must be remembered that the knowledge that is reached is not "new." It is rather being rediscovered by Western technology. The truths that are reappearing in the West have always been the foundation of acupuncture, the traditional Chinese system of medicine. It is this fact, that the system is founded on a true understanding of man and his relationship to the cosmos, that

is enabling it to live on after the death of the old Chinese civilization in which it grew up. Finally, it is this fact that will enable acupuncture to be of service to a new technological civilization.

Phenomena of Skin Electricity

Viktor G. Adamenko

In 1783 a huge meteor passed over England. One hundred people heard a sharp, whistling sound just prior to witnessing a fiery ball. The meteor fell fifty miles from the place the observers were standing.

A similar incident occurred October 1, 1917, in the United States. At 10:30 A.M., citizens of Georgetown, Texas, heard a whistling, droning, clicking sound. Some reported they sensed a surge of heat, the smell of sulphur, and unexpected alarm; shortly thereafter, a meteor streaked across the sky and landed at the border of the state.

The movements of the meteors were accompanied by electromagnetic emanations. They covered a wide spectrum. Several skirted the ground surface and somehow were perceived by the observers. This perception registered prior to the visual sighting—while the meteor was still beyond the horizon. One may hypothesize that the organism in some way perceived the electromagnetic waves and transformed them into a whistling sound.

This theory is supported by several recent observations. A person in the vicinity of high-frequency radio broadcast waves hears a droning sound, a whistle, or a clicking—depending on the condition of the modulation. Radio sound is sensed at frequencies of 425, 1310, and 2982 megacycles. Apparently, short electromagnetic waves register on the skin. The skin acts as a detector of low-frequency discharges. Thereby, a man seems to function as a receiving antenna.

How are these isolated low-frequency electrical oscillations transformed into sound? A simple experiment may prompt an answer.

Two people tightly clench in their fingers conductors connected to a radio transmitter. Then, not touching one another, but slightly leaning toward each other, ear-to-ear, they listen to a radio

broadcast. The broadcast—without loudspeakers—resembles the strength of the sound of an adapter working without an amplifier. The all-enveloping sound disturbs the usual way of listening, but for the two human receivers it was not difficult to single out music from speech, and to distinguish individual words. It is true that the effect might not be from the high resistance of the skin. If they join hands, the sound disappears. The loudspeaker is supplanted in this experiment by the eardrums oscillating under the action of the low-frequency current flowing through them. The reproduction of the broadcast is genuine enough to the percipients.

Dr. A. Tyapkin, the Soviet physiologist, has described how he is able to feel patterns of radioactivity with the tips of his fingers. Here is how a graduate student of biological science described a similar experiment:

> In the room there was a slightly strained silence. About ten people were gathered around a table upon which were several porcelain plates turned upside-down. The door opened and the experimenter quickly stepped up to the table. He extended his hand to the dishes, and then quietly in short intervals pronounced: "Copper. Gold. Bronze. Empty. Silver." The dishes were turned over and under each dish was found the substance named: copper, gold, bronze, and silver coins or rings, but under one dish—nothing. At one dish, the experimenter said: "Unimportant matter here." A rubber band was found under this dish.

This is not so surprising if it is true that one can obtain information through the skin through a sense of smell. When the meteor fell in Texas, observers sensed the smell of sulphur before the meteor appeared in their range of vision.

In the beginning of his scientific work, Dr. A. Yuffe proposed a hypothesis associating odors with electromagnetic waves of infrared range. It is possible that the process of smell is conditioned not by the size or the form of the molecules, but by their oscillating motion. True, the size and form of the resonators determine the rate of oscillation. If the sense of smell is somehow connected with electromagnetic waves, it follows that one might expect the skin to be somehow sensitive to odors.

Duplication of organ perception is not necessarily a unique

phenomenon. In the process of evolution, living organisms have progressed along complex paths of development. At the lower stages of evolution, nerve cells—receptors for light, sound, and smell—were dispersed all over the body surface. For example, the lowly earthworm is deprived of eyes but perceives light through his skin. In the process of development, sensitive nerve cells were concentrated in separate parts. Thus, the organs of hearing in grasshoppers are found on the shins, and on the locust on the sides of the abdomen. Little is known about how such a sensitive arrangement responds to the activity of electrical, magnetic, and electromagnetic fields. However, it is clear that corresponding nerve components are adaptations to these fields, as the eyes are to the perception of light, and as the ears are to the perception of sound.

Dr. A. Podshibyakin discovered that in the presence of close-to-the-ground magnetic storms the electrical potential of the skin rises. Some people seem to experience a foreboding of these invisible whirlwinds in varying degrees. Some experience these sensations twenty-four hours before the storm, others up to three or four days—even before it registers on physical instruments.

Perhaps one of the most mysterious gifts of evolution is the system of so-called acupuncture points, or active-points in the skin. These are distinguished from the usual skin color by very feeble pale yellow coloration. These tiny areas are better conductors of electrical and audio currents than the surrounding areas. There are at least seven hundred such points on the body, varying in size from one millimeter to one centimeter. At these active-points is found a higher degree of electrical conductivity from the neighboring skin surface area. The author constructed a compact device, a tobiscope or "light pencil," to be used for finding these active points according to their electrical conductivity, or affinity. One must keep in mind that this affinity is unstable and is subject to change as a result of emotional reactions and the quantity of inhaled oxygen. For dry skin, the conductivity changes only between the acupuncture points and those skin areas not containing such points. At these areas, conductivity remains unchanged even in a state of intense emotional reaction.

Changing one's emotional condition may increase the diameter of the active-points. In the event that one point overlaps another,

there is formed a point of increased conductivity. In the hypnotic state, emotional reactions are sometimes controllable. This fact gave rise to the possibility of measuring the conductivity of active-points during the varied depths of hypnotic suggestion.

When the subjects were placed in a deep hypnotic trance, they were told that they were actually famous artists or musicians—like Ilya Repin, or Sergei Rachmaninoff.

For those subjects able to involve themselves in "hypno-production," important differences in the conductivity of the active-points were noted. However, the conductivity was unchanged if there was an absence of emotional reactions to the suggestions of the hypnotist (*Figure 66*).

What is particularly interesting is a series of attempts to control the change in conductivity of the acupuncture points using auto-suggestion. From two points, one is able to produce an effort of 50 microvolts, 150 microvolts from several points, and with the assistance of auto-suggestion a half volt. This suggests that a human is a "generator" and in principle can light up a small electric lamp with one emotionally strong-willed effort or, through a radio transmitter, control the movement of a miniature toy auto. However, in skin where there are no acupuncture points, there is no production of electricity.

These discoveries reveal that very little is actually known about the skin. Perhaps the most surprising facts are yet to be found.

Detection of Acupuncture Points by the Biometer

Viktor G. Adamenko, Valentina Kh. Kirlian, and Semyon D. Kirlian

This article concerns the recent invention of the "biometer." Although similar in principle to a "Voltaic pile" battery, it differs from the latter in that instead of a layer saturated with acidified liquid, a human body is placed between the electrodes to set up an electrical current.

The concept of the biometer action is based upon an electrochemical reaction of metals with the biomechanisms enclosed by human skin and the products of their physiological functions.

We know that during the process of activity of the life organism, the condition of the biomechanism of the skin surface changes and is accompanied by changes in chemical products and their functions. It is these changes that determine the potential value of the generated electric current during the interaction of the biometer electrodes with the skin.

The resistance of the conducting paths represent the biological characteristics of the subject being investigated. These are measured in electrical values on the biometer. Evidently, for the establishment of homolographic tables, we can be guided by the indications of the biometer. Further, information about the physiological conditions of the living organism (including pathological conditions) can be obtained in electroenergetic values.

The biometer consists of a zinc cylinder with a bushing of dielectric material pressed into its hold. A brass or copper rod is then inserted. Insulated flexible wires are soldered to electrodes; the wires lead out through the opening in the bottom of the cylinder and are connected, one to the negative terminal of the micrometer, the other to the positive terminal of the micrometer. Thus, the biometer consists of two different metal electrodes separated by dielectric material and connected to a measuring device. The performance is stable, since it does not have elements that

produce failures. Therefore, the device can be considered as a self-supporting system. By selecting another metallic pair, the sensitivity of the biometer may be increased or decreased.

Using the biometer, the locations of the Chinese acupuncture points are determined as follows: the zinc cylinder of the device is pressed in the hand of the subject or the experimenter. If the experimenter is holding it, his other hand is firmly pressed to the subject's body to complete the electrical circuit. Using as the point of the device a brass electrode, the skin in the area of the sought-for acupuncture point is probed. At the moment the point is located, the indicator needle of the micrometer is deflected, simultaneously signaling that the point has been detected and indicating, on the scale, the strength of the current which is conducted through the channel.

The indications of the micrometer depend on the physical, emotional, and other conditions of the subject. For example, during states of nervousness or psychological excitement, the needle deflects more than 25 to 40 microamperes. During nervous or psychological depression the needle may remain on zero or deflect only one or two microamperes. Therefore, in order to find the acupuncture points of a subject who is in a depressed state, the sensitivity of the biometer may be increased artificially by increasing the potential of the generated current. This is done by slightly moistening the palm of the hand holding the biometer cylinder, thus increasing the sensitivity three to five times. The authors recommend this technique only in searching out acupuncture points and only on subjects who are tired, depressed, sleepy, etc.

To determine the general condition of the subject, the experimenter should have him clasp the cylinder of the biometer in his hand while touching the mucous membrane of his tongue or lips with the other electrode. One can then tell, by the micrometer indications, whether the subject is in a state of depression or excitation.

Massage in Oriental Medicine: Its Development and Relationship to "Ki," or Vital Energy

Robert Feldman and Shizuko Yamamoto

An attempt to present a descriptive analysis of oriental massage techniques should, properly speaking, require as much detail as a treatise on acupuncture or herbal medicine. In this paper, however, we shall confine our discussion to the attitudes and approach of the practitioner toward treatment, rather than attempt a step-by-step description of the treatment itself. There are approaches and schools of thought as numerous as its practitioners or geographical origins. *The Yellow Emperor's Classic of Internal Medicine* or *Nei Ching,* one of the oldest and most fundamental works of oriental medicine, classifies various methods of treatment as developing within five major geographical areas of China (Veith, 1970:53–54):

> The four points of the compass and the region of the center are held to produce anthropological differences, and consequently, susceptibility to different diseases in man; and these in turn, can be cured only by that method which is supposed to be connected specially with each particular region.

It is also written in the *Nei Ching,* that the ancient physicians and sages combined treatments for the purpose of curing illness as, in many cases, various treatments were complementary (Veith, 1970:147–148):

> The people of the east live near the ocean and eat much fish and salt. Fish and seafood are thought to "cause internal burning," salt to injure the blood. These factors cause a dark complexion and a propensity towards ulcers, which must be treated with acupuncture by means of a needle or flint.
> The people of the west lived in dwellings of stone, their fields are fertile and their food good and varied. Because their land is

hilly and exposed to the wind and their clothes made of coarse wool or matting, their bodies are robust and healthy and impervious to internal disease. Their internal disease must be cured with herbal medicine.

The people of the north live in mountainous regions, their food consists mainly of milk products. They are exposed to cold winds and frost and hence suffer with many diseases that must be cured with Moxa.[1]

The people of the south live in regions which are fertile through an abundance of sun and dew (although their waters are beneath the earth and the soil is deficient). They live on sour food and curd, and they suffer from contracted muscles and numbness and should be treated with acupuncture by means of the nine fine needles.

The people who inhabit the center live on level fertile ground and are able to obtain a varied diet without great exertion. Yet, they too are attacked by disease, mainly by complete paralysis, chills and fevers. The treatment prescribed for the center consists of massage, breathing exercises, and exercises of the extremities.

Diet and patterns of life-style are, according to this ancient book, inextricably involved with the traditional treatment of illness found within these regions. This emphasis on an inherent connection between the individual and the natural environment around him is fundamental to the practice of oriental medicine and its philosophical principles.

The center of China, or "crossroads of the middle kingdom," is traditionally held as the birthplace of massage. This may also mean that the massage was considered the most natural or instinctual of restorative techniques, somewhat akin to the physical self-adjustments of animals, such as stretching or scratching. It could also be taken that massage was considered the most "centered" or "balanced" of oriental medical techniques. Several practitioners have stated that if we could live as "spontaneously" and "naturally" as wild animals, it would be unnecessary for us to take various therapies, for we would adjust and cure ourselves naturally of most illness.

[1] Moxa are combustible cones of *Artemisia vulgaris* ignited on the skin.

Some oriental treatments, especially in the case of massage, were utilized and refined in Korea and in Japan as well as in China. Certain of the medical arts migrated with Korean Buddhist priests who began to teach their religion in sixth-century Japan. By the seventh century, many Japanese physicians were studying medical practice in China. From their early contact with China, Japanese and Koreans adopted Chinese medical practices and altered or experimented with them to meet their own medical needs.

The Chinese as well as the related Korean and Japanese schools of medicine were concerned that their treatments follow what they believed were life rhythms in philosophy and practice (Veith, 1970:149).

> In former times man lived among birds,
> beasts, and reptiles; he worked, moved
> and stirred in order to avoid and to
> escape the cold and the darkness, and he
> sought a dwelling into which he could
> flee from the heat. Within him, there
> were no officials[2] who could guide out and
> correct physical appearance. Into this
> tranquil and peaceful era, evil influences
> could not penetrate deeply. Therefore,
> poison medicines were not needed for the
> treatment of internal diseases, and
> acupuncture was not needed for the cure
> of external diseases. Hence, it was
> sufficient to transmit the Essence and
> to invoke the gods; and this was the way
> to treat.

In order to describe the practice of massage, or of oriental medicine in general, one might initially make a distinction between philosophy and technique. At its ideological foundation is the holistic philosophy of dualistic monism, manifested in the cosmology of Yin and Yang. Lao-tse, the Taoist philosopher, wrote, "One produces two, two produces three, three is mani-

[2] These officials concern or represent the meridians and body organs of Chinese medicine.

fested in all possible beings" (Ohsawa, 1970:11). Commenting on this philosophy, Ohsawa (1970:11) states:

> "One" produces "two" . . . We understand
> by "two," the two activities Yin and
> Yang; this is the polarization of their
> universe. These two give rise to all
> living and inert beings . . . In this
> statement, one sees set forth the theory
> of polarized monism, and the theory of
> the evolution of the universe and all
> creation. The Yin and Yang theory is not
> ordinary dualism because there is no
> being, nor any phenomenon purely Yin or
> purely Yang; all are extremely varied
> manifestations of the possible combina-
> tions of the two activities.

This is the natural process of Tao, the order of the universe, the all-pervasive flow of existence. Therefore, in massage the practitioner attempts to create an energy circuit with his patient by developing a polarity of electromagnetic charge between himself and his patient. This polarity is never expressed as a purely intellectual concept, but as an actual physical relationship, and entails a passage of "vital energy," "life essence," "Ch'i," or "Ki," as it is called, between the practitioner and patient. The practitioner must always be stronger (in the sense of possessing stronger Ki) than his patient. Therefore, by definition, he must be in a superior state of health. According to the cosmology of Yin and Yang, these two qualities, complementary antagonistic, and existent in all phenomenon, are attracted to one another. Yang is attracted to Yin, and Yin attracts Yang. According to this cosmology, if the patient is more Yang than the practitioner, he, in essence, loses his own energy to the subject given treatment.[3]

The masseur is quite consciously aware of the necessity of developing and maintaining a strong Ki in the course of his treatments. Breathing in close harmony with the patient during

[3] This philosophical concept may be the underlying cause of the changes in "energy fields" of psychic healers and their patients photographed by the Kirlian technique before and after treatment.

treatment and attempting to concentrate Ki at the point of physical contact with the patient are the two most important methods of creating this polarity. Repetitious practice by the masseur is needed in order that these techniques become automatic and natural in their execution.

Practitioners have described their conscious mental state as devoid of conceptual thought. This allows them to concentrate and channel their Ki strongly and evenly during treatment. By acting in this state of awareness, the practitioner believes that his treatment may relate with natural process or life rhythms that will flow more evenly and strongly through him to his patients. Although such description may seem somewhat "mystical," it has been stressed that in order to treat a person thoroughly, one cannot waste one's energy on intellectual distractions. Treatment is essentially a calculated strategy. This strategy clears the mind of distractions so that a full effort can be placed on the necessary physical concentration at the point of physical contact with the patient. This enables the masseur to channel Ki.

The masseur generally attempts to make two sorts of adjustments in the treatment of the patient. The first is to balance and harmonize the Ki of the patient by massage techniques similar to those needle techniques used in acupuncture, namely tonification and sedation of particular points on the exterior of the body. These points lie along certain pathways of Ki known as "meridians." Secondly, the masseur attempts to "stimulate" or "charge" the Ki of the other person by channeling his own Ki into the patient. In orthodox practice this is usually done by utilizing the fingers, palms or thumb pressure; other techniques utilized depend upon the condition of the patient and his size or weight in relation to the practitioner. Although treatment using fingers alone for stimulation is often adequate, many practitioners incorporate other techniques (such as using the feet or back) as well, especially in treating a number of subjects in succession, as the constant utilization of one part of the body can be tiring and therefore a hindrance to the passage of Ki.

The masseur and his patient attempt to reduce their breathing to deeper, slower, and longer cycles. Breathing primarily from the abdomen rather than from the chest is thought to aid in this process and facilitate Ki flow.

Breathing is always from the lower part of the body, emanating and returning to the diaphragm and muscles of the intestinal and pelvic area. The reason for this is that a vital center of Ki lies at a point approximately three fingers below the navel. Accordingly, there are important postural positions for massage that aid one to channel Ki from this area to the arms or legs and point of contact with the patient. Movement always emanates from the practitioner's abdomen outward to the arms or the legs. If one utilizes one's arms or legs without centering movement in the abdomen, the technique is said to be not as effective, in other words physical strength, although it is sometimes helpful, is not the essence of massage practice.

According to the principle of dualistic monism, one often treats an area using a contralateral arm or leg rather than one on the same side. For example, the right foot or hand might be used to treat the left foot or hand.

Ki flows in a specific direction along the twelve major and various minor pathways or meridians through the body. The strength of this energy at particular points on the meridians varies in accordance with the time of the day, season of the year, phase of the moon, and other natural cycles. The meridians and the points along them are associated with ten major organs and two energy systems classified according to Yin or Yang respectively. All of these assume a variety of complementary and antagonistic relationship with each other at these particular points.

The natural cycles are of utmost importance, although this is less so in massage than in acupuncture. Massage usually treats the body as a unit, treating all the meridians rather than just specific points on a meridian to alleviate certain symptomatic conditions. A masseur will, of course, concentrate on certain points and on certain areas.

While massage typically centers upon the stimulation of the acupuncture points, a substantial chiropractic and orthopedic approach to bone and muscle manipulation has developed in the orient. This approach complements and further extends the treatment of the meridians. Spinal adjustments and muscle relaxation, as well as the application of herbal plasters and compresses, are often utilized as aids in massage practice. Herbal remedies are classified according to Yin and Yang as well.

Essentially, in oriental diagnosis, the sickness is diagnosed by the whole condition of the person. The Japanese word for sickness, "Byo-Ki," literally means "sick Ki." The fact that seems most important is that diagnoses *are* treatments; Muramoto (1971) notes that "finding a means of cure is diagnosis." All diagnosis is characterized in terms of Yin or Yang analysis, and includes many practices such as pulse diagnosis, touching the acupuncture points, and observing the patient's color, posture, physiognomy, and blemishes. Ohsawa (1970:48) states:

> Once the Yin or Yang cause has been
> determined, the manifestation and
> localization of the illness are of no
> great importance, since the symptoms
> can vary endlessly, according to the
> state, the age, and the constitution of
> the sick person, according to his
> environment and the season of the year.
> The physician must observe the patient
> in all aspects of his personality, that
> is to say, of his biochemical constitution,
> and then synthesize according to his
> judgment of all that he has seen. The
> observation of the condition is largely
> morphological, since the form and the
> shape are determined by the totality of
> the physical and chemical factors.

All these factors are considered as important manifestations and by-products of the person's vital energy or Ki. To cure a patient is to improve the quality and strength of his Ki. In essence then, the patient must strengthen his Ki himself, although the practitioner can help him greatly. Medicine may alleviate the symptoms of his condition, but the living situation of the patient is thought to rest at the fundamental basis of his problem. Inadequate Ki flow is the result of an unharmonious life-style or diet. If the symptoms are alleviated and if the fundamental condition underlying the illness does not change, the symptoms of the disorder will reappear in the same or other forms. The *Li Ki,* one of the five canons of ancient Chinese science and philosophy,

classifies the highest physician as one who practices "Kokysyu," or preventive medicine. It is stated in the *Nei Ching* (Veith, 1970: 57–58), "The superior physician helps before the early budding of the disease. The inferior physician begins to help when the disease has already developed; he helps when the destruction has already set in."

In ancient China, it was the custom to pay a physician when you were well and not to pay him when you were sick. Many practitioners advocate curing about 80 per cent of the patient's ailments; the other 20 per cent must be supplied by the patient himself. The patient must help himself in order to appreciate his cure. Oriental medicine seeks to create the conditions under which a patient may get well, but does not cure him directly. Fundamentally, this is done by restoring the balance of Ki flow, and stimulating areas of its stagnation. A superior practitioner can locate the acupuncture points solely by touch, and he attempts to develop his ability to perceive subtle differences in the "tonus" of these points, as well as abnormalities in the muscle and skeletal systems. Highly sensitive individuals actually claim to be able to see the Ki flow along the meridians. They also claim to see the color or quality of the vibratory emissions of the body along the meridians and at other points such as those corresponding to the "chakras" or energy centers of Yoga.

Various forms of exercise, such as "Dō-In" (de Langre, 1971), as well as Yoga, the martial arts, and various breathing exercises are often proscribed by practitioners of massage to promote strength and quality of Ki flow. Dietary prescription both of certain foods and herbs seems fundamental to many forms of treatment. Usually this is a diet which stresses certain grains, fruits, vegetables, and selected animal foods.

In China, medicines were held to be most effective in terms of specific seasons and geographical locales. These medicines included "the five grains," considered the "center" of nourishment, as well as "the five free fruits," "the five domestic animals," and "the five vegetables." All of these food varieties were considered medicines related to particular organs, conditions, and therefore to the passage of Ki.

Massage and other forms of oriental medicine, then, seek to treat the whole person in terms of the symptoms, diet, and manner

in which he is living. To influence the physical, mental, or spiritual condition of the person by massage, or by any other therapeutic measure, is to influence the vibratory quality of his Ki. Thus, practitioners must be sensitive to the nature of the individual's Ki or vital energy. This is the essence of oriental medicine.

Questions from the Audience

First Western Hemisphere Conference on Kirlian Photography, Acupuncture, and the Human Aura, May 25, 1972

Q Are there photographic devices by which one can see an image without a camera?

MR. TOTH Energy in the form of light is not dependent on a camera. The television tube, for example, with an electrode behind and in front, pulls the pattern to one side without a camera lens. In Kirlian photography, the field effect is in one direction from one plate to the next. If the object is not in line, one gets an exposed negative with the picture —if it is placed in the beam of radiation before it hits. Even though it uses alternating current, the radiation flows in one direction, from negative to positive. Since the flow is in one direction only, you have a film negative between the two plates. The object must interrupt the beam. If not, the beam passes through the paper and you get exposed film before the image. Three things control the flow of electrons in the tube: the cathode, the anode, and the grid. The flow of electrons in a radio tube are from the cathode to the anode. The same process is involved in Kirlian photography.

Q How do you explain the difference between the top and bottom electrodes if you are using alternating current?

TOTH There is always the difference between the lines. One plug is dead or negative while the other plug is the hot or the positive line.

Q Are you speaking of a grounding system?

TOTH Yes. Even though you may be using alternating current, it is oscillating in one direction.

Q If you use alternating current, is everything negative half the time?

TOTH There are both positive and negative forces at work in alternating current.

DR. TILLER These things are not inconsistent if one recalls that both a unipolar and a bipolar system can be created.

Q If the film used is inside a cardboard sleeve, couldn't the electronic emission be gamma radiation and create light inside the object?

TOTH The Kirlian process is basically X-ray photography done at a different frequency. It passes a form of radiation through the object. The amount of density in the object permits the radiation to pass through. Kirlian photography uses the same process but works at a higher frequency. Eventually, we could obtain a three-dimensional image of the object. The entire process appears to follow the laws of optics.

TILLER It is my understanding that most of the Soviet work has involved photographs taken inside of envelopes.

Q Have any Kirlian photographs been taken in which two persons were together?

DR. MOSS When I was in the Soviet Union, I found that the Soviet investigators had done this by having two individuals place their fingers together. However, the exclusion principle operates whereby the coronas repel each other, producing a barrier between them.

Q Why does light appear over the surface of the object as well as spreading out past the object?

MOSS Electric properties of objects typically show light, both internally and externally.

Q If the photographs are picturing a field effect, why doesn't the electrical illumination go all the way around the object?

TILLER The center doesn't have the appropriate spacing in the photographic process. The spacing must be available for the particles which leave the object to show up on the photographs.

DR. KRIPPNER Mr. Ross, in his laboratory in Rhode Island, is working on a Kirlian device which will photograph the objects in three dimensions. This may solve the problem to which you refer.

Q Is the work of Wilhelm Reich being re-evaluated in the Soviet Union due to the findings of Kirlian photography?

MOSS Reich's work is basically unknown in the Soviet Union.

KRIPPNER Personally, I feel that there is an important connection between the findings of Kirlian photography and the orgone theories of Wilhelm Reich (e.g., 1949) and the bioenergetic therapists. When I was in the Soviet Union, I told the scientists about bioenergetic therapy and found them to be extremely interested in Reich's concepts.

TILLER In my opinion, there is something tenable in Reich's work on orgone energy which is related to Kirlian photography.

Q We have heard several different points of view regarding Kirlian photography. There appears to be a critical difference between Dr. Tiller's notion that the Soviet work may reveal new energy systems and Mr. Toth's conceptualization of Kirlian photography as a variant of X-ray procedures, except on a different spectrum.

TILLER We approach our work differently at present. Only time will substantiate one model or another. The important thing is not to become polarized at this early stage of our investigations.

Q Is it possible to take motion pictures of Kirlian effects?

TILLER Yes. The Soviet investigators are already doing so and have told us how to proceed.

Q Why are fingers used in most Kirlian photography of the human body?

MOSS They are the easiest to use. However, we have also photographed other parts of the body.

Q Have physicians in the People's Republic of China been able to replicate Kim Bong Han's work with acupuncture points and meridians?

TILLER I am unaware that they have made an attempt in China. However, it is my understanding that a physician at Osaka University in Japan has replicated Kim Bong Han's work. I am attempting to obtain a copy of the Japanese report.

Q If there is a meridian ductal system in the body, why has it not been observed by Western physiologists?

TILLER If you are not looking for something, and if it is extremely small in size, your chances of finding it are very

poor. The work done in the People's Republic of Korea should be replicated in the West. Interpretations of this system might vary, but it is critically important that the investigations take place.

Q What would happen if the meridians were severed?

TILLER According to the North Korean report, if the circuitry is snipped, the surrounding tissue will die.

Q Has Kirlian photography been used to photograph viruses or tissue cells in fine detail?

TILLER When I was in the Soviet Union, I heard of this type of work being done. We hope to build a device in California which will enable us to pursue this line of research.

Q Are you familiar with the work of an Italian physicist who claims to have captured an image of Jesus from light and sound sources?

TILLER No.

Q Could the forces which Kirlian photography deals with be within the electromagnetic field as we currently understand it?

TILLER Of course, this is possible. However, if the "lost leaf" effect proves to be genuine, it would be difficult to explain the phenomenon within a conventional frame of reference.

Q Is there any relationship between psychic surgery, acupuncture, and Kirlian photography?

KRIPPNER With the exception of the films I have seen of the late Brazilian healer, José Arrigo, I have found the filmed records of psychic surgeons singularly unconvincing. However, this would certainly be an important area for future research.

Q In major surgery under acupuncture, is it possible that the Western medical model requires the submission of the patient while, under Chinese medicine, the total life energies of the patient are concentrated upon the process?

TILLER This is possible. Under acupuncture, the patient is awake and could consciously assist in the healing process.

Q Usually an aura is visible, to psychics, at up to four feet from the human body. How far is it visible in Kirlian photography?

MOSS It can be made very large or very small, depending on the frequency used in the device.

Q How can one develop the ability to see the human aura?

DR. WORSLEY People generally go about without really seeing things. Thus, they must learn to develop their senses of sight and touch through training and practice. This ability must be worked for and cannot be achieved overnight.

KRIPPNER Auras appear in several paintings by Vincent Van Gogh. A physiological explanation for this phenomenon has been suggested by Stoll (1972). The halos which often appear around the sun have been attributed to ice crystals (Greenler and Mallmann, 1972). Therefore, a number of underlying factors are involved in the so-called ability to see auras (Garbuny, 1965; Lowen, 1967). Some psychics have identified several layers of auras (e.g., Karagulla, 1967:158–170). Jack Schwartz (1972), for example, claims to be able to see seven auras (e.g., physical, oval, emotional, mental, para-conscious, Karmic, and cosmic) which he uses diagnostically.

Q What is the best book about acupuncture?

WORSLEY The classic text is the *Nei Ching,* recently translated into English by Ilza Veith (1970).

Q What kind of information can we obtain from Kirlian photographs?

WORSLEY From the color photographs, we can see the state of health of both the leaf and of the tree from which it came. In people, these photographs can help us determine the state of harmony or disharmony. It is possible that Kirlian photography may eventually assist us in foretelling an individual's disease before there are manifest symptoms.

Q Isn't there an overemphasis placed on the ability to see auras?

WORSLEY To some extent. It isn't really necessary to see auras. The aura is one of many aids to diagnosis. It is helpful, however, because as the human aura changes, the treatment can be evaluated and changed.

Q Could Kirlian photography be used as an aid for selecting candidates for political office?

WORSLEY It would be premature to give an opinion of this possibility. However, no one should run for political office without being sound of mind and body. It is the sickness of the person that makes unwise decisions, not the person himself.

Q Can a person develop his potentialities through acupuncture treatment?

WORSLEY Yes. However, any valid system of healing will assist a person to attain his potential.

Q Is the energy flow through the meridians stable in a healthy person?

WORSLEY The energy flow varies throughout the course of the day. In addition, there are changes in the energy flow through the meridians associated with the seasons of the year.

Q Have you seen the "lost leaf" effect in people?

WORSLEY Yes. We can see the shape of a "lost limb" following amputations. The more pronounced the "phantom pains" are in an amputee, the more visible is the amputated portion of the body.

Q Is there a correspondence between the human aura and the electromagnetic fields which surround living objects?

WORSLEY We do not know how great the correspondence is. We do know, however, that all energy which radiates from the body must be in harmony if the person is to remain healthy.

Q Is there a correlation between the human aura and the data from electromagnetic field monitoring done by Burr and Ravitz?

KRIPPNER There is no way to give a simple answer to the question at this time. H. S. Burr (e.g., 1956) and L. J. Ravitz (e.g., 1970) have found that electromagnetic fields influence the growth and repair of living protoplasm. Furthermore, these fields can be measured electrometrically. Laszlo (1972a:94) reminds us of the enormous complexity of even the simplest form of living organism; the developments in electromagnetic field monitoring attest to this complexity.

Q Is it true that the practice of acupuncture with needles is illegal in the United States except on the part of physicians?

WORSLEY My understanding is that at the present time no one in the United States is permitted to administer needles except licensed physicians or registered nurses. However, it is likely that someone qualified in Chinese medicine may be permitted to work with a registered physician.

Q Can acupuncture cure cancer or malignant brain tumors?

WORSLEY It is criminally liable to claim cures of any sort. Acupuncture does not cure named diseases. We feel that symptoms are distress signals from the body. During an examination, we seek the causative factor of what is wrong with the body and mind. We work on the alleviation of symptoms through a direct approach to the cause of the problem.

Q If someone is color blind, can he see the colors in the human aura?

WORSLEY Perhaps he could learn to feel the colors. These colors can be felt as well as seen.

Q One book on acupuncture describes nine pulses. What is learned from them?

WORSLEY There are actually twelve pulses. These are used to ascertain the functions of each organ. Each pulse has twenty-seven qualities of its own. This is the most integral part of Chinese medicine. By reading the pulse information, one can determine exactly what is wrong with a patient. One can also determine whether the condition of the patient has improved after treatment by reading the pulses.

Q Is it true the meridians involve the forces upon the body by the entire cosmos?

WORSLEY Chinese medicine cannot be fully practiced, for example, without knowledge concerning the sun, the moon, and the positions of the planets. All these features must be taken into consideration while treating a patient.

Q When did you become interested in acupuncture?

MS. CALVET In 1955, I was living in California and found that many poor people were unable to obtain proper medical treatment. In order to assist them, I took a course in sonopuncture, a process which directs high-frequency sound into the acupuncture points. This course was given in Paris and requires equipment which is fairly simple. The sounds are drawn into the acupuncture point, through the meridians, and to the organs involved. My work with sick people in California was highly successful and stimulated my interest in other applications of acupuncture and associated processes.

Q Is the process illegal?

CALVET No. Sonopuncture does not involve needles and there is no penetration of the body. The volume is not loud enough to cause any tissue damage. Sonopuncture is no panacea, but neither does its possible misapplication cause any ill effects.

Q What type of work does the Arica Institute do?

CALVET The Arica Institute is involved in a number of intensive training programs to assist individuals attain their potential as human beings. My involvement with the Arica Institute convinced me of the necessity to join the forces of science and psychic phenomena. The Arica Institute adds trialectic logic to dialectic logic. Trialectic logic, emphasizing how entire systems work together, applies to acupuncture which assists parts of the body to work in balance for the health of the entire organism.

KRIPPNER A description of the Arica training program can be found in the book by John C. Lilly (1972), *The Center of the Cyclone.*

Q How would you explain acupuncture?

DR. FOX Rather than postulating mysterious ducts which have not been demonstrated outside the Democratic People's Republic of Korea, I consider both general medical acupuncture and the more recent acupuncture analgesia to be adequately explained by established, observed, and repeatable neurophysiological pathways. Dr. Felix Mann of London, England, in his recent book (Mann, 1972), devotes a chapter to explaining medical acupuncture. Cutaneo-visceral, viscerocutaneous, and viscero-motor reflex pathways are involved. There is no need to call upon the esoteric or mystical. Many of the observations Dr. Mann cites relate to animals as well as man both in sickness and in health.

For acupuncture analgesia, currently the most widely held theory both in China and the West involves the "gate control" mechanism of pain. Again I am reminded of Occam's razor; put another way: simple explanations of observed facts take precedence over more complex ones.

Q Have you ever used acupuncture?

FOX Yes. On May 15, 1972, I used acupuncture at my institution, Downstate Medical Center of the State University of New York, Brooklyn. I provided acupuncture analgesia for an excision biopsy of benign growth of the tonsil. The patient, who has given his permission to be identified, was Mr. Frederic Newman and the surgeon was Dr. Abraham Lapidot. This case has been submitted to a medical journal and was also covered in the media. The important thing is that "you don't have to be Chinese" to benefit from acupuncture. It works for all mankind. I just received a letter from Dr. Johannes Bischko of Vienna who performed a tonsillectomy under acupuncture analgesia on March 8, 1972. In his latest communication he informed me that he has produced acupuncture analgesia in a cow at the University of Vienna Veterinary School. This was tested by piercing the udder with a needle. Dr. Bischko assures me, and I believe him, that a cow's udder is very sensitive.

KRIPPNER Actually, Dr. Fox was the first physician to use acupuncture in an American hospital. The "gate control" mechanism he speaks of rests on the concept that nerves carrying sensations and pain signals to the brain must pass through a "gate" in the spinal cord. One variation of the theory erects two of these figurative gates—the other is the thalamus, the part of the brain that relays sensory impulses to other areas of the brain. By means not fully understood, this gate can be opened or shut, allowing pain signals to proceed or halting them so no pain is experienced. It is hypothesized that acupuncture anesthesia works by closing the gate. It may be that the needles produce signals that travel to the brain along the same pathways as the pain signals. However, the needles produce such a barrage of impulses that they jam the system and the gate blocks the pain signals (Fox, 1972; White, 1972).

Q What is your reaction to Kirlian photographs?

FOX I certainly commend the investigators for their work. The duplication and apparent improvements of the original research shows there is something of significance there. Exactly what, however, remains to be seen. Whether the patterns we

see represent the human aura, or "bioplasma" as our Soviet colleagues call it, still remains an open question for me.

Q All of this information is very new to me and very hard to fit into my understanding of Western medicine.

KRIPPNER Aldous Huxley (1972) made a statement which may be helpful to you. He pointed out "that a needle stuck into one's foot should improve the functioning of one's liver is obviously incredible . . . Within our system of explanation there is no reason why the needle-prick should be followed by an improvement of liver function. Therefore, we say, it can't happen. The only trouble with this argument is that, as a matter of empirical fact, it does happen." Huxley (1972) asks, "What should we do about events which, by all the rules, ought not to occur, but which nevertheless occur? Two courses are open to us. We can either shut our eyes to the queer embarrassing data in the hope that, if we don't look at them, alternatively we can . . . accept them for the time being as inexplicable anomalies, while doing our best to modify current theory . . ." It is my hope that we will keep our eyes open regarding the data presented here today, at the same time rethinking our current theories concerning medicine to see to what extent they need to be revised in light of these provocative findings.

Q Practitioners of Eastern and Western medicine disagree in several critical ways. Are there similar differences between Eastern and Western spiritual teachers?

TILLER Although there may be some superficial differences, I have found that all the great teachers of history say essentially the same thing.

The Art of the Aura

Ingo Swann

Mr. Swann has been working in New York since 1958. His work has been exhibited in several places, including the American Society for Psychical Research, New York, 1962, and the New York World's Fair in 1964. The most representative of his symbolic works, "Death of a Man," is in the collection of the Erickson Educational Foundation, Baton Rouge, Louisiana. Several of his paintings demonstrate Kirlian-type effects. Mr. Swann demonstrated possible psychic gifts as a child and, in 1971, began to participate in parapsychological research programs with Dr. Karlis Osis of the American Society of Psychical Research, Dr. Gertrude Schmeidler of the City College, City University of New York, and Dr. Stanley Krippner of the Foundation for Para-Sensory Investigation. On May 26, 1972, a research team headed by Dr. Krippner and Kendall Johnson (and including Jon Cohen, Robert McGarey, Rodney Ross, Daniel Rubin, and Steve Zeichner) made several photographs of Mr. Swann's index finger, utilizing a low-frequency photography device developed by Kendall Johnson. Three pictures were taken of Mr. Swann's finger during his ordinary waking state. Mr. Swann voluntarily entered an altered state of consciousness in which he attempted to have an "out-of-the-body" experience": three photographs were taken of the same finger. Finally, three photographs were taken of the index finger while Mr. Swann attempted to imagine heat coming from the fingertip. The results (shown in *Figure 71*) show a comparatively denser effect during the second condition and a marked flare effect during the third condition. All other parameters of the experiment were kept constant while the nine exposures were made.

I attended the First Western Hemisphere Conference on Kirlian Photography, Acupuncture, and the Human Aura on Thursday. It was a great event.

For me, the most amazing development was that for the first time I had the opportunity to view the results of high-frequency and low-frequency photographic results concerning the human

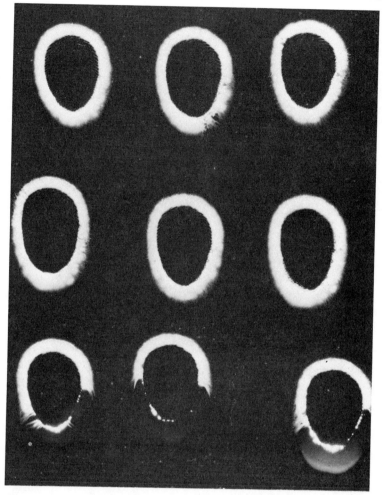

Figure 71. Electrophotographs, index finger pads of Ingo Swann under various conditions (courtesy, S. Krippner and K. Johnson)

aura. In so doing, I was stunned to discover that a great deal of my work between 1962 and 1966 exactly duplicated the results of the electromagnetic fields around the body, as revealed by the recent photographic work using the Kirlian device.

During these years, I had made the decision to depart from the currently acceptable—and unimaginative—art of the day. In so

Figure 72. "Kismet I" (courtesy, I. Swann)

doing, I began to employ auras around bodies, plants, and rocks. In thinking of my body of art as a lifetime endeavor, I saw no real reason not to paint what I could see and what seemed to me to be both a religious and metaphysical phenomenon.

Thus, as I began to paint the auras around figures, I tried to duplicate what I knew, thought, and often could see. Rather than using the traditional auras, which follow more exactly the contours of the body, I painted fields in various colors which included bubbles, dots, and flares of energy. The result was almost exactly the same as portrayed in the Kirlian photography results.

These fields can be first observed in my 1962 painting, "Kismet

Figure 73. "Kismet II" (courtesy, I. Swann)

I" (*Figure 72*). In "Kismet II" (*Figure 73*), the aura patterns are carried to a more extensive conclusion. In "Adagio to the Moon" (*Figure 74*), the effect began to become refined, and the flares and dots of energy were clearly visible. The auric effect became completely organized in "Command of Power" (*Figure 75*); around the body of a man, the characteristic Kirlian-type flares are clearly visible, as well as a larger field surrounding the upper portion of the body. In this instance the Kirlian effect is also seen around the snakes (which represent positive and negative electromagnetic forces), and even around the beetles (which represent infinity).

As my larger work began to emerge, the Kirlian effect was

Figure 74. "Adagio to the Moon" (courtesy, I. Swann)

Figure 75. "Command of Power" (courtesy, I. Swann)

Figure 76. "The Golden Rain" (courtesy, I. Swann)

Figure 77. "The Male Gods" (courtesy, I. Swann)

poetized in such paintings as "The Golden Rain" (*Figure 76*). In 1965, I completed "The Male Gods" (*Figure 77*), in which the auras were represented exactly as seen. In this work, at least seven different forms of the auric potential are illustrated; it can be seen around the gods, the bees, the butterflies, the boar's head, etc. As a style, this type of painting came to a conclusion with the execution of an Edgar Cayce Aura Chart.

There was a study break in my work between 1967 and 1970. However, when I began to paint again, the auric effect had changed so as to represent energy particles in outer space. This is

Figure 78. Ingo Swann and "Aft Ship's View of Sagittarius" (courtesy, I. Swann)

seen in the large (6 by 10½ feet) painting "Aft Ship's View of Sagittarius" (*Figure 78*). This type of representation is validated by recent photographs of the energy potential in empty space, as reported by British investigators. It was discussed at the conference by Dr. William A. Tiller in his paper "Some Energy Field Observations of Man and Nature."

Bioplasma and Kirlian Photography

Zdeněk Rejdák

Ancient scientists thought that the universe was composed of four basic elements: earth, water, fire, and air. Earth in contemporary terminology corresponds to solid matter, water to liquid, air to the gaseous state, and fire to plasma.

Plasma can be radiated from life matter, e.g., plants, animals, and human beings. Some scientists postulate this form of plasma to be the so-called "bioplasma." In other words, there are free electrons and protons in a definite structure associated with living entities. Bioplasma material can be compared to a symphony in which the oscillation of the different energies beginning with sound waves and ending with light waves are represented.

The form and the intensity of the bioplasmic radiation from living organisms depends on the organism's state of health, fatigue, excitement, balance, etc. The intensity of the radiation of a frightened rabbit expands to three times its normal size; with an excited man, the intensity of the radiation is much greater than in his ordinary state.

For testing purposes, a specially designed apparatus developed by the Kirlians is used. To elicit bioplasmic radiation in the realm of the visible as well as ultraviolet light, one has to create a high-frequency field in order that the impressions of the bioplasma should be fixed on a photographic plate.

In 1889 a Czech physicist, Professor B. Navratil, had done work in what he termed electrophotography. In 1896 the French investigator H. Baravuc published photographs by electrophotography of the hands and leaves. At the same time, the Russian professor Narkevich-Todko published material about electrophotography. Narkevich-Todko, for example, constructed a Ruhmkoff-induction pole and used it as a lightning rod. A second pole was connected to a metal plate on which was placed sensitive film. This

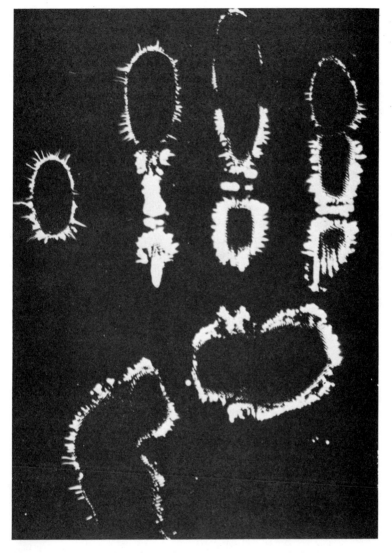

Figure 79. Electrophotograph, hand (courtesy, Z. Rejdák)

served as an electrophotographic device with which he conducted more than three thousand experiments.

In the 1930s, Dr. Silvester Prat and Dr. Jan Schlemmer (1939)

experimented with electrophotography. However, the most intensive work has been done by S. D. and V. Kh. Kirlian.

The Kirlians have concluded that electrophotography enables them to predict the illnesses of plants, animals, and human beings before the symptoms occur. With the help of the electric impressions, one is able to identify the organism's state of the nerves and the fatigue or exhaustion of biological systems. Because the radiation of the fingertips is especially sensitive, very complex functions and vital processes of the organism can be studied by the application of this method (*Figure 79*).

With the help of special microscopic devices, it is also possible to observe high-frequency discharges on the skin. Through the microscope, there arises on the skin various discharge patterns (e.g., light points and crosses). These light formations are of different colors; however, blue, lilac, and yellow are most frequently seen.

The Kirlians have opened the door to a deeper understanding of life processes. Their research investigates highly complicated biological systems using scientific measurement procedures and ingenious devices.

Kirlian Photography, Acupuncture, and the Human Aura: Summary Remarks

Brendan O'Regan

> For centuries, knowledge has meant *proven* knowledge—proven either by the power of the intellect or by the evidence of the senses. The terms of proof were questioned by skeptics two thousand years ago, but these efforts were beaten into confusion by the glory of Newtonian physics. Einstein's work again turned the tables, and now very few philosophers or scientists still think that scientific knowledge is, or can be, proven knowledge. Few people realize that with this development, the whole classical structure of intellectual values falls in ruins and has to be replaced.
>
> Imre Lakatos (1968)

That the classical structure of intellectual values is in ruins does indeed appear to be a fact that few scientists are either aware of or willing to acknowledge. Both situations seem to stem from the high degree of specialization which characterizes the training of the average scientist, particularly in the Western world. On one level, it is not surprising that the majority should be unaware of the deeper significance of this argument. After all, has not the Western scientific world-view proven itself many times? Its enormous richness and power as a mental model of reality has in the past half century been the source of a seemingly unending stream of technologically harnessed advantages for all mankind. It has certainly been the case that the Western scientific mode of stating problems has proved to be predictive of aspects of reality previously hidden from our consideration; productive of a greatly in-

creased understanding of the processes of nature and the universe in which we live; and, in turn, procreative in the best sense of synthesis and genesis of an even greater variety of modes by which to determine finer methods of experiment and design.

Thus it is perhaps all the more disturbing for many people to discover that this set of paradigms, which has for so long seemed all-inclusive, should begin to show signs of incompleteness. And yet what we are really discovering is the way in which these paradigms have defined the possible content of Western science by virtue of their emphasis on both a certain relationship between observer and observed, as well as the concomitant insistence upon a reductionist or atomistic framework for the recognition of "truth." Just why the Western world has been particularly oriented toward the Galilean-Cartesian paradigm, which divides perceived experience into the physically real and the subjectively unreal, is an even deeper question, beyond our present scope. It does seem to be the case, however, that the classical strength of the reductionist criteria for truth are on the wane as we encounter more and more anomalous data concerning aspects of reality which, according to traditional modes of explanation, "shouldn't happen"— but do so anyway.

Developments in Kirlian photography and acupuncture involve yet another aspect of this (at least) partial disintegration of the Western world-view. In this book the established criteria of knowledge and certainty, in the Western sense, have been suspended even further to allow a group of Western scientists to consider as knowledge or data, information which only a few years ago was considered the stuff of quaint customs in "primitive" foreign lands.

Many aspects of reality which we comfortably thought were at best mythical (and therefore unreal) or indicative of picturesque notions to be found in that "bad" philosophy of the East, as some English writers have described it, are emerging as vital to a complete understanding of the whole human organism. It is even more unsettling to discover that many of these holistic concepts have often been denigrated in the West to the point where their antithesis has been incorporated as a cherished value—thereby making an evolution of our knowledge in certain directions all the more difficult. There is, for example, the tendency to think that the way to understand a system is to examine it in terms of its

parts. In doing this, the crucial role played by the relation between them in the whole organism is ignored. Given our present understanding of the crucial role of belief-structures for the very existence of certain phenomena (psychosomatic aspects of disease, for example) Western value-judgments may have been responsible for the disappearance of certain valuable perceptions from the realm of daily experience. This gives us cause for genuine concern. The disappearance of a certain aspect of reality occurs with the disintegration of the form of pattern recognition that initially allowed its observation and reinforced its occurrence.

For example, the art of Chinese healing, of which acupuncture is but a part, involves perceptions that require a world-view which the West dismisses and in so doing has made access to these perceptions all but impossible. This has occurred even to the point of not allowing the question of their very reality to be a respectable one. It is true that the erosion of a world-view often has shattering effects and it is natural for those with high emotional or intellectual investment in the images of their time to wish to retain the security they offer. However, when that investment becomes a barrier to further knowledge, it is clearly time for a change. On the other hand, it is important to understand just why certain points of view seem so preposterous to Western scientists.

As Szent-Györgi (1960) has put it, "the biologist depends on the judgment of the physicist." Nine years later, Waddington said we are still trying "to bring into being a not yet existent discipline of Theoretical Biology." A good model for the future of biology may be what happened to physics not so very long ago. The evolution of modern physics may be described as a transition from the dominance of particle theory to the broader realms of field theory. Even some of those responsible for this magnificent evolution were either unaware of, or else quite resistant to, some of the implications of their own work. Max Planck put forward his "quantization" hypothesis as a regrettable but necessary refinement to Maxwell's theories. Einstein's initial work in 1905 filled Planck with indignation and it was almost ten years before he finally concurred. One might say that Planck had a very strong attachment to the idea of the continuous electromagnetic field and that this attachment was much more than intellectual.

Similarly, we find in modern biology a strong attachment to a

reductionist thesis which is really a variant of the theme of particle theory in physics, i.e., the molecular/cellular basis of biological theory. The concepts involved, from the atomistic DNA level all the way to the biological "particle" or cell, have indeed served very well for some purposes, but in turn they have prohibited many other considerations.

As Presman (1970) has pointed out, there is still a skeptical (and usually negative) attitude to any results of experiments on entire organisms and even on isolated organs. Thus most, if not all, investigations tend to proceed from an investigation of the parts of the system in the hope of thereby describing the whole, even though the organization of the whole system is in no way distinguishable from such investigations. Briefly, there is a whole range of important properties of the biological organism which stem from the fact that biological organisms are in part synergetic. Investigations of them which omit this fact are denied access to an understanding of those essential properties. Hence, the very mode of investigation current in our science coupled with the strong reductionist particle orientation in biological thinking both lead to a situation where the field-oriented ideas and perceptions of the East are basically unintelligible in the West. However, the emergence of a "field" biology has indeed begun, albeit slowly, and its development will be greatly accelerated by research into the more immediately verifiable aspects of Eastern medicine, such as acupuncture.

Practically concurrent with all of this is the change in our response to the assertions of Yogis from India, who have told us for centuries that forms of control over various bodily functions were possible. These controls seemed plainly ridiculous when viewed against the backdrop of Western medical science. In Western terms, there was simply an autonomic and a sympathetic nervous system and, it was supposed, never the twain would meet. Instead, a convergence of East and West *has* occurred and with the advent of biofeedback technology in the West only a few years ago, the whole situation has changed radically (Barber, 1971). Some of the esoteric practices of the Indian Yogis indeed have been found to be possible and we are left to wonder if, since we have definitely been wrong in our judgment of the information pertaining to these practices, perhaps we may also be wrong in

our judgment of much of the other information that has come to us from the East. The change wrought by biofeedback has, of course, more to do with the structure of causality, as perceived in the West, than it has to do with the arrival of any great new insight into the Western world-view.

The route to the achievements described by the Indian thinkers was precisely described by them, the only problem being that for the processes involved to achieve effect, periods ranging from several years to a whole lifetime were required. Such protracted forms of learning have never appealed to the Western mind, perhaps because our sense of time is such that we require more immediate feedback from our actions. What biofeedback has really done, then, is to bring the evidence of effect more immediately into the time-frame of the Western mind by greatly accelerating the learning process. Hence, the "impossible" suddenly became "possible."

In a similar fashion, the advent of Kirlian photography may provide the technological assist which the West seems to need to accept information regarding acupuncture as real. It has been noted by several workers, initially in the U.S.S.R. and now in the United States, that the images produced by the Kirlian process are especially intense over acupuncture points and, further, there are now several devices available which permit the locations of acupuncture points to be determined "objectively." Presumably, we in the West believe our senses only insofar as their impressions are verified by the machines we create!

Most attempts to describe what is actually being measured by Kirlian photography have had to confine themselves to the level of effect, since we seem to have no clear conceptual basis yet for discerning their cause. It is naturally encouraging to be told that what is becoming visible to us technologically by Kirlian photography corresponds well with what is observed directly by those who practice the Chinese form of medicine. There is, at very least, an internal consistency here. As further experiments are done on the mechanisms of interaction between the high-frequency radiation involved in the Kirlian process and the biological system, we will undoubtedly gain the ability to conceptualize into the usual Western scientific formulations the types of effects currently being recorded and connect them with the various states of the body in-

volved. When this is done it will be important to remember that we once rejected the perceptions which allowed us to move along the path toward these discoveries in the first place.

Even at this stage it is possible to state that the real description of what is being observed when Kirlian photography is applied to the living system, will *not* come from attempts to create order in the data by looking only at what such electrical phenomena do to *parts* of the system, such as isolated tissue and membranes. Presman (1964) has pointed out that the general interactions of biological organisms with electromagnetic fields manifest themselves *least* at these levels. (Such observations require that the organism be intact and *in vivo*.) We must be careful, then, to distinguish between explanations which refer to how the color changes we are now seeing can be created artificially in a nonliving system and what those same changes mean when they occur in a living system.

This is not an attempt to argue for a new "vitalism," but an attempt to stress the importance of applying the Kirlian process to the study of those properties of the living system which stem specifically from the interactive or synergetic processes of that system. Therefore, just as there appears to be no logical explanation, in terms of its parts, for the way in which stimulation of an acupuncture point in one part of the body can affect a vital organ in another part of the body, one not linearly connected to it by way of classical nervous connections—this does not mean that interaction is impossible, as current evidence clearly shows it is not. Rather we must be prepared to encounter perhaps a whole new hierarchy of interconnection, stemming from interactive principles of biological organization. One of the most interesting suggestions here is the notion from some of the Russian workers that perhaps the acupuncture points may be connected by the paths of least electrical resistance between the membranes that define the structure of all living tissue.

On another level, what is perhaps most important is that the Kirlian process seems to make possible a direct physical measurement of holistic types of change in the body, such as emotional states and general changes in body energy which may precede the occurrence of disease. It is true that we have been able to discuss some of these changes in terms of specific concentrations of

psychoactive substances in particular locations. Again we must point out, however, that to define explanations as being possible only in accordance with such terms is to miss a whole range of specifically *systemic* changes that may have their origins in no one part of the body. With the ability to perform measurements of systemic change, such as the Kirlian technique apparently allows, our ability to observe these phenomena has undergone a quantum leap to a much higher level of integration. It is tempting to observe that a Kirlian image taken of a part of the organism may contain evidence of change occurring *systemically* in the organism as a whole. This holographic viewpoint is opposed to the more usual type of measurement of a change in blood pressure, measured in the region of the arm, indicating change in the operation of the heart. Presently available information and information yet to come from this kind of medicine will provide us with an important pathway toward a full understanding of the enormously complex entity called the human body and its relation to the cosmic environment.

Biology, as J. D. Bernal (1965) has pointed out, is now primarily a descriptive science which resembles geography; it must eventually evolve toward something higher. The pioneer work of Harold Burr (1957) in the United States and, more recently, that of A. S. Presman (1970) in the Soviet Union, has already done much to point the way. The consistency of history argues for the complexity of the task but perhaps we should remember Whitehead's remark (1960): "I give not a whit for simplicity on this side of complexity; but for simplicity on the other side of complexity, I would give all."

Epilogue to the Second Edition

Since we wrote the introduction to this volume's first edition in 1972 (published as *Galaxies of Life*), there have been several important developments in the field. Many of them were discussed at the Second Western Hemisphere Conference on Kirlian Photography, Acupuncture, and the Human Aura, held in New York City's Town Hall on February 13, 1973. At this meeting, evidence was presented by Richard Miller (a physicist at the University of Washington) that the human "aura" may be, in part, gaseous emission from the body. Taking another research approach, John Pierrokas (a New York psychiatrist associated with the Institute of Bioenergetic Analysis) noted that the human organism emits light, even in a darkened room.

Acupuncture in the U.S.S.R.

As for acupuncture, several parallel developments can be cited. In the Soviet Union, acupuncture research and practice have continued to grow. In the July 1972 issue of *Zdorovye,* a popular Soviet health magazine, Dr. B. V. Petrovsky, Minister of Public Health, revealed that he had supervised the opening of special acupuncture facilities in large medical clinics of all major cities and industrial centers in the U.S.S.R. In the same issue, Dr. V. G. Vogralik produced data on acupuncture treatment from the Gorky Medical Institute. He noted that over the last fifteen years, a total of 1,146 patients at the Institute's clinic had received acupuncture treatment for such ailments as bronchial asthma, stomach ulcers, spastic constipation, and high blood pressure. Of that number, a cure was reported for 726 patients (about two out of three) while the condition of an additional 221 was considered to be greatly improved. Dr. Vogralik further noted that acupuncture facilities existed in thirty-seven Soviet cities even before the 1972 expansion program instigated by Dr. Petrovsky.

Many of the events in the Soviet Union were discussed in Moscow during July 1973, when sixty representatives from ten

different countries attended the International Meeting on the Problem of Bioenergetics and Related Areas. Stanley Krippner was one of the program chairmen for this meeting; in attendance were two contributors to *The Kirlian Aura*—Viktor Adamenko of the U.S.S.R. and Brendan O'Regan of Eire.

Acupuncture in the U.S.A.

In the meantime an acupuncture clinic opened in New York City, only to be shut down by the New York State Department of Education. Most of the clinic staff moved to Washington, D.C., where the laws are not as restrictive. In California the State Medical Association has encouraged the study of acupuncture and the state legislature has produced a law allowing acupuncturists to work under the supervision of licensed physicians for the purpose of research. An expansion of this provision was passed by the legislature in 1972 but was vetoed by the governor.

In many parts of the United States physicians have demonstrated an eagerness to learn about Chinese medicine; for example, several symposia in California have attracted large crowds. Similar workshops, featuring Guidy Fisch of Switzerland and Nguyen Van Nghi of South Vietnam, have been held for physicians in Florida and Louisiana; both climaxed with a demonstration of acupuncture anesthesia during surgery. In April 1973 an acupuncture symposium for physicians and dentists was held in New York City; it featured Aimé Limoge of France, Felix Mann of Great Britain, and several distinguished American physicians. Among the latter were Howard A. Rusk, director of the Institute of Rehabilitation at the New York University Medical Center, Frank Z. Warren, director of the National Acupuncture Research Society (co-sponsor of the symposium with the New York University Medical Center), and John W. C. Fox, a participant in our First Conference, and an assistant professor of anesthesiology at the State University of New York, Downstate Medical Center.

The U. S. National Institutes of Health, in 1972, organized a committee on acupuncture, naming Dr. Howard Jenerick as executive secretary. The prestigious *Journal of the American Medical Association* began publishing articles on acupuncture and *The American Journal of Chinese Medicine* came into existence to cover the topic in depth. Some health insurance firms such as the

Continental Assurance Company and the Continental Casualty Company inaugurated coverage for acupuncture treatment performed by a licensed physician. At the same time, Dr. Fox warned against the practice of acupuncture by amateurs, noting that injury or death could result if contaminated needles were used. In a newspaper interview, he also revealed that an asthma patient had died at the hands of an unqualified practitioner who knew the proper insertion point but did not know how many times to turn the needle.

The Acupuncture Controversy

This warning was echoed by a group of acupuncture specialists from the People's Republic of China interviewed in Shanghai. In the interview, published in the Milwaukee *Journal,* June 4, 1972, a cautionary point of view was presented on acupuncture anesthesia; one physician said, "Unless the circumstances are exactly right, these kinds of operations should be done with conventional anesthesia." The Chinese practitioners did not claim that acupuncture was a medical panacea. However, they noted its success in such ailments as skin disorders, migraine headaches, lower-back pain, arthritis, asthma, myopia, post-polio paralysis, and crippling conditions due to birth injuries. When asked about the explanation for acupuncture's effectiveness, one of the specialists commented, "We have no pat answer, only a number of theories. We argue over them a great deal at scientific meetings."

Considerable controversy regarding the theoretical basis of acupuncture exists in the United States as well. Arthur Taub of the Yale University School of Medicine attacked the interest in acupuncture of the National Institutes of Health and branded as "premature" the convening by physicians of workshops to discuss the practice. In a letter published in the October 6, 1972, issue of *Science,* Dr. Taub stated:

> . . . Acupuncture in the treatment of chronic disease is an ancient system of medicine, predicated theoretically upon a nonheuristic world-view (an admixture of Yin and Yang) and practically based upon a system of diagnosis (the subjective sensation imparted to the examiner by the beat of the radial pulse at the wrist) and a therapeutic technique (the insertion of metal needles one to two millimeters beneath the skin, with

or without the passage of minute amounts of electric current). Neither the diagnostic nor the therapeutic technique has any basis . . . There has been no controlled statistical evidence from the Chinese or from the many Western European practitioners of acupuncture that is in any way superior to a placebo in the treatment of chronic pain.

Taub further noted that the success of acupuncture anesthesia, as witnessed and reported by American visitors to China, was unconvincing. One such report, by Dr. E. Grey Diamond, was published in the *Journal of the American Medical Association,* December 6, 1971. It reviewed six operations, all of which responded well to acupuncture anesthesia. However, Taub noted that in only one of the six cases no narcotic or analgesic medication was administered; that patient underwent a type of neurological surgery for which anesthesia is generally unnecessary.

The October 17, 1971, Providence *Sunday Journal* quoted Joshua Horn, a British surgeon who spent fifteen years in China, as saying that the control of pain with acupuncture results entirely from the power of suggestion and the faith of the patient in the technique. Janet G. Travell added that she has experimented with a vapor spray that cools the skin, thus reducing muscular pain. Thus, there may be a purely physiological effect in acupuncture anesthesia resulting from the stimulation of nerves by the needles. A related effect is the attenuation of shock-elicited pain by applying tactile stimulation to the shocked site. This research, reported in the May 21, 1971, issue of *Science* by J. David Higgins, Bernard Tuvsky, and Gary E. Schwartz, also revealed that the tactile stimulus was able to reduce pain only when it had the opportunity to produce the spinal gating effect.

The "gating theory," associated with the work of Ronald Melzack of McGill University and Patrick Wall of University College, London, has been applied to acupuncture in an article by Dr. Wall in the *New Scientist,* July 20, 1972. The theory holds that stimulation of the large "A-delta" fibers in the sensory nerves (as produced, presumably, by acupuncture needles) closes a hypothetical gate in the spinal cord. This would block pain impulses which travel along a different set of smaller nerve fibers, from traveling up the cord into the brain. As this would only block pain traveling along peripheral nerves leading to and from the spinal

cord (i.e., from the neck down), the existence of a second gate in the thalamus of the brain has been postulated by Paul Man and Calvin C. Chen of Northville State Hospital in Michigan. Man and Chen suspect that this second gate closes pain sensations from reaching the cerebral cortex from below or above the spinal cord (as in dental extractions or abdominal operations).

The American physician, William Kroger, took issue with the "gating theory" in an article published in the October 17, 1972, issue of the *Society for Clinical and Experimental Hypnosis Newsletter*. Stating that Melzack and Wall "do not adequately provide a scientific rationale for acupuncture anesthesia," Kroger proposed several important variables including "the generalized stoicism of the Chinese, the ideological zeal, the evangelic fervor . . . , Mao Tse-tung's thought directives . . . , the cere-monial-like placement of the needles and their twirling . . ." This "misdirection of attention" increases receptivity to autosug-gestion and raises the pain threshold; a similar effect is brought about by hypnotic induction to reduce pain. Herbert Spiegel, interviewed in the June 21, 1972, issue of *Psychiatric News,* concluded that acupuncture's apparent effectiveness in pain relief may be due in large part to its similarity to hypnosis. Dr. Spiegel added:

> The major difference is that the trance induction ceremony is verbal in hypnosis with the hypnotist talking to his subject. In acupuncture, there is the sticking of needles. But both achieve a similar result—an altered state of concentration.

In the meantime, physicians continue to visit China and to bring back additional information. Luciano Roccia of Italy's Turin University observed children with nerve deafness undergo acu-puncture treatment. The American surgeon Paul Dudley White returned from China with a reasoned observation (cited in *News-week,* August 14, 1972): "If it were the world's best technique, we'd all be using it. If it were useless, it would have been dropped thousands of years ago. There's something in it, but it's difficult to say just what." And so the matter stands.

Kirlian Photography

The past few months have seen an increase in the number of Kirlian devices built in the United States. Most of these devices have been built by students, many of them guided by information they obtained from the first edition of *The Kirlian Aura.*

The second edition of this book contains certain alterations in those chapters referring to the Soviet work on Kirlian photography and psychic "healers." As more information has become available, it appears that the American photographs of psychics taken before, during, and after "healing" are closer to the Soviet results than suspected. Much of the work in the U.S.S.R. has been accomplished by Viktor Adamenko with a "healer" named Alexei Krivorotov. It has recently been discovered that Krivorotov's sons, Vladimir and Victor, possess similar "healing" talents.

The striking photographs of the American "healer" Ethel E. DeLoach, which originally appeared in *The Kirlian Aura,* were reproduced on the cover of *Osteopathic Physician,* October 1972. In this special issue on Kirlian photography, *Osteopathic Physician* surmised that the technique might become a diagnostic aid. It featured articles by various participants in the First Conference (e.g., Larry Amos, James Hickman, and Kerry Krumsiek; E. Douglas Dean and Ethel E. DeLoach; Thelma Moss and Kendall Johnson; Max Toth, and J. R. Worsley).

The February issue of *Popular Photography* featured an article, "Kirlian Imagery: Photographing the Glow of Life," by Natalie Canavor, Cheryl Wiesenfeld, and Donald Leavitt. It was suggested that the process produces an electrostatic image that indicates the distribution of fluid in the tissue. Regarding leaves, it was proposed that "the distribution of fluids and their density may reveal not only a particular phase of photosynthesis, but also the efficiency of the photosynthetic process insofar as the production of simple sugars is concerned." Regarding humans: "Variations in the distribution of fluids could reveal the state of health and perhaps the emotional state of the person. The presence or absence of anxiety markedly changes the fluid balance of the human body . . . The Kirlian system may generate a great deal of interest regarding its application to emotional analysis."

Soviet researchers in Kirlian photography have reported the

Figure 80. Electrophotograph of "phantom leaf" (courtesy, H. G. Andrade)

"lost leaf" effect (*Figure 49*) but this finding had not been replicated when the first edition of *The Kirlian Aura* went to press. On March 10, 1973, Stanley Krippner received a photograph (*Figure 80;* also see front cover of this book) which may represent the first "phantom leaf" seen outside the U.S.S.R. It was taken in São Paulo, Brazil, by H. G. Andrade, Director of Research, Brazilian Institute of Psychobiophysical Investigation. He stated:

> We have obtained many photos demonstrating the Kirlian effect using an apparatus that was constructed by our group. The

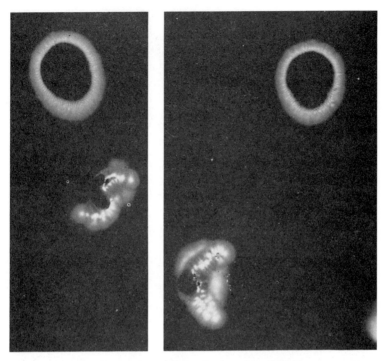

Figure 81. Left: Electrophotograph of telepathic "M"

Figure 82. Right: Electrophotograph of telepathic "7"

photo demonstrating the "lost leaf" effect does not necessarily represent perfect evidence of the "phantom leaf." Another interpretation may exist for it. We are trying to work out a procedure that will permit a systematic replication of the "phantom."

Parapsychology and the Kirlian Effect

In the introduction to this volume's first edition, we raised the question as to whether the Kirlian effect was parapsychological in nature. There has been no evidence that the flare patterns themselves represent any paranormal phenomenon; however, Kirlian photography may be a useful tool in studying psychic "healing" and other forms of psychokinesis.

For example, a Kirlian photographer, Jonathan Cohen, reports that an agent in a distant room was asked to send a telepathic image to the subject who was being photographed. The subject receiving the image tried to psychokinetically create it on the electrophotograph. *Figure 81* shows the subject at rest (above) and his attempt to produce the letter "M" (below) which he had accurately received from the agent. In *Figure 82,* the agent had sent the number 2. However, the subject, as well as the photographer, claimed to have received a number 7.

In conclusion, we feel that the second edition of *The Kirlian Aura* re-emphasizes the general systems approach taken in our previous volume to the emerging field of study described by our Soviet colleagues as "psychoenergetics." There is a growing need for basic information regarding the bioelectric fields of life and their applications. Perhaps the material in this book can meet part of that need as well as stimulate further advances in research, theory, and practice.

STANLEY KRIPPNER and DANIEL RUBIN
April 17, 1973

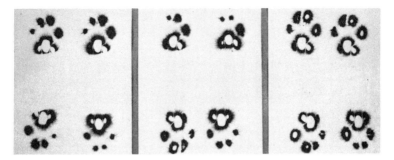

Figure 83. Electrophotograph, cat's paws; 3 sec. exposure, Polycontrast Paper (courtesy, J. Hickman, L. Amos, K. Krumsiek)

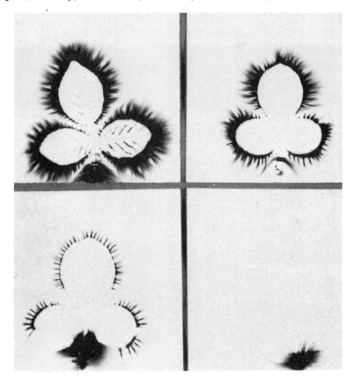

Figure 84. Electrophotograph, rose leaves, 15 sec. exposure, immediately after leaf was picked, 7 hrs. after, 14 hrs. after, 21 hrs. after; Polycontrast Paper (courtesy, J. Hickman, L. Amos, K. Krumsiek)

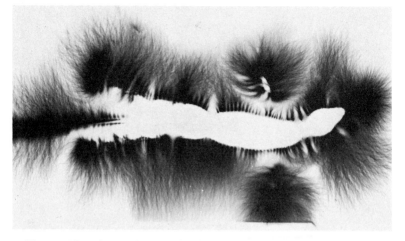

Figure 85. Electrophotograph, ventral side, race runner; 15 sec. exposure, Polycontrast Paper (courtesy, J. Hickman, L. Amos, K. Krumsiek)

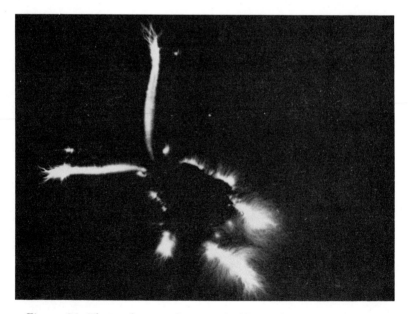

Figure 86. Electrophotograph, ventral side, cockroach; 2½ sec. exposure, Ortho Film (courtesy, J. Hickman, L. Amos, K. Krumsiek)

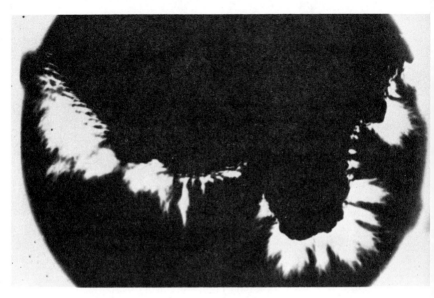

Figure 87. Electrophotograph, side view, right breast, thirty-eight-year-old female; 3 sec. exposure, Ortho Film (courtesy, J. Hickman, L. Amos, K. Krumsiek)

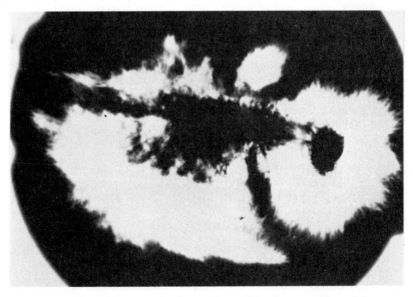

Figure 88. Electrophotograph, front view, right breast, thirty-eight-year-old female, 2½ sec. exposure, Ortho Film (courtesy, J. Hickman, L. Amos, K. Krumsiek)

References

Adamenko, V. G. Electrodynamics of living systems. *Journal of Paraphysics,* 1970, *4:*113–120.

Adamenko, V. G. Private communication, November 1971.

Adamenko, V. G., and Kirlian, S. D. Russian Patent No. 209968, 1966.

Barber, T. X. Preface to *Biofeedback and Self-Control,* 1970, Barber, T. X., et. al. (eds.). Chicago: Aldine-Atherton, Inc., 1971. Pp. vii–xvi.

Beal, J. B. Methodology of pattern in awareness. *Fields within Fields . . . within Fields,* 1972, *5:* 42–48.

Beal, J. B. Private communication, December 1971.

Bernal, J. D. *Theoretical and Mathematical Biology.* Waterman, T. H., Morowitz, H. J. (eds.). Waltham, Mass.: Blaisdell Publishing Co., 1965, 5.

Boswell, H. A. *Master Guide to Psychism.* New York: Lancer Books, 1969.

Brozek, J. Soviet psychology's coming of age. *American Psychologist,* 1970, *25:*1057–1058.

Burr, H. S. *Yale Journal of Biology and Medicine,* 1957, *30:*161.

Carey, G. C. The tradition of the St. Elmo's fire. *American Neptune,* 1963, *23:*29–38.

Clynes, M. Biocybernetics of the dynamic communication of emotions and qualities. *Science,* 1970, *170:*764–765.

Cole, M., and Maltzman, I. (eds.). *A Handbook of Contemporary Soviet Psychology.* New York: Basic Books, 1969.

de Langre, J. *The First Book of Dō-In.* Hollywood, Calif.: Happiness Press, 1971.

DeLoach, E. E. A Case History of Psychic Healing. *Newsletter of the Jersey Society of Parapsychology,* 1972, *2:*4.

Devine, R. E. Psych-Analyzer. *Electronic Experimenters Handbook,* Spring, 1970.

Duke, M. *Acupuncture.* New York: Pyramid House, 1972.

Eckert, R. Bioelectric growth of ciliary activity. *Science,* 1972, *176:* 473–481.

Edwards, F. *Stranger Than Science.* New York: Ace Star Books, 1959.

Edwards, F. *Strange Worlds.* New York: Bantam Books, 1969.

Eisenbud, J. *The World of Ted Serios*. New York: William Morrow & Company, 1967.

Fox, J. W. C. Introduction to *Acupuncture* by Duke, M. New York: Pyramid House, 1972.

Fuller, R. B. *Intuition*. New York: Doubleday & Company, 1972.

Gaidoz, H., and Rolland, E. St. Elmo's fire. *Mélusine*, 1884–1885, *2:*112–113.

Garbuny, M. *Optical Physics*. New York: Academic Press, 1965.

Greenler, R. G., and Mallmann, A. J. Circumscribed halos. *Science*, 1972, *176:*128–131.

Hall, C. S., and Lindzey, G. *Theories of Personality*. New York: John Wiley & Sons, 1957.

Herbert, B. The Kirlian controversy: "Cut-away" effects. *Journal of Paraphysics*, 1972, *6:* rear cover.

Holzer, H. *Psychic Photography: Threshold of a New Science?* New York: McGraw-Hill Book Co., 1969.

Huxley, A. Foreword to *Acupuncture: The Ancient Chinese Art of Healing* by Mann, F. New York: Vintage Books, 1972.

Inyushin, T. C. Toward the study of the electrobioluminescence of acupuncture points under normal conditions and with the action of laser radiation. In *Problems in Bioenergetics,* Dombrovsky, A., et. al. (eds.). Alma-Ata, Kazakh, U.S.S.R.: Kazakh State University, 1969. Pp. 64–68.

Inyushin, V. M. Bioplasma and interaction of organisms. In *Symposium of Psychotronics,* Rejdák, Z., et. al. (eds.). Dowton, Wiltshire, England: Paraphysical Laboratory, 1970. Pp. 50–53.

Inyushin, V. M. *Toward the Problem of the Luminescence of Tissue in High-Frequency Discharge Biological Action of Red Light*. Alma-Ata, Kazakh, U.S.S.R.: Kazakh State University, 1967.

Inyushin, V. M., et. al. *On the Biological Essence of the Kirlian Effect*. Alma-Ata, Kazakh, U.S.S.R.: Kazakh State University, 1968.

Johnson, K. Private communication, April 1972.

Jonas, G. Manfred Clynes and the science of sentics, *Saturday Review,* May 13, 1972.

Karagulla, S. *Breakthrough to Creativity*. Los Angeles: De Vorss & Company, 1967.

Kholodov, Y. A. *The Effect of Electromagnetic and Magnetic Fields on the Central Nervous System*. Moscow: Nauka, 1966.

Kim, B. H. Kyungrak System and Theory of Sanal. *Proceedings of the Academy of Kyungpak of the Democratic People's Republic of Korea*, 1963, Number 2.

Kim, B. H. On the Kyungrak System. *Journal of the Democratic People's Republic of Korea,* 1965, Number 2.

Kirlian, S. D. Russian Patent No. 164906, 1963.

Kirlian, S. D., and Kirlian, V. Kh. *In the World of Wonderful Discharges.* Alma-Ata, Kazakh, U.S.S.R.: Kazakh State University, 1958.

Kirlian, S. D., and Kirlian, V. Kh. *Photography and Visual Observation by Means of High-Frequency Currents.* Alma-Ata, Kazakh, U.S.S.R.: Kazakh State University, 1959.

Kirlian, S. D., and Kirlian, V. Kh. Photography and visual observations by means of high-frequency currents, *Journal of Scientific and Applied Photography,* 1961, *6*:397–403.

Krippner, S., and Davidson, R. Parapsychology in the U.S.S.R. *Saturday Review,* March 18, 1972.

Lakatos, I. Meeting of the Aristotelian Society at 21 Bedford Sq., London, W.C.1, October 1968.

Laszlo, E. *Introduction to Systems Philosophy.* New York: Gordon & Breach, Inc., 1972a.

Laszlo, E. *The Systems View of the World.* New York: George Braziller, 1972b.

Lavine, L. S., et. al. Electric enhancement of bone healing. *Science,* 1972, *175*:1118–1121.

Lewin, K. Behavior and development as function of the total situation. In *Manual of Child Psychology,* Carmichael, L., (ed.). New York: John Wiley & Sons, 1954. Pp. 918–970.

Lewin, K. *A Dynamic Theory of Personality.* New York: McGraw-Hill Book Co., 1935.

Lewin, K. *Field Theory in Social Science: Selected Theoretical Papers,* Cartwright, D. (ed.). New York: Harper & Brothers, 1951.

Lewin, K. *Principles of Topographical Psychology.* New York: McGraw-Hill Book Co., 1936.

Lilly, J. C. *The Center of the Cyclone.* New York: The Julian Press, 1972.

Lowen, A. *The Betrayal of the Body.* New York: The Macmillan Company, 1967.

Lucretius. *On the Nature of Things.* Chicago: Encyclopedia Britannica, 1952.

Mann, F. *Acupuncture: The Ancient Chinese Art of Healing.* New York: Vintage Books, 1972.

Maxwell, J. C. *A Treatise on Electricity and Magnetism, Volumes I and II.* Second Edition. London: Oxford University Press, 1881.

Mikhalevskii, V. L., and Frantov, G. S. Photographing surfaces of metal ores by means of high-frequency currents. *Russian Journal of Scientific and Applied Photography and Cinematography,* 1966, *2*:380–381.

Milner, D. R., and Smart, E. F. *There Are More Things*. London: Privately printed, 1973.

Monteith, H. C. Private communication, February 1972.

Moss, T. Searching for psi from Prague to Lower Siberia. *Psychic,* 1971, *2*:40–44.

Moss, T., and Johnson, K. Radiation field photography. *Psychic,* 1972, *3*:50–54.

Muramoto, N. Oriental diagnosis. *The Macrobiotic,* 1971, *11*:9.

Murphy, G., and Kovach, J. K. *Historical Introduction to Modern Psychology*. Third Edition. New York: Harcourt Brace Jovanovich, Inc., 1972.

Nebel, J. *The Psychic World Around Us*. New York: The New American Library, 1970.

Ohsawa, G. *The Unique Principle*. Boston: Tao Books, 1970.

O'Neill, J. J. *Prodigal Genius, The Life of Nikola Tesla*. New York: David McKay Company, 1971.

Ostrander, S., and Schroeder, L. *Psychic Discoveries Behind the Iron Curtain*. Englewood Cliffs, N.J.: Prentice-Hall, Inc., 1970.

Ostrander, S., and Schroeder, L. Psychic enigmas and energies in the U.S.S.R. *Psychic,* 1971, *2*:9–14.

Parin, V. V. Foreword to *Electromagnetic Fields and Life* by Presman, A. S. New York: Plenum Press, 1970.

Pavlov, I. P. *Lectures on Conditioned Reflexes, Volume I*. New York: International Publishers Company, 1928.

Prat, S., and Schlemmer, J. Electrography. *Journal of the Biological Photographic Association,* 1939, *7*:145–148.

Pratt, J. G. A meeting on parapsychology in Moscow. *Theta,* 1968, Number 23.

Presman, A. S. The role of electromagnetic fields in vital processes. *Biofizika,* 1964, *9*:13.

Ravitz, L. J. Electromagnetic field monitoring of changing state-function, including hypnotic states. *Journal of the American Society of Psychosomatic Dentistry and Medicine,* 1970, *17*:119–129.

Razran, G. *Mind in Evolution: An East-West Synthesis of Learned Behavior and Cognition*. Boston: Houghton Mifflin Company, 1971.

Reich, W. *Character Analysis*. Rangeley, Maine: Orgone Institute Press, 1949.

Reiser, O. L. Solar system resonance, the galactic aurometer and the DNA helix. *Fields within Fields . . . within Fields,* 1972, *5*:115–130.

Rose-Neil, S. The Work of Professor Kim Bong Han. *The Acupuncturist,* 1967, *1*:15.

Russo, F., and Caldwell, W. E. Biomagnetism phenomena: Some implications for the behavioral and neurophysiological sciences. *Genetic Psychology Monographs*, 1971, *84*:177–243.

Schwartz, J. The Human Aura. Paper delivered at the Fourth Conference on the Voluntary Control of Internal States, Council Grove, Kansas, April 1972.

Seipel, J. H. The magnetic field component of the neural impulse. Final Report, N.A.S.A. Research Grant NGR 09–009–005, 1971. Mimeographed.

Seipel, J. H., and Morrow, R. D. The magnetic field accompanying neuronal activity, a new method for the study of the nervous system. *Journal of the Washington Academy of Science*, 1960, *50*:1–4.

Stoll, E. Medical portraits: Goya and Van Gogh. *The Sciences*, 1972, *12*:16–21.

Szent-Györgi, A. *Introduction to a Submolecular Biology*. New York: Academic Press, 1960.

Tesla, N. *Lectures, Patents, Articles*. Belgrade, Yugoslavia: Privately printed, 1956.

Tiller, W. A. A technical report on some psychoenergetic devices. *A.R.E. Journal*, 1972, *7*:81–94.

Ullman, M. Fragments of a parapsychological journey. *Newsletter, American Society of Psychical Research*, Summer, 1971.

Vasilev, L. L. *Mysterious Phenomena of the Human Psyche*. New Hyde Park, N.Y.: University Books, 1965.

Veith, I. (ed. and trans.). *Huang Ti Nei Ching Su Wen: The Yellow Emperor's Classic of Internal Medicine*. New Edition. Berkeley, Calif.: University of California Press, 1970.

von Bertalanffy, L. General system theory and psychiatry. *American Handbook of Psychiatry, Volume Three*, Arieti, S., (ed.). New York: Basic Books, 1966. Pp. 705–710.

White, J. Acupuncture: The world's oldest system of medicine. *Psychic*, 1972, *3*:12–18.

Whitehead, A. N. *Process and Reality*. New York: Harper & Row, 1960.

Zahradnicek, J. *The Photochemical Effects of Maxwell's Currents*. Prague: Faculty of Sciences, Masaryk University, 1948.

Zelany, W. Variation of size and charge of Lichtenberg figures with voltage. *American Journal of Physics*, 1945, *13*:106.

Index

Acupuncture
 as anesthesia, 134, 167, 191
 controversy over, 190
 developing potential through treatment by, 165
 different kinds of, 133–34
 effect of, on disease, 123, 142, 166
 and Kirlian photography, 20–21, 22, 70, 92*ff.*
 as parapsychology, 18
 and psychic healing procedures, 80
 theory of, 122–23, 141
 in U.S., 189
 in U.S.S.R., 188
 works with Ch'i energy, 142
Acupuncture points, 103
 as conductors, 147
 locating, 123, 150, 185
 as massage points, 156
 monitoring of, 128
 stimulating of, 93
Adamenko, Viktor, 18, 25, 51, 86, 93, 189, 193
Adrenalin, 131
Alcohol, 63, 66
American Journal of Chinese Medicine, 189
American Society for Psychical Research, 170
Amos, Larry, 193
Amphetamines, 66
Analgesia, acupuncture. *See* Anesthesia
Andrade, H. G., 194
Anemia, 130
Anesthesia, acupuncture, 134, 167, 191
Animal magnetism, 66
Arica Institute, 167
Arrigo, José, 163
Astral body, 51
Auras, 22, 51, 55, 169. *See also* Bioplasma; Corona discharge
 ability of psychics to see, 164
 around fingers, 62
 around human body, 163
 effects of alcohol on, 63
 of healers, 70
 increase during meditation, 67
 may be gaseous emission from body, 188

Baravuc, H., 178

Beal, J. B., 22, 28
Bernal, J. D., 187
Bertalanffy, Ludwig von, 19
Bioenergetic therapy, 162
Biological plasma. *See* Bioplasma
Biometer, 149–50
Bioplasma, 52, 55, 78, 105, 121, 169, 178. *See aso* Auras; Corona discharge
Bioplasmic body, 142
 definition, 51
Bischko, Johannes, 168
Blood, 123, 130
Boswell, Harriet, 31
Boyer, D., 112
Breathing exercises, 67, 156, 158
Burr, Harold, 165, 187

Caldwell, W. E., 22
Canavor, Natalie, 193
Carey, G. C., 25
Castor, 25
Cell division, 132
Center of the Cyclone, The, 167
Chen, Calvin C., 192
Ch'i, 134, 141, 154–57
 replenished from air, 143
Chinese medicine, 153, 166, 183, 189
Chromosomes, 133
Cohen, Jon, 170
Cold electron emission, 85
Colloid instability, 134
Conrad, Pete, 28
Contact photography, 50. *See also* Kirlian photography
Continental Assurance Company, 190
Continental Casualty Company, 190
Corona discharge, 51–52, 55. *See also* Auras; Bioplasma
 around fingers, 62
 increased by relaxation, 67
Corposant, 25
Cortical hormones, 131
Corticosteroids, 131

Davidson, Richard, 17, 22
Dean, E. Douglas, 63, 193
DeLoach, Ethel E., 80, 81, 193
Deoxyribonucleic acid, 131
Devine, R. E., 126
Diamond, E. Grey, 191

Dielectric breakdown, 111
Dielectric devices, 95, 96
Dielectric material, 35, 74, 75
 properties of, 47
Dietz, David, 27
Dioscuri, 25
Disease, 123
Dō-In, 158
Downstate Medical Center, New York, 168
Drugs, 66
DuBois, William, 75

Eckert, Roger, 21
Edmond, John, 31
Eisenbud, Jule, 32
Electroencephalographic techniques, 90
Electromagnetic fields, 86, 90, 146
 biological activity of, 87
 influence growth of protoplasm, 165
Electron microscope, 101
Electron-proton optical system, 50
Electrons, field emission of, 114–18, 121
Electron scattering processes, 121
Electrophotography, 178. *See also* Kirlian photography
Elements, 178
Endocrine system, 131
Energizers, 66
Energy body, 142
Estrogen, 131
Evolution, 86, 88
Exercise, 158
External Duct System, 130

Fermie's fire, 25
Field A. C., 112
Field biology, 184
Field effect in Kirlian photography, 86*ff*., 91, 160
Field emission, 114–18
 electrons liberated from material by, 121
Film, 80, 96, 161
Finger, photographs of, 80, 103
Finger pressure, 90
Fingerprint, erased, 105
Fisch, Guidy, 189
Foundation for ParaSensory Investigation, 75
Fox, John W. C., 189
Franklin Institute, 53
Frantov, G. S., 18
Fuller, R. Buckminster, 19

Gaidoz, H., 25
Galvanic skin response, 62
Greenler, R. G., 164

Halos, 101–2
Healers, 68–69, 80, 103
Hematopoiesis, 130
Herbal remedies, 156
Hickman, James, 193
Higgins, J. David, 191
High-voltage radiation photography, 80. *See also* Kirlian photography
Homolographic tables, 149
Hormone production, 90
Horn, Joshua, 191
Human aura. *See* Auras
Huxley, Aldous, 169
Hyaluronic acid, 131
Hypnosis, 66, 128, 192

Image amplification, 99
Internal Duct System, 130
Intra-External Duct System, 130
Inyushin, V. M., 51, 105, 121

Jenerick, Howard, 189
Jersey Society of Parapsychology, 80
Johnson, Kendall, 112, 170, 193
Journal of Biological Photography, 52
Journal of the American Medical Association, 189, 191

Kazakh State University, U.S.S.R., 141
Kazakhstan photographs, 142–43
Ketosteroid, 131
Ki. *See* Ch'i
Kim Bong Han, 93, 127, 129, 130, 132, 143
Kim Bong Han Sanal, 132
Kirlian, Semyon, 18, 51
Kirlian, Valentina, 18, 51
Kirlian devices, portable, 73
Kirlian microscope, 96
Kirlian photographs
 of fingers, 56, 80
 noncontact, 75
 theories about, 78
Kirlian photography
 and acupuncture, 20–21, 22, 70
 color used in, 102
 equipment used for, 70, 73–74, 92*ff*.
 field effects of, 85*ff*., 91, 160
 film used for, 54, 80, 96, 161
 human aura visible in, 163
 information obtained from, 164
 of living organisms, 44–45, 47
 method for, 36*ff*., 47*ff*., 54*ff*., 94*ff*.
 moving pictures in, 96
 and orgone theory, 162
 power sources for, 32, 36, 52–53, 93, 160–61

reveals changes in skin temperature, 65
reveals personal interactions, 68
used to photograph viruses, 163
used to monitor health, 20, 91
used to understand ESP, 18
uses X-ray technique, 161
Kokysyu, 158
Kovach, J. K., 17
Krippner, Stanley, 17, 22, 170, 189, 194
Krivorotov, Alexei, 81, 193
Kroger, William, 192
Krumsick, Kerry, 193
Kyungrak system of ducts, 143

Lao-tse, 153
Lapidot, Abraham, 168
Laszlo, E., 165
Leaves
emissions from, 102, 112
energy transfer interaction between living and dying, 111
photographing, 103, 106
radiation sources in, 104
Leavitt, Donald, 193
Lewin, K., 86, 87, 89
Lichtenberg figures, 33
Life force, 141, 154
Life magazine, 28
Lightning photography, 30–31
Light pencil, 147
Li Ki, 157
Lilly, John C., 167
Limoge, Aimé, 189
Lost leaf effect, 60–61, 78, 122, 163, 194
Lowen, Alexander, 67
Lymph system, 123, 130

McGarey, Robert, 170
Magnetic fields, 22
Mallmann, A. J., 164
Man, Paul, 192
Mann, Felix, 167
Marijuana, 66
Maryland College of Pharmacy, 29
Massage, oriental, 151–53
centers on acupuncture points, 156
Matter, types of, 78
Maxwell, J. C., 33
Maxwell's currents, 33
Medicine
Chinese, 153, 166, 183, 189
preventive, 158
Meditation, 66
Medullary hormones, 131
Melzack, Ronald, 191
Meridian system, 125, 131, 132, 141, 156, 162

Mesmerism, 66
Metal, theoretical development for, 114
Meteors, movement of, 145
Microscope
electron, 101
Kirlian, 96
Mikhalevskii, V. I., 18
Miller, Richard, 188
Milner, D. R., 106
Milwaukee *Journal,* 190
Mononucleotides, 131
Monteith, H. C., 111
Morrow, R. D., 21
Moss, Thelma, 22, 112, 193
Moxa, 152
Mumler, William, 31
Muramoto, N., 157
Murphy, Gardner, 17
Muscle relaxation, 156

Narkevich-Todko, Yakov, 18, 178
National Foundation of Gifted and Creative Children, 75n
National Institute of Mental Health, 66
Navratil, B., 178
Nebel, John, 32
Nei Ching, 151, 164
Nerve system, 123
Neural Duct System, 130
Newman, Frederic, 168
New Scientist, 191
New York *Herald,* 31
Nguyen Van Nghi, 189

Odors, 146
Ohsawa, G., 154
O'Neill, John J., 26
Open system, 20
O'Regan, Brendan, 189
Orgone energy, 162
Oriental massage, 151
Osis, Karlis, 170
Osteopathic Physician, 193
Ostrander, S., 34, 60

Pain, 70
phantom, 165
Pain relievers, 66
Parapsychology, Soviet, 18
Pavlov, I. P., 17
Peripheral vascular system, 63
Petrovsky, B. V., 188
Phantom leaf effect. *See* Lost leaf effect
Phantom pains, 165
Photoelectric emission, 118–19
Planck, Max, 183
Plants
photographing, 103

response of, to Kirlian photography, 59
Plasma, 78
Podshibyakin, A., 147
Pollux, 25
Popular Photography, 193
Pranayama, 67
Prat, Silvester, 179
Presman, A. S., 88, 89, 184, 187
Preventive medicine, 158
Providence *Sunday Journal*, 191
Psych-Analyzer device, 126
Psychic healers, 68–69, 89
Psychic photography, 31
Psychoenergetics, study of, 92
Psychological ecology, 89
Pulses, 166
Pupil dilation, 90

Radiation photography. *See* Kirlian photography
Radio sound, 145
Ravitz, L. J., 21, 165
Reich, Wilhelm, 67, 161–62
Ribonucleic acid, 131
Roccia, Luciano, 192
Rolland, E., 25
Ross Rodney, 170
Rubin, Daniel, 170
Rusk, Howard A., 189
Russo, Frank, 22

Saga magazine, 28
St. Elmo's fire, 25, 26, 27, 28, 85
Sanal, 132, 133
Schlemmer, Jan, 179
Schmeidler, Gertrude, 170
Schroeder, L., 34, 60
Schwartz, Gary E., 191
Schwartz, Jack, 164
Seipel, J. H., 21
Self-emissions of living things, 102
Semiconductor effect, 127
Sentics, 90
Serios, Ted, 32
Skotographs, 31
Smart, E. F., 106
Society for Clinical and Experimental Hypnosis Newsletter, 192
Spiegel, Herbert, 192

Spinal adjustments, 156
Stanford device, 112
Stoll, E., 164
Superficial Duct System, 130
Synergy, 19–20
Systems science, 19
Szent-Györgi, A., 183

Taub, Arthur, 190
Tesla, Nikola, 26, 53
Tesla coil, 53
Thoughtography, 32
Tiller, William A., 60, 177
Tobiscope, 18, 123, 125, 147
Toth, Max, 193
Trance, 66
Tranquilizers, 66
Travell, Janet G., 191
Tuvsky, Bernard, 191
Tyapkin, A., 146

U. S. National Institutes of Health, 189

Valium, 66
Van Gogh, Vincent, 164
Veith, Ilza, 164
Viruses, 163
Vital energy, 141, 154
Vogralik, V. G., 188

Waddington, 183
Wall, Patrick, 191
Warren, Frank Z., 189
White, Paul Dudley, 192
Wiesenfeld, Cheryl, 193
Worsley, J. R., 193

X-ray photography, 161

Yang and Yin, 141, 153
Yellow Emperor's Classic of Internal Medicine, The, 151
Yoga, 66, 67, 158
Yuffe, A., 146

Zahradnicek, Josef, 32
Zdorovye (periodical), 188
Zeichner, Steve, 170
Zelany, W., 33